Spiritual
Tattoo

Spiritual
Tattoo

A Cultural History of Tattooing, Piercing, Scarification, Branding, and Implants

JOHN A. RUSH

Frog, Ltd.
Berkeley, California

Copyright ©2005 by John A. Rush. All rights reserved. No portion of this book, except for brief review, may be reproduced, stored in a retrieval system, or transmitted in any form or by any means—electronic, mechanical, photocopying, recording, or otherwise—without written permission of the publisher. For information contact North Atlantic Books.

Published by Frog, Ltd.

Frog, Ltd. books are distributed by North Atlantic Books
P.O. Box 12327
Berkeley, California 94712

Book design by Suzanne Albertson
Printed in the United States of America
Distributed to the book trade by Publishers Group West

North Atlantic Books' publications are available through most bookstores. For further information, call 800-337-2665 or visit our website at www.northatlanticbooks.com.

Substantial discounts on bulk quantities are available to corporations, professional associations, and other organizations. For details and discount information, contact our special sales department.

Library of Congress Cataloging-in-Publication Data

Rush, John A.
 Spiritual tattoo : a cultural history of tattooing, piercing, scarification, branding, and implants / by John A. Rush.
 p. cm.
 Summary: "Reviews body modifications from prehistoric times to present, outlining processes and procedures and discussing social and psychological motives"—Provided by publisher.
 Includes bibliographical references and index.
 ISBN 1-58394-117-7 (pbk.)
 1. Body marking. 2. Tattooing. 3. Scarification (Body marking) 4. Body, Human—Religious aspects. 5. Body, Human—Symbolic aspects. I. Title.
GN419.15.R87 2005
391.6'5—dc22 2004025244

2 3 4 5 6 7 8 9 Malloy 10 09 08 07 06

Contents

Preface

Spirituality, or the experience of a presence that exists beyond but close to our senses, has been a cornerstone of our species for more than two million years (see Chapter 1.) All cultures have beliefs and behaviors representing these experiences, designed to define, symbolize, and make mental sense out of the tangible world and that unseen world beyond.

There are many paths to spirituality or contacting that "other," some of which can be unexpected, meaning they might involve coercion or submission. Some paths are taken willingly, by becoming the spirit (or god), or by respectfully recognizing a separation. Within these possibilities and paths are numerous methods of body modification, painful body modifications (in most cases), including scarification, tattooing, branding, piercing, and other forms of mutilation, designed to purge or purify as a primary step to a spiritual life. Not everyone has a spiritual experience from a tattoo or piercing, but it is not because they lack the capacity. It is because they did not understand these painful paths as corridors leading to a side of our mind that connects to that "other," that energy source that informs all, often referred to as Yahweh, God, Jesus, Allah, Osiris, Aten, Innana, Cernunnos, Indra, and so on.

Pain and suffering, whether voluntary or forced, are used in many traditions as a form of purging in order to prepare for a spiritual life whereby one lives with one foot in the tangible universe and the other resting firmly in that spiritual realm. Judaism, Christianity, and Islam are but three traditions that subscribe to pain and suffering as the path, the Dao.

Pain and suffering are by no means the only path to spirituality, but the frequency with which they are found speaks for a long, long tradition. Why? This is not an easy answer, but we can begin by noting that pain and suffering lead to the dumping of endorphins (the opiates of the brain),

and usually if not always (depending on the level of pain) there is a period of calmness as the opiates are reabsorbed or metabolized. This would have been recognized by our ancient ancestors upon experiencing injury and subsequent care from others. When people recover it is as if something has been released, added to, or somehow manipulated in the body. Rituals of pain (circumcision, scarification, tattooing, etc.) are analogues of nature's ways and are designed, through imitation and the power of symbols, to heal. Just as the young man experiences the pain of living, so does the community, and just as the young man tolerates the pain, so can the community. With the cutting the old is drained away, and the new (the tattoo, scar, piercing) takes its place. These rituals validated the individual, the community, and nature in all its beauty and horror. But the real reason, well, that lies somewhere in our imagination.

There is no right or wrong—except through our cultural beliefs. A bird or cat would never construct a belief that it had done the wrong thing or sinned in any way; this is a human preoccupation and one that has allowed us to live and cooperate in groups for mutual benefit. If you do the wrong thing you are out (death); if you follow the rules you are in life (see Rush 1999). Thus we learn what is right and wrong, and when we do wrong things (as culturally defined), and we know that certain behaviors (and thoughts) are wrong, we feel tension, often called guilt or shame. Any belief or behavior that serves symbolically to release that tension is a potential focal point for the individual and the group. That focal point could be prayer, shamanic rites, food, sex, drugs, pain, and so on. The most prominent and widespread focal point of tension release and a return to balance is pain, and it is the same in our religious systems as it is in the secular ("as above, so below"). Our legal system, for example, is designed around the infliction of pain for bad behavior so that the situation can be brought back to a lawful state (retribution or a retrieval of what was lost); the individual has to do penance and/or pay back what he or she has "taken away" through the outlawed behavior. Discipline of children through spankings or harsh words—both forms of rejection—is common in many cultures.

Most punishment rituals (symbolized in most cases as being in jail or paying a fine) are designed to render the individual physically and emotionally helpless without choice, just as, interestingly enough, other types of rituals do—for example, rites of passage. Punishment rituals are enacted to remove something from the system, an unacceptable behavior or perhaps the total person, in order to regain control or remove obstacles to the future. Likewise, the pain experience (scarring, tattooing, piercing, etc.), either connected to an authorized religious tradition or self-induced (with the help of others), is carried out to regain control over self or remove barriers to the future.

This work is about the human body as a vehicle for purging emotional and physical issues and as a preparation for a spiritual life; first you have your purification and then your revelation. This book is not for everyone, and it may be difficult for some to appreciate the pervasiveness of this behavior and my observation that the cornerstones of the major three Western traditions (Judaism, Christianity, and Islam) are pain, suffering, and human sacrifice.

Chapter One is an overview of the different methods of body modification practiced cross-culturally and the motives behind some of these very painful rituals.

Chapter Two is a look at the processes of scarring, tattooing, piercing, branding, and skin stripping. In Chapter Three I discuss the words "spiritual" and "spirituality," showing that these terms can have diverse meanings but most would agree that the reference, in its narrowest sense, is to some energy that informs all. Using a model from Hatha Yoga, I attempt to place types of body modification on specific chakras according to the Hindu or Buddhist ideas of spirituality.

Chapter Four involves pain and suffering as a model for salvation. "No pain, no gain" is the mantra recited over and over by the three main Western religious traditions.

Because pain and suffering are major roads to salvation, how might one use physical pain (through tattooing, scarification, piercing, etc.) to purge

one's guilt and sin, move past the tangible world, and approach the spiritual realm? This is the topic of Chapter Five. In Chapter Six I briefly conclude what has been known for thousands and thousands of years. A spiritual life can only be obtained *through* the body, *through* the senses. If the body is characterized as corrupt, nasty, and evil (especially in Judaism and Christianity), your passport to spirituality is withdrawn by those claiming some authority in the matter (religious clerics), and God no longer shows His (or Her) face. If the body is corrupt then it is not a proper medium for salvation—it is only through submission we are "saved."

Spiritual Tattoo is about moving towards a spiritual life, defined here as behavior that is healthy, helpful, and non-hurtful. It is a life where material cravings are few but the desire for understanding and illumination is paramount. This work opens the door. *The Twelve Gates,* a companion volume (forthcoming), opens the door wider and is a preparation for that other side, death.

Many people assisted in this work. I would first like to thank all those individuals who shared their modifications and related stories. Their stories validate my thesis that body modifications are useful processes for purging emotional pain, initiating physical healing, moving through significant life events, and communing with the spiritual realm.

Many professionals aided in pulling together the numerous photographs and drawings. They include Kim Forest, Bill Hill, Raleigh, Melissa Robbe, and Doug Romano of Wild Bill's Tattoo, Roseville, California; Matt Bruce, Victoria, B.C.; Juliana Correa for her drawings, found in Chapters Two and Six; and the staff at North Atlantic Books (Richard Grossinger, Brooke Warner, Kathy Glass, Paula Morrison, Susan Bumps, Lindy Hough, and Sarah Serafimidis) for their suggestions and patience in organizing this manuscript.

A special acknowledgement goes to my wife, Katie, who showed me the way by enacting her own tattoo ritual on her fiftieth birthday, and by embodying patience and understanding when I went on my own very intense, two-year journey of life, death, and resurrection.

—John A. Rush

Scarification and Tattooing:
A Cultural History of Pain

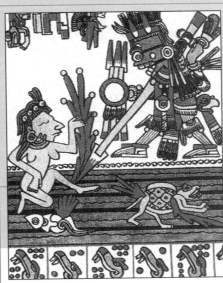

Introduction

Body modifications through mutilation, scarification, and its corollary tattooing—the insertion of pigment into abraded, punctured, or incised skin—have a long history and a much longer prehistory. The oldest indisputable evidence for the practice is to be found on preserved bodies accidentally or ritually mummified in one form or another. There is archaeological evidence for tattooing, including sharp bone needles associated with charcoal and red ochre that date as far back as 30,000 BCE (Before Current Era), or the beginnings of the Upper Paleolithic, although we have no actual preserved skin from that time period. Tattooing, or more likely scarification, was probably practiced by our ancient ancestors of 200,000 years ago or more, although there is neither tangible evidence nor suggestive artifacts.

One way of approaching prehistoric tattooing is to ask, why tattoo? Why permanently alter the surface of the skin with line, dot, and squiggle? To suggest possible answers requires constructing a plausible story as to how our ancient ancestors made a living and how they thought about the world around them. For example, we know that a certain level of reasoning about the world is necessary for a species to classify and manipulate nature, that is, make and use portable tools and pass the technical information down from generation to generation. This process of collecting information about self, group, and environment and encoding it for transfer through time requires a certain level or type of intelligence. Mithen (1994:31–32) offers useful speculation using Gardner's (1983) multiple intelligences approach to learning and teaching, and suggests that Gardner's typologies could include, for example, a sub-category called "technical intelligence." Lock and Colombo (1999:596) offer interesting data on comparative cognitive abilities, suggesting that "A number of human cognitive systems, and their properties—for example memorial processes, categorical auditory and visual perception—appear to have

3

quite deep phylogenetic roots." Thus, how we define intelligence, or what benchmarks we use, can skew our view or our reasoning in regard to possible behaviors of our ancient ancestors and their manipulation of the environment.

We have some tangible evidence (the Acheulean handaxe mentioned below) for very complex behavior, or "technical intelligence," and possible *magical* thinking approximately two million years ago. We also have ethnographic data (the study of contemporary people) pointing to activities that, in many ways, could mirror the behaviors of our ancient ancestors as far back as *Homo erectus* of 1.5 to 2 million years ago. There are other scholars, however, who would place the symbolic nature of something like tattooing and/or scarification within a much more recent time period.

According to Klein and Edgar (2002), a quantum leap in human thinking occurred only around 50,000 years ago (see also Mithen 1994 and Lewis-Williams 2002), resulting in art rendered on the walls of caves or rock shelters in many areas of the world. It began in Africa and then spread to Australia, Asia, and eventually Europe (see Wells 2002 for the latest "out of Africa" time table). Klein and Edgar (2002:271) state:

> Our third and final observation is that the relationship between anatomical and behavior change shifted abruptly about 50,000 years ago. Before this time, anatomy and behavior appear to have evolved more or less in tandem, very slowly, but after this time anatomy remained relatively stable while behavioral (cultural) change accelerated rapidly. What could explain this better than a neural change that promoted the extraordinary modern ability to innovate?

These authors simplify the problem by assuming a "neural change," pushing aside social stress factors that are likewise good candidates for this behavioral change. Social stress factors include an increase in life-span, population pressures and intra-group conflict, conflict with neighboring groups, an increase in the knowledge base leading to information storage

problems, and so on. Suggesting a physical, neurological change would be like saying that because the Sumerians and Egyptians did not have our technology, they must have had different neural wiring and consequent thought patterns. Jaynes (1990) does make this suggestion for the Sumerians but concludes that the difference in consciousness between these ancient people and us has more to do with catastrophic events than with strict physical, biological evolution.

Klein and Edgar do not mention tattooing or scarification in their work, but they do indirectly point out that art is an extension of one's self. Art truly is the duplication of a thought, a Xerox copy stuck on a cave wall, images and beliefs captured and placed outside the artist. Tattooing, on the other hand, is like impregnation. You construct an idea, belief, or behavior through analogies in nature and mentally move from the *outside* (the event in nature, an image, etc.), to *inside* (one's thoughts), to the *outside*, where assistance or at least tools are necessary to place the thought or symbol back "into" or onto the body. This is a coding of the body, a characterization or label, something owned by the tattooed, *and* it is never separate from the mind and/or culture that thought it up. This outside-inside-outside-inside (under the skin) mind/body process is similar to that discussed by other authors (see Gell 1993 and Caplan 2000).

Symbolism and Survival Strategies

It is well known that beliefs and behaviors tend to be very conservative. We develop patterns, which are difficult to break, and culture instructs us on proper "ways" of doing (Dao, Dharma, Ma'at, Me), especially when it comes to sacred rituals, for example church rituals, rites of passage (the movement of an individual from one status to another—see Rush 2002), and important symbols in daily living. Secular rules are easier to change without serious rebellion, implied rules being a possible exception (see Rush 1999). To change a "sacred" symbol, ritual, or associated artifact, on the other hand, would alter its power, and logic assumes that you always

change *up* to a socially perceived symbol of power. We go from an amulet, a crystal, for example, imbued with special protective power, or a fetish or talisman and its spirit power, to all-powerful Gods and Goddesses who can control the crystal and the spirit. Changing these symbols—the materials, shapes, colors, context, or retranslating their meanings—represents a possible crisis. The rapid shifting of certain symbols and their values noted in today's world is not indicative of pre-literate people. This is a mental or perceptual problem that I believe our lineage, including *Homo habilis* and *erectus,* encountered time and again, making social changes or adjustments slowly at first, and then more and more rapidly as we move toward the Upper Paleolithic. The mental problem is creativity, or innovation, that is, keeping change in check so that our kind can slowly move forward, understanding little by little how to manipulate nature and make a better living. Eventually, with symbols and science, we can aspire to become immortal, a common mythic motif with a long season. However, too much creativity leads to instability and possible chaos. Innovation—for example, the development of the throwing spear—surely altered social structure in terms of how nature was perceived (gaining the upper hand over the competing predators). Moving from a scavenger and gatherer to a hunter and gatherer had profound implications; all the myths had to be reconstructed.

Rapid change, again, can lead to chaos and social breakdown, but sometimes it leads to a superchunking of knowledge that becomes generally accepted, although the average person may not understand the details. This is where specialists come in, and specialists can change the characteristics and expectations of a culture. For example, gravity has to do with mass and attraction, but I do not necessarily know the math that supports it—I would have to take the specialist's word on the details. We understand a great deal about the physical nature of the sun, but I might not know the specifics. Specialists, even part-time specialists, become a necessity as information in a system increases, and specialists are in a position to control or alter the group's perception of natural events.

There are many ways of explaining rapid social change, and Klein and Edgar help us see ancient behavior and thinking from a different perspective (also see Pfeiffer 1982). Since the time of the Australopithecines noticeable alterations in behavior have developed, evidenced through associated artifacts/stone tools that appear to correspond to the evolution of larger brains. In terms of a technological leap, however, the greatest difference is from the Australopithecines to *Homo habilis*. During this approximately two-million-year time span (from 4 MYA to 2 MYA—Million Years Ago), our ancestors went from being passive recipients of nature, or simply taking what Nature provides, to being active participants who see "something" in nature, like a predator's tooth, find a like substitute, and transfer the qualities of that something in nature to the substitute. The rest of the tools, from the Acheulean handaxe, knife blades, and swords, to the bow and arrow, right up to the modern artillery piece or rifle, are variations on a basic theme, that is, the teeth, tusks, and claws of predators.

A Message in a Bottle

I think there is general agreement that some very ancient tools (such as those of the Acheulean handaxe tradition) are more than simple tools with a totally practical application such as defleshing scavenged carcasses. As Mithen (1994:33) comments, "In general, stone industries from the Acheulean onwards appear to reflect a high level of technical intelligence, notably involving spatial thought and motor co-ordination." There is no evidence of modified or engraved bone, antler, or ivory, which is puzzling because the Australopithecines are supposed to have used antler and bone as tools, and one would think that these would remain in the tool kit of *Homo habilis*.

In any event, it does not necessarily follow that lack of engraving on wood or bone implies a lack of artistic intelligence. In fact, engraving or shaping bone or wood is analogous to shaping stone. Modifications of

nature (wood, stone, etc.) above and beyond the practical are a signal that we do have a consciousness *and* imagination. In another publication (Rush 1996) I suggested that Acheulean handaxes (Plate 1-1), through analogous thinking, might represent the teeth and claws of the big cats, wild dogs, and other predators who hunted our *Homo erectus* ancestors 1.5 to 2 million years ago. These tools are more than they need to be and, in my opinion, represent tangible symbols of power—the power of the animals they both feared and revered. (If you believe in Jungian archetypes, these predators may be the monsters in our childhood dreams!) On the one hand, our ancient ancestors fear these powerful predators (death), but on the other hand, these predators provided our ancient ancestors

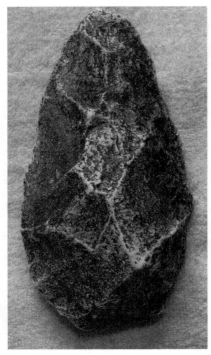

Plate 1-1: Acheulean handaxe dated to approximately 1.5 million years ago. Approximately five inches long and three inches wide.

with food (life) by throwing us a bone, so to speak. It is also my contention that *Homo erectus,* the maker of these tools, walked out of Africa following the predators. My point is that if our *Homo erectus* ancestors could make this intellectual leap, this magical thinking of capturing the power of an animal in a modified form (the rock material used), they would have made other analogous connections (perhaps decorating the body in animal forms with mud, etc.) of which we know nothing. Those things we fear are oftentimes the very things we wish to become.

About 300,000 years ago, after over a million years, the Acheulean handaxe tradition ended. It was replaced with a more varied tool kit including the throwing spear, and there is a slow movement from social scavenging to social hunting. This did not happen all at once, everywhere, but ideas do have a tendency to spontaneously pop up in diverse geographical areas, and good ideas can rapidly diffuse. Now it was possible to kill at a distance, decreasing the risk of injury from a cornered or injured animal.

It is also my opinion that the throwing spear is likewise analogous to the tooth of a predator—a tooth that leaps upon its prey in a similar fashion as the lion or tiger that pounces on her prey—or a laser-guided bomb that leaps upon the city. Psychoanalytical theory equates spears with the penis but in my opinion the spear is a tooth. Neither metaphor is necessarily correct, but I daresay that it is highly unlikely that any of our ancient ancestors ever witnessed these predators fucking their prey to death.

The general configuration of the handaxes existed for over a million years, but this does not mean that this was the best they could do or that these people necessarily were wired differently than we are. What it might suggest, and we see this with contemporary people, is that to change the tool would change its symbolic value and, thus, its symbolic power would be lost. Time is a factor as well. It is probably at those points where food is reasonably available for several generations and lifespan increases that new ideas come into place. Why? Because the older you get, the more experiences you have and the more connections noted among things. One of those growth spurts does occur around 50,000 years ago, corresponding with Klein and Edgar's position mentioned above.

However, we cannot assume that creativity was always rewarded in our ancient ancestors. Culture, like genes, is conservative, and it is very risky to discontinue doing what works. And what were our *Homo erectus* ancestors doing? In all likelihood they were following predators that offer a meal during a time period where there was little to eat and they were on the edge of survival. Also keep in mind that all *Homo erectus* bands were not doing the same thing; we cannot assume uniformity of behavior among *Homo erectus* groups in Africa, Europe, or Asia.

One of our earliest ancient ancestors, *Homo erectus,* in my opinion had a very strong identity with predators, not as food items but as "beings" to emulate, much the same as we have sports teams named after wild, vicious, and predatory animals. Such identities are promising symbols for scarification or tattooing in some manner.

Neanderthals

There is general agreement that the Neanderthals evolved from *Homo erectus* in Europe, and some anthropologists see them as part of our ancestry while others do not. It is a matter of how one interprets morphology (features on the bones), mtDNA, and Y-Chromosome analysis. In any event, these were clever people who appear to be the first to bury their dead and to make jewelry or ornamentation from bone, ivory, and animal teeth, complete with perforations and other incised marks. "The researchers and others have found dozens of pieces of sharpened manganese dioxide—black crayons, essentially—that Neanderthals probably used to color animal skins or even their own" (Alper 2003:86). The dates for Neanderthals in Europe are from approximately 200,000 to 28,000 years ago, and if they practiced tattooing or body painting, as suggested by Alper, then this type of symbolic rendering existed at least 150,000 years prior to the estimates for "art" given by Klein and Edgar (2002).

Cave Paintings and Rock Art

Rock art can be found on all continents (except Antarctica), but paintings or engravings deep in caves are currently known only from Australia and Europe (France and Spain). The dates of these paintings range from 32,000 to 12,000 years ago. Many of these caves are decorated with animals, more abstract designs like dots, and images considered shamanic in nature (see Clottes and Lewis-Williams 1998). After approximately 12,000 years ago the caves appear to have been abandoned; the painting or engraving ends up outside on rocks exposed to the day; and finally, by 10,000 years ago, this type of symbolic rendering ceases as well. It appears to be replaced by more portable objects and what have been called aesthetic tools with "artistic" engravings. There appears to be some sort of shift in thinking when the caves were abandoned in favor of more available images. (Does this mean a shift in neural wiring?) In other words, from a stylistic point of view, we go from inside (the womb of the earth) to outside (emergence) (Plate 1-2). In Plate 1-2a, you see a naturalistic rendering of a bear from

the Chauvet cave (see map, Plate 1-2d), dated to approximately 32,000 years ago. Also during this time period and likewise existing to the end of the Upper Paleolithic, archaeologists have found what are called Venus figures (Plate 1-2b), or pudgy female figurines, probably used in birthing magic and found in a swath of territory from northern Spain to Lake Baikal in the east. Clearly, many of these represent pregnant ladies with life on the *inside* in a similar fashion as the painting of life in the caves. The cave bear is a particularly interesting animal in these respects because it goes into the cave in the fall, hibernates (dies), and is reborn in the spring—usually with new life represented in both her "resurrection" and new cubs (life, death, and resurrection).

The cave paintings, in most cases, are rendered naturalistically. This is likewise true for the Venus figurines although many have accentuations of the hips, breasts, and neck. The figure in Plate 1-2c has been referred to as "the Sorcerer" and is located in a cave called The Three Brothers (Les Trois Frères); it dates to approximately 14,000 years ago. Here we see a naturalistic rendering as well as a composite of animal symbols (body parts) juxtaposed to possibly represent the sun (the feline characteristics, e.g., the male genitals of a cat), the moon (the antlers of a deer which fall off and regenerate, like the moon loses it shadow and resurrects), the underworld (the face of possibly an owl),), and predatory animals connected to life and death (the tail and ears of a wolf, and the cat features), along with the skeletal/muscle structure of a human inside this composite "suit" of symbols. Many researchers suggest that this is an image of a shaman, the animal master, who acts as a conduit between the human and the animal and supernatural worlds. As we move toward the end of the Paleolithic and into the Mesolithic of around 10,000 years ago, more and more abstract designs are encountered, and these are found exposed for all to see. I suggest that any tattooing during the period of the Upper Paleolithic (tattooing equipment has been found dating to this time period) was more than likely naturalistic and, if the caves are any indication of artistic capability, probably quite spectacular.

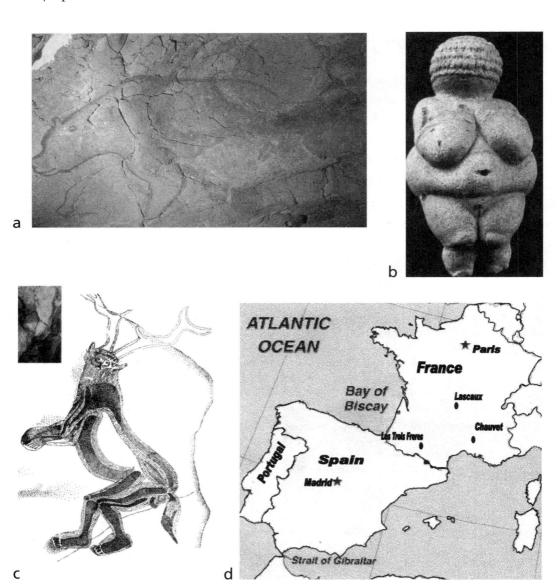

Plate 1-2: Naturalistic image of bear (a) in cave at Chauvet, dated to approximately 32,000 years ago; (b) a naturalistic Venus figurine. These are contrasted with the image in (c) the Sorcerer of Les Trois Frères, an abstract composite of symbols dated to the end of the Upper Paleolithic (approximately 14,000 years ago). (d) Map of cave sites.

These Venus figures are with us today in our art, myths, and religions. She is the Mother Goddess whose accent changes with culture. She is Innana of the Sumerian tradition, Devi of the Indus Valley civilization, Isis in Egypt, Coatlicue of the Aztec tradition, 'Athtar of the pre-Islamic Arab tradition, and the Madonna figure in Catholicism. Some differences between the Venus figures of the Upper Paleolithic and the later figures of the Neolithic include more accents of the face and specific features (most of the Venus figurines of the Upper Paleolithic are faceless), and the position of the "infant" changes from being inside to outside of the body. With the Virgin Mary, not only do we go to the outside, but now "impregnation" and "birth" have nothing to do with nature; —this is a representation of *spiritual* life, death, and rebirth or resurrection (Plate 1-3)—that which is beyond flesh and the tangible world. This move from naturalistic to abstract is a reflection of more complex, abstract thought and behav-

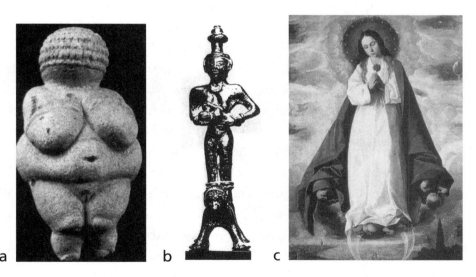

a b c

Plate 1-3: As we move from the Upper Paleolithic to the Mesolithic we go from naturalistic (a) to abstract (c), the life ending up on the "outside" as depicted by the Hittite figurine (b) dating to approximately 1500 BCE, all the way to an abstract rendering of spiritual birth and life in the Madonna figure ("The Immaculate Conception" by Zurbaran 1598–1664) (c). Here life (spiritual) is simply emerging from her long shawl.

ioral and ritual patterns, guides, or meditation points, if you will, for emotions and energies.

Anthropologists have attached many meanings to the cave paintings, from art for art's sake, hunting magic, and social allegory, or the representation of day-to-day activities including feasts, communal hunts, magic, and so on. These paintings also undoubtedly represent cultural overlays of meaning, as they were produced over a long period of time and some of the art belongs to one cultural constellation (religious, economic, political, etc.) and others to different constellations. There is good reason to believe that all these positions come into play (that is, art for art's sake, social allegory, and so on), because magic, religion, ritual, and spirituality cannot exist without a social context.

There is little in these images from Europe to suggest tattooing or scarification. From a psychological level, however, these cave paintings may represent a separation or a splitting of the "artist" from his or her work. It has been suggested that the techniques used in producing at least some of these paintings—using the mouth to blow the charcoal and other pigments onto the cave walls—was a magical method of putting the breath (Little Wind, Big Fly, *Spiritos, Ankh, Ruakh, Ruh*) or life of the artist into his or her work. This symbolizes a direct connection of the artist with the animal depicted, with the breath perhaps a method of keeping the animals alive for another meal so that they will return again and again.

Cave paintings, however, might be seen not as the "incorporation" of an idea in the same manner as tattooing, but instead as the depiction of the animal (bringing it into the cave) for magical (perhaps a covenant of respect) or other social-statement purposes (the behavior of the animal in hunting or migration purposes). Remember that the cave bear would emerge from the cave after seemingly dying and coming back to life. In a similar, analogous manner, the idea is to bring the dead animals (killed for food) back to life. If this is correct, then this may also represent some type of a *distancing,* a difference between "us" and "them," perhaps a clear expression of a respectful superiority over these "neighbors," perhaps less

about identity than control. The paintings, furthermore, are oriented to the group and the individual's place within. Tattooing or drawing animals or images on your body would represent a more personal and direct identity with these animals or the symbols for which they stand, and not a separation, as might be the case with cave paintings. Tattooing represents a different category of psychological (and perhaps social) commitment.

It is generally accepted that cave "art" might have little to do with aesthetics and not "art for art's sake" at all. Likewise, tattooing, scarification, mutilation, and piercing for spiritual, magical, or medical/curative reasons need not be categorized, all or in part, as "art." The caves in France and Spain are a cornucopia of symbolic references about which we unfortunately know very little for sure. I suggest that there is another type of identity being displayed here, perhaps for the first time, and that is equality with and respect for these animals or even a recognition that we are now on top.

Nature's Way

Symbols in/on the skin may predate the cave paintings by many thousands of years. How can I say this? This is because Mother Nature leaves her marks. First, the body is modified through the maturation process, and purposeful (socially directed) modification would represent an emulation of that process. Second, the female body is modified during and after pregnancy. Third, accidental cuts and punctures and accompanying infections can act as crises or social and personal stress points leading to individual psychological changes that could have profound implication for group survival. Visions that often accompany high fevers could act as guide posts for individual and group change. Injuries and illness open a door that can only be closed with a story that leads to action.

Marks left from cuts and abrasions would have been at least as common for our ancient ancestors as they are today (if not more so). Natural scarification might be seen as a rite of passage, and through magical

thinking scarification becomes a way to prevent (through group or self-scarring or mutilation) the really disastrous cut or predator attack. Self-scarring could also represent an identification with the animal's power. This type of imitative magic was used as a prophylactic to prevent misfortune, such as among the indigenous North American peoples (e.g. Iroquois, Navajo). As an identity with power one has to look no further than the Catholic communion with the wine and the wafer (the blood and body of Christ)—again, a form of imitative magic.

Without a need or knowledge of wound cleaning or suturing, scars that remained must have been quite prominent, assuming little or no hair as cover. The scar would act as a memory device, a reminder of the event, similar to the cuts and marks left from modern-day gang fights or war wounds. Just consider the stories told of one's scars of life (physical and emotional) in every culture, all over the world. It is only a small leap to making your own scars symbolizing survival rather than death—that is, to commemorate an event—or scars that in some symbolic manner (imitative magic) represent the animals (or the power of these animals—forces of nature) with whom one identifies. Again, predators were important to our scavenging ancestors, as they represented basic concerns of life and death.

Tattooing or scarification (cicatrisation) at the time of *Homo erectus* of 1.5 million years ago has to remain speculative—to say the least! But if such behaviors did exist they would more likely have served as identity markers with the powerful, the predators that hunted them, and as marks of individual valor or jeopardy. Just as the Acheulean handaxe represents a usurping of the power of the predators that hunted us (in my opinion), any scarring or tattooing might have served a similar purpose, that is, to hold a sanctioned symbol (the Acheulean axe) not only in one's hand where it could possibly get lost or broken, but under one's skin: "I and the Father are One," "Osiris is going to Osiris." The deification of animals or, more accurately, their behaviors and power (real or imagined), must have a long season. We deify power, but weakness has its place as well.

Weakness is the field upon which the strong play. Regardless of the meanings behind these tools, paintings, and figurines there is a story, a myth, and the intention of these myths is to direct emotions and associated behavior toward group unity and purpose. We owe a great deal to these powerful predators, as they gave life to our ancestors in a way they could not imagine. These predators culled out the weak, the sick, the old, and the stupid, modified our brains and bodies, and pushed us toward a genetic fitness that allows us to do some incredible things and to think in ways wherein there are no limits. Evolution is all about modification of brain and brawn.

Like all group animals we need to be connected emotionally, physically, and socially, and one characteristic that *appears* to separate us from almost all other life forms on this planet is that we can imagine *another,* a mirror of ourselves. We can have a dialogue with this "other" and it will talk back to us. This dialogue can be with your self or an imagined other— friend, child, monster, God, and so on. That "other" is really you; back and forth, talk, talk. This phenomenon of talking to ourselves (and others) and seeing ourselves *in* others and the larger environment, past, present, and future, is found in a behavior or process that we take for granted— language—our ability to convert sounds, hand gestures, lines and squiggles into symbols and to pass them from person to person through time. This ability, I believe, shows up in a proto-form about 1.5 MYA (—Rush 1996). It is impossible to conceive of cultural continuation without language. Language (spoken or written) can reach past many generations to create a charter or set of rules for believing and behaving that can last millennia.

Psychology and Philosophy of Tattooing

There are many books and articles that provide an adequate history of mutilation, scarification, piercing, and tattooing, and I refer the reader to the recent works of Gilbert (2000), Caplan (2000), and Favazza (1996)

as reference texts for bibliographical materials, and Mercury (2000), Robinson (1998), Groning (1997), and Camphausen (1997) for color and black-and-white photos.

Body markings, including piercing and implants, can be seen as ink blots, if you will, of what an individual or culture values or considers important at the conscious and obviously the subconscious level. According to Caplan (2000:xi), almost all cultures at one time practiced tattooing. By extension, we can likewise say that all cultures practiced some type of body modification. Because body alteration is found in diverse cultures around the world, we are seeing both diffusion and perhaps a natural tendency to identify and codify using the body as a palette. Tattoos, scars, mutilations, and so on capture personal and cultural ideas and beliefs, and skin is the original parchment. After all, nature leaves its mark through stretches (stretch marks on abdomen and breasts from pregnancy), scrapes, and cuts. Scarring, tattooing, and mutilation originally may have been analogous to these very natural processes.

The mind might forget an obligation but an indelible mark of that obligation (as with the circumcision of Abraham) serves to forever *re-mind*. I first saw this type of behavior in the old western movies of the late 1940s, where "brothers" were united in a blood ritual with the scar as a reminder. In remembrance of Hussein, a martyred Shi'a leader and grandson of Mohammad, many Shi'a men took to the streets of Kabul, Afghanistan, on March 1, 2004, whipping themselves with chains. This is a meditation on the centuries of persecution by the Sunnis but was banned under the Taliban rule.

Body modification appears to be an exclusively human phenomenon and is, therefore, a sign of culture or "cooked," while the non-tattooed or uninitiated body is natural, virgin, primitive, blank, or "raw" (Levi-Strauss 1969). Rather than tattooing being a "primitive" behavior, as reflected in the term "modern primitives" (Vale and Juno 1989, Camphausen 1997, Mercury 2000), tattooing could also be seen as uniquely human and thus "civilized" (Rubin 1988). Judaic-Christian and Islamic dogma places the

body within the realm of primitive, base, and (especially within the Judaic-Christian tradition) evil and bad (Genesis 3:7–10, 9:22, 23; Exodus 20:26; Leviticus 18:5–19, 20:17; 1 Samuel 20:30, etc.). In the Christian tradition, nakedness and shame are synonymous. Read literally, one could have difficulty understanding the motives of a God who creates humans in his own image, an image of perfection, but at the same time an image that is base, nasty, and indecent. Tattooing, scarification, implants, and piercing might be seen, then, as a glorification of the human body with an enjoyment of fleshiness and sensuality, symbols to be seen and appreciated.

Egypt

The earliest documented tattoos from a culture for which we have a written history are found in Egypt. The history of Egypt has emerged from the record of events as encrypted on stone and papyrus, reports of travelers, and archaeological interpretations. There are many gaps in our knowledge, especially as to when this behavior first emerged in Egypt and why the ancient Egyptians tattooed and pierced their ears.

As Jones (2000:2) reports, "The Egyptians are the first to provide evidence of tattooing. Here it is first found on mummies of the Eleventh Dynasty, about 2100 BC; the color used was a dark, blackish-blue pigment applied with a pricking instrument, perhaps consisting of one or more fish bones set into a wooden handle."

According to Gilbert (2000:11—See Plate 1-4):

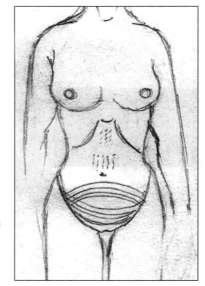

Plate 1-4: Approximate locations of tattooing on Amunet, Priestess of the goddess Hathor at Thebes during the Eleventh Dynasty (2160–1994 BCE). Note how the tattooing around the pubic area possibly denotes an upper and lower, or life and death (redrawn by Juliana Correa).

One of the best preserved of these mummies is Amunet, who in life was a priestess of the Goddess Hathor at Thebes during Dynasty XI (2160–1994 BC). As principal representative of all other Egyptian Goddesses, Hathor symbolized the cosmic mother who gave birth to all life on earth. Throughout Egypt, temples were erected and festivals were held in her honor. The most important of these was the festival celebrating her birth, a drunken orgy that was held on New Year's Day. Amunet's mummy is well preserved . . . Parallel lines are tattooed on her arms and thighs, and there is an elliptical pattern below her naval. According to Egyptian scholar Robert S. Bianchi, the tattooing has "an underlying carnal overtone."

The last statement about carnality may or may not be correct, and it may not be necessary to imply "carnal overtones," but something a little more complex and spiritual instead. Plate 1-5 shows a clay Pig Goddess from Thrace (north of the Aegean and west of the Black Sea), dating to the Neolithic (approximately 5000 BCE). What we see are many inscribed marks around the pubic area (lines curved down and lines curved up), arms, and thighs, but the breasts are not accentuated. According to Neumann (1972:106):

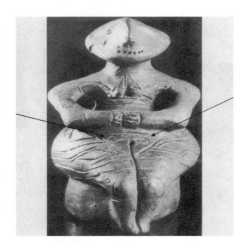

Plate 1-5: Neolithic Pig Goddess (from Nemann 1972, Plate 6). Note the small breasts, the opposition of the spirals in the triangle around the pubic area (life and death?) similar to that of Amunet (Plate 1-4), as well as "tattoos" on arms, hips, and thighs.

The Thracian figure of a seated Goddess is one of a group of Neolithic ceramics that have been found in a territory extending from western Russia to the Balkans and central Europe. They originate in a matriarchally accented cultural milieu ... This plastic takes some of its uncanny quality from the contradictions contained within it. The vessel form stresses the corporeal elementary character, while the dense, *tattooed ornamentation* tends toward *disembodiment;* the body is literally covered by the symbol. *The tiny, barely suggested breasts reinforce the unconscious tendency to surpass the elementary and corporeal. Here the element of abstraction that brings out the symbolic transformative character of the Feminine is particularly evident: the belly is not vaulted in fertility and fullness;* rather, the genital triangle, which is accentuated for this reason, bears the symbol of the spiral, one end rolled upward and other downward.

This brings us to an essential content of this abstracting tendency. A Goddess represented in this way is never a Goddess only of fertility but is always at the same time a *Goddess of death and the dead.* She is the Earth Mother, the Mother of Life, *ruling over everything that rises up and is born from her and over everything that sinks back into her. [Emphasis added.]*

I do not believe that the similarities in the tattooing on Amunet (the up-and-down elliptical pattern below her navel) and the marks on the Pig Goddess are accidental. In fact, the description given of the Thracian figure could equally well be applied to Hathor (Earth Mother) and one of her other attributes, Sekhmet, the Destroyer Goddess. The point is that symbols are complex and can radiate in many directions at the same time. We do not have an adequate explanation of the symbols, so any meaning must remain speculative (see Goodison and Morris 1998). When depth psychologists (like Neumann) enter the picture, we encounter beautiful metaphors and explanations that open us up to other possibilities.

Gilbert (2000:11) goes on to discuss statuettes with tattoos of the type found on Amunet, suggesting fertility and rejuvenation, perhaps a complement to the image of the lotus (Plate 1-6a) because of its aphrodisiac, sexual/life-rejuvenating properties. For the ancient Egyptians sexuality was synonymous with life.

The statuettes were placed as a tomb offering ("brides of the dead") and apparently designed "to arouse the sexual instincts of the deceased and to ensure his resurrection" (Gilbert 2000:11; also see Antelme and Rossini 2001 for an understanding of sexuality in ancient Egypt). These are wonderful metaphors because they are carnal *and* spiritual at the same time; spirituality is experienced through the body.

I am curious as to why all the tattooed mummies thus identified in Egypt belong to females although tattoos appear on both male and female statues and paintings. Exact references, or a specific word for "tattoo" or "tattooing," do not exist in ancient Egypt, although Gilbert (2000:13) suggests the term *mentenu,* which he translates as "inscribed," a general enough term to include tattooing. There are other words as well, such as *tem* or *temtem* (to cut, carve, scrape or engrave), *s-pekhar* (to write, register, or inscribe), *ut* (to write, inscribe, engrave; also used as a noun to signify a stela or tablet). Because they did tattoo, there has to be a word or metaphor for this behavior.

In any event, the ancient Egyptians also practiced circumcision, which was eventually adopted by the Jews and Islamites but with a very different symbolic meaning. For the ancient Egyptians, circumcision was analogous to the snake shedding its skin and being reborn or resurrecting, but the behavior does not seem to have been "a pervasive practice in the New Kingdom" (Meskell 2002:88) and may have been restricted to the elite, that is, priests and pharaohs. There is an interesting myth regarding circumcision in the *Coffin Texts,* magical methods inscribed on and in coffins of the First Intermediate (2125–1975 BCE) and Middle Kingdom (1975–1630 BCE). "It is the blood that descended from the phallus of Re after he proceeded to circumcise himself, and those gods are those who

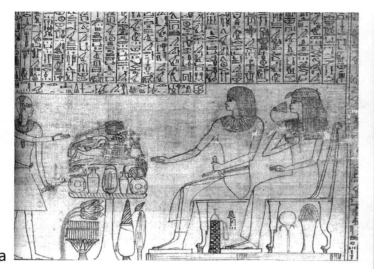

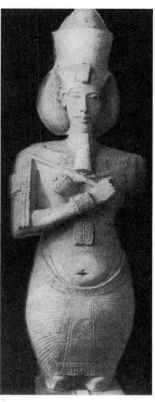

a

b

Plate 1-6: (a) This is from the Papyrus of Nebseny, Book of the Dead, New Kingdom, Eighteenth Dynasty (1400–1390 BCE), showing Nebseny and his wife Senseneb, who is smelling a blue lotus. Other lotuses are beneath and on the offering table, with those under the table detailed in red. (Photo taken by author, British Museum.) (b) Statue of Akhenaten (King Amenhotep IV), Aten Temple, Karnak.

came into being [immediately] after him" (Clark 1978:262). In Genesis 17:9–14 we learn of the covenant between Abraham and God involving a mark of commitment, that is, circumcision.

> This is my covenant with you and your descendents after you, the covenant you are to keep: Every male among you shall be circumcised. You are to undergo circumcision, and it will be the sign of the covenant between you and me. For the generations to come every male among you who is eight days old must be circumcised, including those born in your household or bought with money from a foreigner—those who are not your offspring.

Abraham circumcised himself at the age of ninety-three. Circumcision, again, was borrowed from the Egyptians and it appears that the Jews were emulating the elite, that is, the priests and Pharaoh. The Jewish community has been characterized as a community of priests, and we can appreciate this direct connection with Egypt although the purposes for circumcision are different.

As an interesting aside, after Moses encounters the God-plant on Mt. Sinai (Exodus 3–4) and obtains instructions to go to "Pharaoh" (the individual Pharaohs are never named in the Bible), we then read about Moses stopping at a lodging place where "the Lord met Moses and was about to kill him. But Zipporah took a flint knife, cut off her son's foreskin, and touched Moses' feet with it" (Exodus 4:24). Would this have been a sanctioned behavior for a mother to circumcise her son? Why does Zipporah touch Moses' feet with the foreskin? There appears to be some coding going on with respect to the God-plant. According to Ruck et al. (2001), this God-plant is a mushroom, *Amanita muscaria,* and the encounter that Moses has with the Lord when the "Lord was about to kill him" might refer to a "bad trip." The *Amanita muscaria* does have a skin that sloughs off (foreskin?), mushrooms in general are characterized as "phallic," feet are "probably a euphemism for 'genitals'" (Barker 1985:92, Note 4:25), and the touching of Moses' feet may simply be a statement that Moses will not die, that it is just the effect of the mushroom. In any event, this passage made its way into the Old Testament not by accident, and if it is to be read literally, then circumcision—that personal sacrifice, that body modification or mutilation—is certainly an integral cornerstone of the Jewish tradition, although other types of modification (ear piercing, for example) are seen as aberrant.

The story of Moses appears, in large measure, to be an adaptation from the historical events surrounding Akhenaten (Amenhotep IV, ruled from 1353–1335 BCE), the heretic pharaoh who disbanded the Theban priesthood and dictated that all will worship the sun disk, the Aten (referred to as Adon—"Lord" or Adonis—"my lord" in the Jewish tradition). Like

the story of Moses, Akhenaten attempted to install a form of monotheism among the Egyptian people, was forced to leave Thebes, and eventually drops away from Egyptian history (see Gadalla 1999). We also hear that Moses/Akhenaten was organizing the tribes and was a nuisance to the Egyptians. After "wandering" in the desert for "forty years" (1335 to approximately 1307–1306 BCE) Moses/Akhenaten presents himself to the court in an attempt to regain his birthright. He is run out of Dodge once again and goes into the Sinai and up into the Jordan area. Seti I (ruled from 1306–1290) catches up with Moses/Akhenaten and kills him, and this is why Moses never gets to see the promised land.

Akhenaten attempted to install a religious revolution in Egypt (some people call him the first monotheist) but he also introduced the world to a very different art style (some call this "expressionism"—see Hornung 1999:44), whereby he is portrayed with prominent head, facial, chest, and stomach modifications (see Plate 1-6b) that suggest not only androgyny but another rendition of the condition of the "gods." Akhenaten and the Aten are one. Akhenaten is no longer represented like living humans or identifiable animals (except Seth), but instead as something different and all-encompassing (the androgyny). Seth's depiction in such a strange or unusual manner (a human body with the head of an animal that no one can exactly identify) may be, in part, the model Akhenaten used for depicting himself as the living embodiment of the Aten. Keep in mind that just a couple of hundred years before, during the occupation by the Hyksos, Seth was a major deity of worship. Seen as an all-encompassing symbol of chaos and evil, Seth might have been part of the inspiration for reinventing the all-encompassing Aten.

Europe

Tattooing in Europe can be dated to prehistoric times, as evidenced by the Iceman (Plate 1-7), presumed to have died around 3200 BC, predating the Egyptian material by a thousand years. This unlucky individual was

Plate 1-7: Iceman, 3200 BC. There are fifteen well-preserved tattoo groups on (a) leg and (b) back, adding up to fifty-eight in total.

wounded and left to die but was covered over and preserved by a glacier until 1991, when he was found by hikers in the Alpine Oetz valley (centered on the border of Austria and Italy). This 5,200-year-old corpse has a total of fifty-eight tattoos on his body. The analysis of these tattoos strongly suggests that they were medicinal tattoos, possibly representing acupuncture points for relieving pain (Zur Nedden and Wicke 1992) but also for creating anesthesia, promoting endurance, and detoxification, to name a few possibilities. Most of the tattoos are found over joints noted during autopsy to be arthritic. Neumann (1972), mentioned above, refers to the markings on the Pig Goddess as "tattooed." If this is correct, and this figure reflects the same on human flesh, the dates for tattooing can be pushed back at least two thousand years to around 5000–6000 BCE. Beyond this we are into speculation, although the evidence (possible tattooing paraphernalia) is good for the Upper Paleolithic. Purposeful body modification probably goes back much further.

Archaeological Finds and More Recent History

The frozen tombs of Pazyryk are instructive for understanding ancient tattooing among nomadic pastoralists who rode horses and herded cattle in and around the foothills of the Altai Mountains, located on the borders of present-day Russia, China, and Mongolia (Plate 1-8a). The burials span a time period between 500 and 300 BCE. As nomadic peoples move from place to place, they invariably bump into others desiring to use the same territory, and this at times led to conflict. They had to be brave and possibly ruthless people who had to kill or be killed. They were warrior people who took what was in front of them. These are the ancestors of what have been variously called Aryans, a Sanskrit word meaning "noble," or Indo-European, referring mainly to a language stock originating somewhere in the area north of the Black Sea. Between 2000 and 1500 BCE groups moved out from the Black Sea area toward all points of the compass, commingled with indigenous populations they encountered, and eventually became the Celts in Western Europe, the Aryans of India, the Greeks, Hittites, Kurgan, and so on. It is pretty safe to say that most of these horse-mounted herding people (sometimes referred to as Scythians) were patrilineal, patrilocal (Mallory 1989:123), and male-centered, worshipping that which is everywhere—the wind and the rain, the sun, moon, and stars (the "bright ones" or *Daevos, Devas, Deus*). The personification of the forces of nature into gods and goddesses shows a common thread of a single god who stands out above the others as a mirror of the prevailing on-the-ground social order: a tribal chief who has the final say in tough matters.

Sedentary living accommodates a different sense of personification than does nomadism. Sedentary people live in a more static world and change is seasonal. Although change is likewise seasonal for herding people, their frame for change is geographical and thus forces into existence a different emphasis on sacredness compared to sedentary people. Both share in common the sun, moon, stars, wind, rain, and various natural elements.

Beliefs in superordinate agencies become very complex, and devices are developed for their storage. One device was undoubtedly the tattoos that represent generalizations or stories. These stories would hold a common theme (see Propp 2001) but there would be stylistic changes and symbolic references unique to each group, even with the continuity of form. The designs on Pazyryk mummies are similar to those found on other Scythian mummies in distant geographical areas and to this day in Turkish and Persian art.

The approximate date of expansion of these earlier people from the Black Sea base, as mentioned above, is somewhere between 2000 and 1500 BCE. This move to better pastures was probably the result of over-population, climatic issues, conflict, or any combination of events. Their suggested kinship structure has been compared to that of the "Omaha-type system" (Mallory 1989:123–124) wherein maternal kin are important (for example, a wife's brother or especially her uncle) for creating strong relationships outside of one's family. This would be useful when cementing alliances, negotiating treaties, trading, and so on. Because nomadic people continually bump into one another, this would serve as a mechanism of introduction, an outside-of-the family contact that could allow face-to-face talk to establish intent. Tattooing might also help identify clan members reunited after many years of geographic separation.

The tattoos on both men and women are quite spectacular among the Pazyryk mummies (Plate 1-8b, c). Because the underlying muscle is discolored, but not the fat layer between the skin and muscle, this indicates that the tattooing occurred when the individual was at a cultural point of adulthood (perhaps fifteen to eighteen) and suggests a rite of passage imbuing the individual with power. The tattooing procedure involved pricking the skin with a needle dipped in ink, which appears to be blue in color. About the same time period but in Western Europe, the Celts covered their bodies with *woad,* a blue dye produced from *Isatis tinctoria,* prior to going into battle. In fact, the blue dye was all they wore in many cases. Although I cannot find reference to the exact type of ink used in the

Pazyryk burials, we do know that there is a cultural continuity and sharing of information across Central Asia extending to Western Europe, encompassing what has been termed Indo-European.

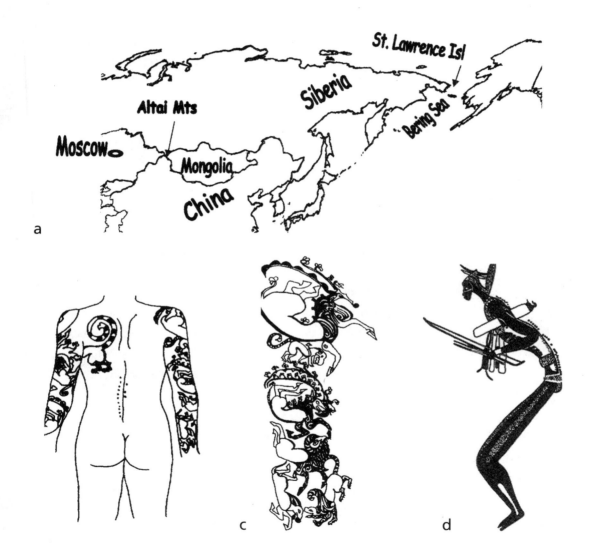

Plate 1-8: (a) Map of Siberia; (b and c) Tattoos, Pazyryk burials, foothills of the Altai Mountains (from Pearson 2002:66); (d) African Bushman rock art (from Devereux 1997:164).

Of the many animals (sixteen) portrayed in the tattoos, a little less than half are mythical, composite beasts that include predatory elements (eagle's beaks, fangs, etc.). This suggests a combination of predatory and herbivorous symbolism where the predator pounces on the herbivore, just as the sun pounces on the moon, and the warrior pounces on his enemy. These symbols can also be seen on saddles, harnesses, and so on, so that there is a continuum of magical thinking and real-life events.

> Thus the chimeras/griffins (both on the human skin and in contexts in close association to the human body), and to a lesser extent the birds, are most directly associated with the human realm inside the burial chamber. The monstrous chimera/griffin creatures, however, may be perceived not only as "imaginary" but also as liminal "betwixt and between" creatures of danger, power and chaotic violence. Their adornment of the human skin thus serves to draw attention to and to reinforce the central significance of this boundary between the individual and the chaos beyond, transgressed by the tattooing but thereafter protected by the powerful and dangerous entities. Similarly the predatory/prey pairs of carnivores attacking herbivores occur especially on the saddle, the interface between person and horse. It is interesting that horses, like humans, are generally not represented in the art. They are adorned, as people are, and are incorporated into the tombs of people. Horses were thus symbolically close to humans though they were treated not as equals but as companions to the dead. (Pearson 2002:66–67)

One can note the dots to the left and right of the spine of a particular warrior (Plate 1-8b), and one might be tempted to compare these dots to those found on Bushman (South Africa) rock art of what may be a shaman; note the dots running along his spine (Plate 1-8d). This pattern of dots running up the spine has been interpreted as the supernatural force, the *n/um*, taking hold of one's body during trance (Devereux

1997:164). This force may invigorate the body and give one magical powers. It could be an initial metamorphic or lycanthropic change to the animal one hunted or was going to hunt, or perhaps it is the soul leaving the body on a journey to join with supernatural forces. I am not suggesting a pre-historical connection between the Bushman and the Siberian symbols but, instead, magical thinking that can be seen in many areas of the world. Recall that the Iceman had tattoos next to his spine, although these are lines and not dots.

The possibilities of invigorating, charging, or activating the spine, and/or endowing oneself with magical help, or transforming into a predatory animal or honoring the animal itself as a form of reverence, all have an interesting connection in the practice of yoga. In Bikram Yoga (hot yoga), there is a floor posture called Half Tortoise *(Ardha-Kurmasana).* In that posture you sit on your heels with your forehead on the floor in front of your knees, arms locked out and stretched as far in front of you as possible. This straightens and lengthens the spine. My instructor will come up in back, stand on the balls of my feet, and run the palm of his hand firmly and slowly along my spine from the sacrum right to about the base of my skull. I always feel a surge of energy. When I commented about this I was told that this is a posture for invigorating the body, with the hand pressure moving that energy (the Kundalini serpent—see Chapter Three) from the pelvic area, beginning at Chakra 1, *Muladhara* or "base root," up through the other Chakras to Chakra 6, *Ajna,* that space between the eyebrows, the third eye or seat of consciousness. This is also the point of the "guru's command," and through the guru's touch at the right moment at this spot between the eyebrows, the guru brings the individual to illumination, destroying all karma from past lives. The point here is that perhaps the dots on the Pazyryk mummy might have been magical in some way, as appears to be the case for the other tattoos. Whatever the interpretation of these might be, behaviors touch the spiritual through the body in a surprisingly similar fashion.

There is the possibility that these dots on the Pazyryk mummies are acupressure or acupuncture points in a similar fashion as the Iceman. Anyone who has ridden a horse for any length of time understands the meaning of a backache. That continual slamming of the spine against the saddle (or the horse's bare back) will cause injury to the disks and vertebrae over time.

One is left wondering about the mythic characteristics of these images, these chimeras and griffins. Where did these images come from? When we examine the cave paintings in France and Spain (see Ruspoli 1986; Bahn and Vertut 1988; Chauvet et al. 1996), dated to the Upper Paleolithic, we encounter mainly naturalistic images and very few images or drawings that are abstract like the chimeras or griffins on the Pazyryk mummy. At Lascaux there is perhaps a unicorn at the entrance to the Hall of Bulls; a composite image of a human, feline, deer, wolf, and perhaps an owl (the Sorcerer) at Les Trois Frères; and so on. These mythic images may simply have come from the imagination, or perhaps that imagination had help. Found in the burial at Pazyryk is a small tent, apparently used for the inhalation of *Cannabis sativa* (Pearson 2002:81). *Cannabis sativa* grows throughout Europe, China, and Africa, and its use certainly predates the Pazyryk evidence by many thousands of years (Devereux 1997). The Sorcerer of Les Trois Frères, described above, has another curious aspect in that it has an x-ray nature—you can see the bones of the individual/shaman within this composite "animal suit." Such images can result from the ingestion of more powerful substances, for example, Psilocybin-type mushrooms.

In several of the caves we encounter rows of dots, often positioned near the shoulder, legs, underside of an animal, or cutting across the antlers of a stag (see Ruspoli 1986:158–160). I count fourteen dots on the back of the Pazyryk burial (Plate 1-8b), assuming that this is an accurate drawing of the tattoos, and it is unlikely that this is an arbitrary number. It has been suggest that the number seven was important to the symbolism of the Upper Paleolithic (Ruspoli 1996:158) and fourteen is twice seven.

One also encounters at Lascaux a pony (Plate 1-9a), beneath which is a row of dots. To the right is a rectangle, and another row of dots with four red parallel lines just below. It has been suggested that this represents the constellation of Orion, or other stars in the sky—perhaps the "Bright Ones" of the Vedic tradition.

Lascaux dates are early Magdalenian, beginning 18,000 or 17,000 years ago. Going back to Aurignacian times (32,000 years ago), we encounter these dots as well as dashes at Chauvet, a cave in south central France (Plate 1-9a). If the reader will follow an artificial sequence, that is, Plates 1-9b through 1-9g, it would appear that the artist was trying to conceptualize an animal using dots rather than drawing lines (the original dot-matrix printer?). Keep in mind that, after drawing an outline, tattooing is a matter of poking holes in the skin and connecting the dots. This brings to mind the Zodiac and perhaps an attempt to draw on the "night sky" (the inside of a cave) the stars gestalted in the form of animals from the stars, the "bright ones" in the actual night sky above. In regard to perceptual hand-eye coordination, it might be easier to learn to draw the outlines of animals (or perhaps anything) by using dots instead of lines as reference points. All that is required is to connect the dots, the stars in the sky, and connecting dots is the basic technique of tattooing.

Returning to the Pazyryk mummies, ear piercing is evident, with a single piercing of the males' left ear, and women pierced in both. No mention is made in the literature of scarification, but there is definite evidence of postmortem mutilation. Pearson (2002:67) comments:

> The tattooed man in Barrow 2 was not only scalped but his head was pierced by three holes made by an oval battle-axe, in addition to his skin being methodically sliced open across his body. Although he was probably about sixty years old when he died, his wounds indicate a violent death for this old warrior. Tattoos were probably indicators of high status and noble birth, but they might also read as the garb of the warrior.

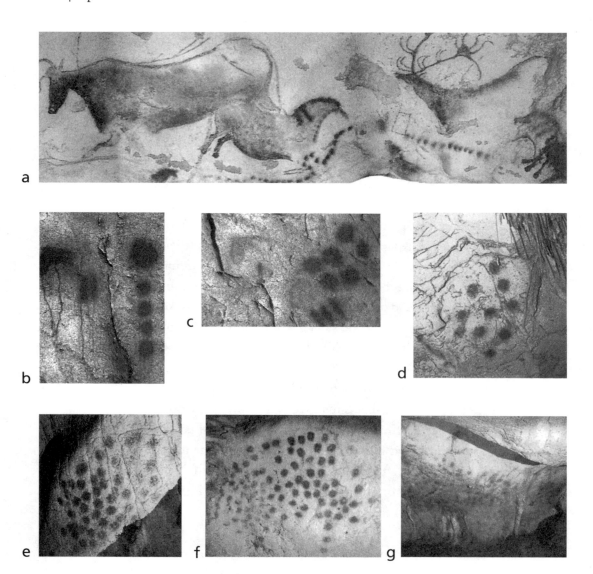

Plate 1-9: (a) Cave art from Lascaux (from Bahn and Vertut 1988:63). (b–g) Might be seen as an evolution of dots to build an image of an animal.

As the "garb of a warrior," these symbols would imbue magical power, strength, swiftness, and invincibility, and inspire courage. And, although a warrior's garb, such symbols were probably very personal, as in most instances clothing covered these mythic tattooed beasts unless these warriors went into battle naked, as was the case with many of the Celts.

Another interesting find was accidentally unearthed in 1972 on the Southeast Cape of St. Lawrence Island (present-day Alaska) in the Bering Sea. It was the frozen body of an elderly woman who had apparently been in her subterranean house during an earthquake. The hut was covered over, and the woman was asphyxiated. Her right forearm, back of the hand, and fingers (Plate 1-10a) are covered with lines and dots, along with a heart-shaped image on the back of the hand. "The tattooing on the left arm was even more elaborate, with multiple flanged hearts attached by vertical and horizontal lines. The left hand showed ovals within ovals and dots on the fingers" (Zimmerman 1998:138). These lines and dots are reminiscent of the lines and dots found on hands of ancient Persian women and current-day Muslims in the Middle East and Africa. In the Muslim tradition the number of dots is significant in referencing mystical concepts as well as providing protection from evil forces.

As with the Pazyryk mummies, there is really no way of interpreting these dots and lines outside of comparisons with statements from early researchers or travelers and current-day beliefs and practices. Krutak (1998, 1999) states that the arm and hand designs of a St. Lawrence woman indicate who she is and clan membership; tattoos over joints were for closing pathways previously open to evil spirits, but might have likewise served as acupuncture/pressure points.

Bars and dots, however, are encountered in another context, and that is within the mathematical system of the Maya and Mixtec in Mexico a few thousand miles to the south. As Coe (1967:59) comments, "The Maya, along with a few other groups of the lowlands and the Mixtec of Oaxaca, had a number system of great simplicity, employing only three

symbols: a dot with the value of 'one,' a horizontal bar for 'five,' and a stylized shell for 'nought.'"

The heart-shaped symbol on the right hand (Plate 1-10a) in no way resembles the "stylized shell" of the Maya (the Classic Maya date from 292 to 900 CE, or Current Era), which looks like a football with over-sized stitching on the top. This heart-shaped symbol, however, is very similar to one of the symbols for blood (Plate 1-10b) used by the ancient Maya (see Longhena 2000:30). Like the humans from the Pazyryk burial, this individual would have worn covering over her arms when outside her subterranean house. During her time period (400 CE), this type of tattooing on the forearm might indicate age, perhaps an association with celestial events, or clan membership, or "blood" relationship, possibly symbolized in some way by the heart-shaped figure and associated lines.

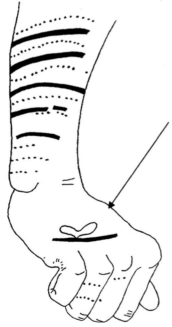

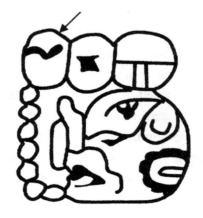

Plate 1-10: (a) Tattooing on right arm and hand of elderly woman, Kialegak Point, Saint Lawrence Island, Bering Sea (see map 1-8a), dating to approximately 400 CE; (b) Mayan (Classic Period, 300–900 CE) glyph for Copan-notice the top left portion of the glyph, which stands for blood, and note the similarity with the Saint Lawrence Island "heart" tattoo on the hand.

a　　　　　　　　　　　b

The medium or ink used for tattooing on St. Lawrence Island in historic times was soot mixed with urine. It was applied with steel needles, although bone needles were probably used in prehistoric times.

Tattooing, scarification, and mutilation have served many purposes through time. As Gustafson comments (2000:17), "Tattooing is a universal and age-old phenomenon with many functions, including: decorative; religious; magical; punitive; and as an indication of identity, status, occupation, or ownership."

The Greeks and Romans used tattooing to indicate status or clan membership (slave, freeman, political affiliation, etc.) and for religious/mystical/spiritual reasons (ancestor worship, life and death rituals, curing procedures). People rally around specific symbols—symbols that represent power personally and/or politically, geographically, and spiritually.

From the analysis of European tattooing one encounters a diverse and complex set of reasons for "why tattoo." Although the following references relate mainly to the European condition, they are universal.

The Sacred Body

According to Joseph Campbell (1990:1), "The first experience of anybody is the mother's body." (Certainly he understood the first *real* experience is self and other at the same instant.) There are several experiences (at least) that we all share in common, the most obvious being birth, a major theme of this volume, and death, the topic of a companion volume, *The Twelve Gates.* With the experience of birth, our world splits in two; now there is myself and the "other" or anything that I experience as separate from myself. As I gain more experience in this world and begin to understand the rules, I develop an awareness of my own behavior and its compatibility within a specific context, that is, how my behavior will impact the "other." This is your social conscience, that little voice that instructs, going by various names in various cultures—for example, Jiminy Cricket (Northern Europe), angels/devils (Middle Eastern), Devi/Naraki

(East Indian), alter ego (Western psychology). Once out of the womb the individual goes through countless discoveries of polarities, such as day-night, sun-moon, male-female, father-mother, me-myself, raw-cooked, and so on.

Everyone has a different experience, both as a singularity (when in the womb due to a complicated interplay of genetics, diet, and stress that no one understands to any certain degree) and at the point of the "big bang" when we move through the tunnel and are flushed into the "other." For every second thereafter we all have a personal experience of this "other" or "outside" that is dynamic and not static. But one of the first and most enduring experiences is that of one's own body. The birthing process has to be a total sensory trip, without expectation or any language or story to categorize and explain what this "other," suddenly emerging from all points of the compass, is about. The birth process is a shock to the new-born and the mother (and in most instances other participants as well), a stopping or altering of a very repetitive existence in that warm dark place, the womb; it's a kick-start, if you will, to any number of possibil-ities. Threatening information, perhaps that slap on the butt, could trig-ger fear, an automatic response wrapped around that "will to life," a genetically engineered instinct. Certain sounds or lighting, on the other hand, might trigger a sense of comfort, and so on. Within all that com-plexity there is the awareness of one's physical self *now on the outside* of its mother, a physical self that becomes aware of polarities, such as hunger or thirst and satiation, cold and hot, roughness and softness, wet and dry, light and dark, and so on. We learn where we itch, hurt, feel pleasure, along with the effect of our emotional states as culture tells us how to feel within specific contexts. We learn from touching ourselves and others exactly where those pleasure and pain points reside. This knowledge has accumulated over time and around the world to build elaborate and useful medical systems (acupuncture, Ayurvedic medicine, etc.) as well as mar-tial art systems. I do not think it unusual that the Iceman's tattoos were made over recognized acupuncture points; I would not be surprised if

those dots running up the spine on that Bushman figure represent a similar sensory experience as found in Yogic practices with the ascent of the Kundalini energy. Although today (in the West) culture can interfere with our innate need to touch and be touched, for most of the approximately two million years of culture building—from *Homo habilis* to us—our ancestors were in constant physical contact. Grooming, body painting, decorating, scarring, tattooing, and so on are extensions of how we, as individuals, view ourselves and bond to others, and that view begins the moment the singularity ends and the dualistic world is created, that is, birth.

Our first experience at birth, then, is that of our own body as it communicates with the mother, the "other." Your body is a cultural canvas, and it is by no means blank. You come into this world with knowledge above and beyond our everyday experiences, and it is through your body that you approach understanding of that knowledge.

However, your body is not you. "You are not your body," a typical *neti, neti,* negating statement in the Hindu tradition, is an intellectual yoga or method of unraveling all aspects of one's self to get to the God within. Anything that you can name about yourself is not God; whatever is left over *is* that God, that energy informing the universe. In many respects, though, and as far as your senses can tell, all you have *is* your body. Your mind is in charge of that body (consciously and subconsciously), and it articulates with that "other" using the body as a medium.

In the Hindu tradition your body is a container and when you die the container dies, but your *atman,* that energy informing your cells, goes on to inhabit other containers in an endless round of life, death, and reincarnation. In Christianity you have one container and when you die your spirit (energy) might go to hell, where you are going to have to pay up for your sins. And if you don't believe in an afterlife, well, forget new heaven, new earth. If you do not believe in an afterlife of any worth, you might want to spend considerable effort in slowing down the effects of aging—manipulate genes and go for immortality. Understanding genetics

will one day bring us to the point (if we aren't already there) of ultimate body modification, which might be a necessity in deep space travel. Nor would we necessarily be able to adapt to the life forms on other planets, as all science fiction enthusiasts readily acknowledge.

Governments going back many thousands of years have attempted to own the individual's body and soul through incarceration, branding and tattooing, burning, and so on. The Aztecs were obsessed with piercing and blood-letting. As punishment, for example, insubordinate priests were pierced with maguey spines over most of their body (Plate 1-11a). Plate 1-11b shows a nine-year-old pierced with maguey spines by his father for not obeying. The pain is socially directed, that is, its intent is to bring the individual in line with society's rules, and society tells you what punishments are appropriate for specific inappropriate deeds. This is the punitive side of body mutilation.

But society may likewise instruct you to endure pain, not for the purpose of punishment, but to keep the universe alive. It was common practice for Mayan priests to enact ritual human sacrifices, but they also self-mutilated for blood sacrifices (Plate 1-11c). "[S]elf-mutilation was carried out by jabbing needles and sting-ray spines through ears, cheeks, lips, tongue, and the penis, the blood being spattered on paper or used to anoint idols" (Coe 1967:154). Bernal Diaz (1967:123–124), a soldier who accompanied Cortes on his trek to Mexico City, gave this description of priests, whom he referred to as *papas*.

These papas wore black cloaks like those of canons, and others smaller hoods like Dominicans. They wore their hair very long, down to their waists, and some even down to their feet; and it was all so clotted and matted with blood that it could not be pulled apart. Their ears were cut to pieces as a sacrifice, and they smelt of sulphur. But they also smelt of something worse: of decaying flesh.

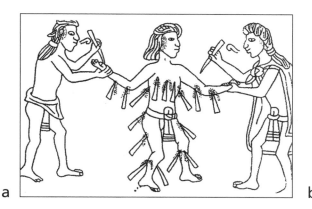

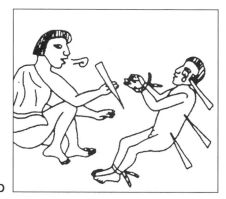

a

b

Plate 1-11: (a) An insubordinate priest is pierced with maguey spines all over his body (Berdan and Anawalt 1997:129); (b) A nine-year-old is pierced with maguey spines by his father for not obeying (Berdan and Anawalt 1997:123); (c) A Venus god spears the shin of the Goddess of Running Water, Chalchiuhtlicue, a behavior that would have been enacted by priests who pierced their shins to obtain blood for sacrifice (Diaz and Rodgers 1993:25).

c

Some religious traditions and cultural practices even go so far as to not only control the individual's body through incarceration or death (or dismemberment), but all of his or her family members too as a means of eliminating revenge by survivors. A similar thinking, from the ancient Egyptians, can be deciphered on the Merneptah (son of Ramses II) Stela dating to 1207 BCE. We read of the Egyptian campaign against tribes in the Sinai, "Canaan has been plundered into every sort of woe; Ashkelon

has been overcome; Gezer has been captured. Yano'am was made nonexistent; Israel is laid waste, its seed is not." A tribe is a group of interrelated kin, and this type of warfare, which comes into existence in the Middle East around 2300 BCE, involves killing all the enemy—every man, woman, and child, not just the leader(s). And although the story presented on this stela may not be completely factual, the sentiment is there for all to see—especially your enemy. Retaliation and personally getting even with a perceived enemy is built into the fabric of most tribal groups, for example, the Arab cultures dating back to pre-Islamic times. The laws or rules of retaliation (*qisas,* "tracking the footsteps of an enemy") are complex, honor-bound, personal in nature, and have been replaced by a more impersonal system in Western culture within which all are accountable, that is, Muslim, Jew, Christian, Hindu, atheist, and so on, and the punishment rendered cannot fall into what has been defined as cruel and unusual. Some of the retaliation methods used in Arab cultures in pre-Islamic and modern times would pass the test of cruel and unusual. This is where we get into a hand being removed for certain offenses (Qur'an, Surah V:38), a foot for others, or if a Muslim kills an infidel (anyone holding to another tradition) he should not be killed in return, and so on.

In the England of not so long ago, a man's wife would be raped and impregnated by a government official as a symbolic (and literal, in a sense) gesture of the "discontinuation" of a man's life and his powerlessness in the face of "authority." We do some pretty horrible things to each other in the name of Gods and State.

The body as State-owned is clearly indicated in the repressive behaviors of the Taliban in Afghanistan, where women were (and largely still are) forbidden to show their faces, men were required to have beards of a particular length, and so on. The consequences of breaking rules include rape, beatings, and/or death.

Dismemberment while still alive is not only a mythic theme (Osiris, Jesus, etc.) but a reality in many traditions, including Islam and Christianity. Outside of explosives, decapitation is the method of choice of body muti-

lation in Islamic countries. In the pre-Islamic period, as mentioned, revenge warfare was the rule, and to this day when more liberal Muslims speak out against Islamic Fundamentalist atrocities it can invite revenge *(qisas and tha'r);* this reaction extends past tribal lines and can include anyone with a contrary opinion. At the core of Islam, Christianity, and Judaism are control, judgment, and violence directed at dissenting members and all outsiders (see Juergensmeyer 2003, Reed 2002, and Schwartz 1997). What Jesus taught and what passes for Christianity are not the same. Control of mind, body, and soul is the goal of these archaic traditions. This is more than adequately spelled out in Biblical scripture. In Mark 9:43–48 we read:

> If your hand causes you to sin, cut it off. It is better for you to enter life maimed than with two hands to go into hell, where the fire never goes out. And if your foot causes you to sin, cut it off. It is better for you to enter life crippled than to have two feet and be thrown into hell. And if your eye causes you to sin, pluck it out. It is better for you to enter the kingdom of God with one eye than to have two eyes and be thrown into hell, where "their worm does not die, and the fire is not quenched."

In Matthew 5:29–30 we find:

> If your right eye causes you to sin, gouge it out and throw it away. It is better for you to lose one part of your body than for your whole body to be thrown into hell. And if your right hand causes you to sin, cut it off and throw it away. It is better for you to lose one part of your body than for your whole body to go into hell.

These passages, when read literally, not only justify self-mutilation (Favazza 1996:235) but mutilation in the name of God and State in order to protect you from the ravages of hell, and through fear you remain subservient

to the tribe or State. Keep in mind that morality and religion are two entirely different things, and although there are wonderful sentiments connected to Judaism, Christianity, and Islam, these are secondary and are conveniently pushed aside in the name of God. Islamic clerics convince individuals—men, women, and children—to strap on bombs and blow up people in the name of Allah. This is a most spiritual act and considered a high form of devotion to one's deity and also an extreme form of religiously sanctioned self-mutilation. But on the other side, is this mutilation not the Christ's image and the cross (raw) substituted for high explosives (cooked)?

From another time period, but in the same frame of religious reference, "the iconoclastic emperor Theophilus punished two brothers named Theodore and Theophanes, convicted as 'iconodules' or worshipper of icons. First . . . he had them severely beaten, then he had their faces tattooed, and poured ink into the tattoos, and the tattoos formed letters" (Jones 2000:10). The two brothers eventually became saints with the surname *graptoi,* 'the Inscribed'."

In a not dissimilar vein, one of the symbols connected to the Harry Potter character, by J. K. Rowling, is the scar on his forehead. This came about when he was touched by evil Voldemort. The intent was to kill, but instead Harry Potter's powers grew beyond that of Voldemort. This wounding, as in the case of the *graptoi* above, actually conferred rather than removed power. In the recent remake of the tale of Zorro (*The Mask of Zorro,* 1998), Zorro/De la Vega (played by Anthony Hopkins) carves the sign of Zorro ("Z") onto the left side of the governor's throat after he attempts to modify (shoot holes through) the bodies of three innocent peasants. The theme here is that those in authority are on notice that justice will be served, in this case by the hero (Zorro) who represents the energy of the people. Zorro, as played by Antonio Banderas/Alejandro Murrieta in the 1998 movie, likewise scars the face of Captain Love as a remembrance of his brother's murder and beheading.

One difference between Harry Potter and Zorro is that Voldemort's

mark empowered and is therefore on Harry's head (and hidden by hair—hidden powers), while Zorro's mark on the governor is a warning and therefore on the throat (covered by a scarf so as not to constantly remind others of rascally behavior). The scar on the Captain's face is there for all to see and thus justifies the Captain's death.

Luke Skywalker in the *Star Wars* series loses his right arm in a battle with his machine father, Darth Vader. This is a sacrifice that cut in both directions, that is, the son no longer can stand on the "right side" (take over from his father), and the severed arm represents a severed relationship, at least at the machine level. But from the other side, Luke joins the machine world through his prosthetic arm.

Tattoos, branding, and so on are chunks of information, symbols that open to a wide range of ideas. As an example, data about individual characteristics of convicts in nineteenth-century England, that is, hair color, eye color, scars, tattoos, and so on, were collected as a matter of identifying individuals who might escape during transport or while imprisoned at penal colonies in Australia (Maxwell-Stewart and Duffield 2000). The same process of identification is utilized today and is especially apparent with respect to gang members and "career" criminals (see Valentine 2000). Jail and gang tattoos, as found in Canada and the U.S., do not represent punitive, government-sanctioned marks of ownership. Instead they symbolize group affiliation, status in the group, commitment, perhaps a worldview of being "outside" the law, individuality, racism, calendars, terrorist pursuits, and so on (Valentine 2000 and Pearlmutter 2004).

Tattooing, though, can be used in some unusual ways so as to be "one up" on the establishment. A primary point made by Maxwell-Stewart and Duffield (2000) is that the Australian prisoners (transported from England to Australia between 1817 and 1853) in many cases were poking fun at the establishment, especially religious do-gooders, with tattoos of Biblical scripture. In other words, tattoos represented a statement of government injustice and a means to keep the spirit intact. Many prisoners saw their suffering as the suffering of Christ, which places the

individual in a very different status from that of prisoner or convict. It has also been suggested that tattooing in these cases might likewise be linked to the stigmata phenomena, or marks or scars on the hands, feet, over the heart, and head, symbolizing the suffering of Christ (see Favazza 1996 and his discussion of stigmata and martyrdom). The experience and marks from beatings/whipping could likewise be retranslated as a suffering servant of Christ. As Maxwell-Stewart and Duffield (2000:132) comment, "identification with Jesus, the archetypal 'Suffering Servant', could be a powerful weapon. When flogging is viewed this way, the tables are reversed: the more degradation inflicted on the flayed bodies of the subordinated, the more moral power the targets of abuse can draw from the tormentors."

The relatively recent fervor over Mel Gibson's *The Passion of the Christ* is instructive on many levels. *The Passion of the Christ* is the rendering of a Biblical myth. There is no reliable, first-hand account of Jesus (at that time period) and certainly no blow-by-blow description of his crucifixion. When viewed as fact, rather than a mythic theme with a deeper meaning, all the spirituality is lost. When seen as fact, however, one is exposed to the true meaning of intolerance and control of mind, body, and soul. This is not the place to re-examine the "true Jesus," but those interested in precedents to the mythic theme of martyrdom can consider the story of the Egyptian god Osiris, who was dismembered by his brother Seth. Through this act Seth releases Osiris's energy to fructify the earth, and eventually Osiris becomes the *resurrected* Judge of the Dead in the Underworld. Or consider Atys of Phrygia (1170 BCE), who "was suspended on a tree, crucified, buried and rose again" (Graves 1971:127).

In our current world condition, almost on a day-to-day basis, Muslims martyr themselves by strapping on bombs and blowing up innocent people in the name of Allah. There is a long tradition of human sacrifice, and the axis upon which it turns supplies both Islam and Judaism a mythical charter for nation building.

The "binding of Isaac," or the *Akedah,* is celebrated in the Jewish tra-

dition each year at Rosh Hashanah and Yom Kippur. The binding of Isaac is one of those hero tests, in this case a test to see if Abraham would totally submit to the command of the Lord (at least that is one interpretation). Abraham binds Isaac (which suggests that Isaac is not necessarily a willing participant in this), is about to carry through with his sacrifice, but is prevented from doing so by an angel. Jews see Isaac as the first martyr of their tradition even though he was not killed by his father's hand. The symbolic value here is diverse. This is an act of submission. It is a statement that God comes first over family and friend. It means that death in the name of God *is* appropriate.

> Mohammed also seized on the Akedah, when he rewrote Abraham's sacrifice. The Koran's version of the Akedah is that Abraham tried to sacrifice another son, named Ishmael, near Mecca. Since Ishmael went on to become the founding father of the Arabic peoples in the Hebrew Bible as well as the Koran, Mohammed thus expropriated Judaism's foundation sacrifice for his desert tribes and their own ancestral place of pilgrimage at Mecca.
>
> The almost desperate desire of Jews, Christians, and Muslims to claim the salvific power of a distant event on Mount Moriah shows how strongly the idea of human sacrifice as a foundation of the social order is rooted in the religious subconscious (Tierney 1989:371).

Islam is the only contemporary religion that regularly practices human sacrifice to a god, although it is justified in Jewish and Christian dogma. One who kills himself for the glory of Islam is not committing suicide but, instead, is a martyr *(shahid)*. Killing oneself for the glory of Islam not only places the individual in the special favor of Allah in paradise, but the act is designed to stir the passion of others, to bring people to action for the cause. The roots of this philosophy and behavior are very deep.

Religion and violence are not strangers. Judaism, Christianity (for the most part), and Islam can be characterized as patriarchal, monotheistic systems, and all three are covered in blood. All three have been conquest religions (and still are to this day), and "in the Name of God" allow for the darkest Shades to swallow the Earth; all have "committed sins in the service of truth." All three engage, or have engaged, in the dark side of tattooing, scarifying, piercing, branding, crucifying, burning at the stake, and mutilation in order to punish and purge.

We read in Leviticus 19:28, "Do not cut your body for the dead or put tattoo marks on yourself. I am the lord." But to say that it is wrong to tattoo or scarify for spiritual or aesthetic reason turns all these traditions on their head. It is okay to mutilate, brand, and otherwise abuse the body in the name of God or the law but shameful to beautify the body, that which was made in His own image. Let me quote to you Isaiah 3:16–24.

The Lord says,

The women of Zion are haughty, walking along with outstretched necks, flirting with their eyes, tripping along with mincing steps, with ornaments jingling on their ankles. Therefore the Lord will bring sores on the heads of the women of Zion; the Lord will make their scalps bald.

In that day the Lord will snatch away their finery: the bangles and headbands and crescent necklaces, the earrings and bracelets and veils, the headdresses and ankle chains and sashes, the perfume bottles and charms, the signet rings and the nose rings, the fine robes and caps and cloaks, the purses and mirrors, and the linen garments and tiaras and shawls.

Instead of fragrance there will be stench; instead of a sash, a rope; instead of well-dressed hair, baldness; instead of fine clothing, sackcloth; instead of beauty, branding.

Your men will fall by the sword, your warriors in battle. The gates of Zion will lament and mourn; destitute, she will sit on the ground.

Certainly this is a statement of the downtrodden to the "haughty" rich, but these are declarations on both sides of how we ought *not* to treat one another. In other words, don't flaunt yourself in front of others if you have more than your share, and have compassion for others. There also is a clear distinction between "us" and "them" and a clear statement of "body" politics.

Some religious traditions emphasize an afterlife as the "real" place, a place on the other side of death, that new heaven, new earth. But what if there is no new heaven, new earth, and paradise or hell is right here depending on your point of view? When we are with our demons we see those demons all around us. But in the Buddhist mind, heaven is right here and it is up to you, through your experiences, to find that "place." His disciple said to Him, "When will the Kingdom come?" (Jesus said,) "It will not come by waiting for it. It will not be a matter of saying, 'Here it is' or 'There it is.' Rather, the Kingdom of the Father is spread out upon the earth, and men do not see it." (The Gospel of Thomas)

The message is that heaven is right here, and it is a matter of experiencing it through your senses—open your eyes and modify your thinking!

Transitions: Real-Time Modification

Over twenty years ago Gail Sheehy (1984) introduced to the mainstream the subject of junctures or transitions in a person's life. In the course of living, boundaries are approached, either ascribed by nature (e.g. events as we age, such as crawling, walking, puberty, etc.) or culturally constructed transitions (achieved statuses, such as transition from middle school to high school, marriage, divorce, college, etc.). Culture is biology

wrapped in social rules, and these rules become highly ritualized, just as our biology is structured and repetitive ("ritualized") and not simply a mosaic of random chemical and electrical reactions.

To become immortal means being in harmony with the universe, doing what you are supposed to do, according to the ancestors or according to modern beliefs and behaviors. Staying in harmony means dealing with transitions, that is, the movement from place to place, the changing of the seasons, aging, and so on. Our ancient ancestors recognized that some biological transitions need extra attention or social help in order to assist the passage. These rituals are what anthropologists call "rites of passage." Along with this there are rites that encompass the community and/or nature, and not just the individual. For example, the Jewish Bar Mitzvah and Bat Mitzvah, or coming-of-age ritual for young men and women (at age thirteen), communicates that he or she is responsible for following the commandments (the 613 Mitzvot) and now can be formally recognized as a full member of the Jewish community. This is also a community event designed to acknowledge itself and its members as a whole—what in the classical anthropological literature is called a "rite of intensification." The Bar or Bat Mitzvah is a symbolic rendition of rites and rituals that were enacted as real events, that is, as a sacrifice, a giving back, alliance to the group, and so on. In some preliterate groups, however, the rituals were closer to real or imagined events of a distant past. Instead of consuming the wine and the wafer as in the Christian tradition, there was real human blood and flesh.

The classic example of the male rite of passage comes from the researches of Spencer and Gillen (1968, originally published in 1899). Amongst the tribes of Central Australia, the Arunta for example, there is a very elaborate rite of passage for males between the age of eleven and thirteen. One fine morning the men, women, and children of the tribe assemble, and boys in this age range are selected for this rite. Each is tossed up in the air repeatedly and carefully caught, while the women dance around. The young man is now being taken over by the men; they have the power to

"throw him in the air," to take over his life, a power that formerly belonged to the mother. The "brother" of each young man's wife-to-be paints totem animals on his naked flesh (these usually are not his totem animals but those of other clans). The young boy moves to the men's camp and away from mother, and learns how to hunt big game rather than rats and lizards, the game of women and children. Shortly after this his biological father or grandfather will poke a hole through his nasal septum and a bone will be inserted to flatten the nose and make it more aesthetically appealing. This piercing is likewise a social symbol that the young man is a candidate for future ceremonies, the *Lartna* and *Ariltha,* or circumcision and sub-incision, respectively. Females also go through nasal septum piercing, but the operation is performed by the husband shortly after marriage.

Several years may pass before the second and third ceremonies *(Lartna* and *Ariltha),* but usually circumcision occurs around the time of puberty. When the elders determined a right time for these ceremonies the young man would be forcibly taken from the village to a ritual area, painted again, and ritually secluded, thus marking his transition from the world of women to the world of men, or the world of nature (women) to the men's club ("society"). The young man does not know what is going to happen to him; these are mysterious rites and the only way you can know them is through initiation and membership in the men's club.

After several days of watching ritual animal dances, being squashed under a pile of human bodies, danced on, along with mock attempts by women to seduce the young man and stall his entrance into the world of men, he is finally hoisted on a shield, taken a short ways from camp, and circumcised with a stone knife. "The assisting *Atwia atwia* at once grasped the foreskin, pulled it out as far as possible and the operator cut it off, and immediately, along with all the men who have acted in any official capacity during the whole course of the proceedings, retired out of the lighted area, while the boy, in a more or less dazed condition, was supported by his *Oknia* and *Okilia,* who said to him, 'You have done well, you have not cried out'." (Spencer and Gillen 1968:246–248)

He is introduced to the *churinga,* the sacred bullroarer that will help stop his bleeding. Because these sacred and mystical symbols on the *churinga* are "owned" by the men, their existence cannot be known to the women, and he is threatened with grave harm should he lose this or should he speak of this sacred object to the women. He is likewise reminded of food restrictions, as is his mother, for if she ate "opossum, or the large lace lizard, or carpet snake, or any fat, . . . she would retard her son's recovery" (Spencer and Gillen 1968:250).

> After the operation of *Lartna,* the foreskin, amongst the Finke River groups of natives, is handed over to the eldest *Okitia* of the boy who is present, and he also takes charge of the shield in the haft of which the blood from the wound was collected. The piece of skin he greases and gives to a boy who is the younger brother of the *Arrakurta* (the one circumcised), and tells him to swallow it, the idea at the present day being that it will strengthen him and cause him to grow tall and strong. The shield is taken by the *Okilia* (oldest male relative) to his camp, where he hands it over to his *Unawa,* or wife, and she then rubs the blood over the breasts and foreheads of women who are *Mia alkulla,* that is, elder sisters of the boy's actual *Mia* and *Ungaraitcha,* or elder sisters of the boy.
>
> These women must not on any account touch the blood themselves, and after rubbing it on, the woman adds a coat of red ochre. The actual Mia (mother) is never allowed to see the blood.
>
> Amongst some groups of Western Arunta the foreskin is presented to a sister of the *Arakurta,* who dries it up, smears it with red ochre, and wears it suspended from her neck. (Spencer and Gillen 1968:250–251)

The next ritual procedure is called the "ceremony of head biting" *(Koperta kakuma)* wherein the young man lies down and two to five men bite him on the head until he bleeds, which could be one bite or many from each

of the participants. The stated purpose is to make sure that the *Arakurta's* hair will "grow strongly."

After the circumcision has healed, the young man is subjected to a second operation on his penis called sub-incision, an operation from which the women are entirely excluded. Although the young men volunteer for this procedure, if they refuse they cannot enter the men's society. The procedure is as follows. The "volunteer" lies down on his stomach, and then he is laid on top of by two of the men, and "(a)s soon as ever he was in position another man sat astride of his body, grasped the penis and put the urethra on the stretch. The operator who is called *Pininga* and is chosen by the Oknia and Okilia, then approached and quickly, with a stone knife, laid open the urethra from below" (Spencer and Gillen 1968: 255–256). The cutting of the boy is in the foreground of activity, but in the background more cutting is going on.

> At the moment when the *Arakurta* (the one to be sub-incised) is seized for the purpose of having the rite of *Ariltha* performed upon him the men set up a loud shout of "*Pirr-rr*"—loud enough to be heard by the women in their camp. The latter at once assemble at the *Erlukwirra,* that is the women's camp, and the *Mia* of the boy cuts the *Unchalkulkna* woman across the stomach and shoulders, and then makes similar cuts upon women who are the boy's *Mura* and elder and younger sisters, as well as upon those who are her own elder sisters. While making the cuts she imitates the sound made by the *Ariltha* party. These cuts, which generally leave behind them a definite series of cicatrices, are called *urpma* and are often represented by definite lines on the Churinga (Spencer and Gillen 1968:256–257).

After completion of this operation the boy sits on a shield and the blood from the wound is allowed to run from the shield and be consumed in the fire built for this purpose.

These rites and rituals are designed to aid not only in the transition of the boy to a man, but they are a transition for the community as well, that is, legitimizing the change in status and acknowledging, through participation, one's place in the group, male or female. The purpose behind the blood-letting is to drain the blood of the mother from the child, and the scarification of the female relatives is probably to mark clan identity and share in the pain of the young man going through this obviously agonizing procedure. Beyond this there are some psychoanalytical interpretations, one of the more interesting being that of Bettelheim (1962). He suggests that women may have formerly been on more equal footing with men, and probably had some symbolic connection to fire and its use. It is stated in their myths that men were in earlier times circumcised with fire sticks until an old woman showed the men how to use a knife. Beyond this there is the suggestion that the rites are a symbolic representation of a man's first menses and an emulation of the mystery connected to the female ability to bring forth life. Among the Aborigines it was believed that women were impregnated by rock, tree, or other types of spirits, and the male's part in conception was unknown to these people.

These transitional rites that move the individual from one status to another are common in all societies, and they can be placed into several categories. First, there are those that are culturally/ religiously demanded in order for an individual to be accepted as a full-fledged member. Second, there are those devised for membership into a sub-group of a larger society. Third, some rituals are individual in purpose or represent an individual transition culturally allowed (ear piercing, tattooing, implants, etc.) and, fourth, we have those considered pathological (self-mutilation).

Rites of passage are not seen as important in much of North American society because of the value of self-responsibility, a dislike for authority (those who would assist in rites of passage), disconnected families, a semi-nomadic lifestyle (especially if connected to the military or large businesses with corporate offices all over the world), and religious traditions that have been brought into doubt. With more and more electronic media,

the everyday world of real, tangible people, traffic jams, and long lines at the supermarket can almost be entirely avoided. Although this can cut down on information overload (people, noise, pollution, etc.), it is isolating. With self-responsibility we move closer to personal identity and personal choice in these rites of passage. Isolation brings personal identity into focus and body modification is one type of expression.

Tattooing, scarification, branding, implants, and self-mutilation are all, in one manner or another, statements about transitions, of getting rid of, altering, or adding something to one's life. Even if a piercing is done for aesthetic/artistic reasons, this is still a statement to the world; you are now different, you have made a transition, and "x" marks the spot.

Modern body modification has become an obsession in North America. Makeovers, including breast augmentation, face and jaw alterations, liposuction, and cosmetic dentistry (Engler 2000) are, for the most part, readily accepted by a public fascinated with ego, acceptance, and a culturally contrived concept of beauty. Somehow these procedures are considered different from tattooing, scarification, and certain types of piercing. This difference can perhaps be explained by the behavioral reference of the procedures. In other words, breast augmentation, nose jobs, face tightening, tummy tucks, and so on are movements toward a cultural concept of beauty and a standard of youth; while individual-directed (rather than social-directed, e.g. branding or whipping) mutilation, scarring, or tattooing point in another direction—that is, toward self or individualism, or perhaps toward pathology because it is so far from the accepted norm. The former displays the norm, while the latter displays the other possibilities, but the purpose, at least at some level of awareness, *is* to move from one physical and emotional condition to another and in most cases display the modification.

One of the most common body modifications found across the globe is ear piercing. It was practiced by the ancient Egyptians, and numerous examples of hoop and lotus-flower earrings and ear plugs and studs have been found (Capel and Markoe 1996:89–90). A statement in the Bible

suggests a possible origin for this or some connection of "ownership" and ear piercing in Middle Eastern cultures. In Exodus 21:5 we read, "But if the servant declares, 'I love my master and my wife and children and do not want to go free,' then the master must take him before the judges. He shall take him to the door or the doorpost and pierce his ear with an awl. Then he will be his servant for life." This is a strange statement, suggesting that this activity did probably occur, but it might be connected to other more ancient rites—perhaps marriage or the uniting of families in a blood pact.

Ear piercing was also practiced by the Scythians, as mentioned earlier, and a continuation of this practice can be seen in India, where there is a long tradition of *karnavedha,* or ear piercing, that occurs at eight months old (more recently this ritual is performed on the tenth or twelfth day after birth) for both males and females. Both ears are pierced, with ornaments of the right ear signifying health and the left ear signifying wealth. The reasons given for this body modification include an awakening of truth, health enhancement connected to the practice of acupuncture, protective power, and as signs of beauty. Yogis of the Natha tradition will stretch the piercing to stimulate the *nadis* or astral energy flow throughout the body.

Ear piercing is very much accepted in North American society, but the piercing of other body parts—for example, a ring through a nose (Plate 1-12a)—is less accepted. Placing rings or studs through the nose or nasal septum is a common procedure in many areas of the world. Like ear piercing in North America, nose piercing is done mainly for aesthetic reasons or, in some cases, as a mark of remembrance of a special person or as group identity. We also encounter eyebrow rings (Plate 1-12b), ear plugs (Plate 1-12c), nipple rings (Plate 1-12d), uvula rings (Plate 1-12e), belly button rings (Plate 1-13a), labial rings (Plate 1-13b), and penis rings or studs (Plate 1-13c), most of which are done for aesthetic or sexual reasons. Tongue piercing (Plate 1-13d) has become a common practice,

which definitely impedes speech but is usually done for sexual reasons. A giving up of articulation ability (society) for sexual satisfaction (nature) is an interesting trade-off. Plate 1-13e and f show a rather unique piercing of the ear.

Plate 1-12: Piercing of (a) nose; (b) eyebrow; (c) ear by Matt Bruce; (d) nipples; (e) uvula by Matt Bruce.

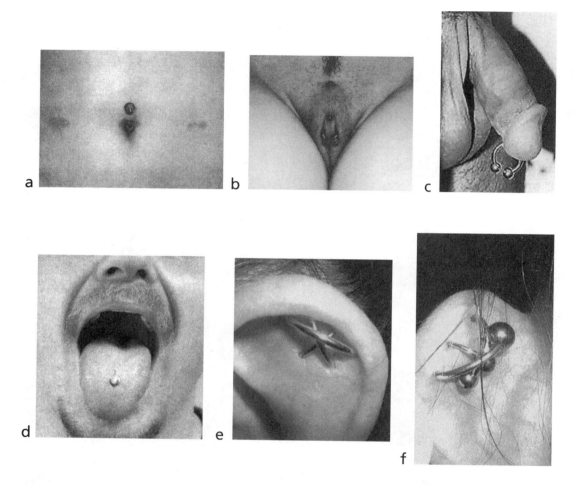

Plate 1-13: (a) Piercing of belly button; (b) labia; (c) penis (Prince Albert); (d) tongue; (e and f) ear, both front and back (piercings a, b, e, and f by Matt Bruce).

Modification of teeth, usually for aesthetic reasons, is found in many areas of the world both prehistorically and to this day. Modifications can include staining (Viet Nam, Borneo, Alor), filing (Alor, Borneo, Middle America), jeweled or gold inlays (Middle East), whitening and straightening (North America), and so on. Some modifications create secondary or accidental modifications. For example, the wearing of labrets common among the Inuit can lead to polished facets on labial surfaces of lower incisors and canines. In the West we have our own unintentional modification where "in style" shoes can alter the alignment of the toes and cause bunions. This was a common consequence of pointed shoes worn by women in the 1940s and '50s. Some of the current shoe styles lead to bunions, not to mention alterations of the spine and hip alignment from wearing high heels.

Magical Tattoo

The tattooing industry in North America has experienced a steady growth over the past two decades. I see more and more young adults, both male and female, with tattoos, from singular and small symbols to rather elaborate pieces covering many square inches of skin. Much of the data I collected from students and the general public indicates that tattooing, for the most part, is an individual experience representing a transition point in the person's life. As socially sanctioned rites of passage or transition rituals have fallen away in North American culture, the individual is left to reinvent them on his or her own (see Bernstein 1987 and Rush 2002). Symbolic remembrance is important and strongly suggests the necessity of such rites for the human animal. For example, the loss of a parent or remembrance of a close relative (Plate 1-14a) deserves personalized recognition. Rebellion is another theme where the tattoo is a statement of body ownership or simply a way to torment a parent (Plate 1-14b); these tattoos are often regretted in time.

a

b

c

Plate 1-14: (a) Remembrance of significant others. This gentleman's hands were photographed in this position and tattooed holding a portrait of his mother (art by Kim Forest); (b) Rebellion. This black widow spider was a statement of rebellion against parental authority, and authority in general. This type of rebellion is often regretted, especially when the individual has his or her own children (artist unknown); (c) Group Identity. The Fifth Element tattoo represents a life-long friendship among four men (artist unknown).

Trans-generational tattooing is of interest, as it appears expected as a ritual in some families. In my research mother and daughter tattooing appears to be more frequent than father-son tattooing. Motives in most cases involve identity with rather than rebellion against other members of the family. Males were less likely than females to suggest that a tattoo was a parental bonding ritual.

Group identity is another motive. The Gothic visual identity (all black and dark clothes and make-up, black hair, chain loops, nose, eyebrow, belly button, labial piercing, etc.) is often accompanied by Celtic-style knotted necklaces and ankle and wrist bracelet tattoos. In another case of group identity, a contemporary symbol representing wholeness was chosen (Plate 1-14c), in this instance, "The Fifth Element," from the movie of the same name.

In many cases the tattooing designs are is quite extensive and intricate. Many are sexual in nature and located in a place where that sexuality is enhanced. Symbols of sexuality or sexual identity and mate attraction are quite common. Males, for example, tend to openly display tattoos on arms (Plate 1-15a and d), although this is not always the case (Plates 1-15b and c). The ladies tend toward the less obvious and choose, instead, areas designed to spark curiosity in the observer (e.g. the small of the back, Plate 1-16a and b, or along the iliac crest, Plate 1-16c). Fully covered tattoos, on the other hand, offer shock value when seen for the first time (Plate 1-16d).

The butterfly (Plate 1-17a and b) is a common symbol used by the lesbian community as a statement of metamorphosis or new life from an old imprisonment—a body that perhaps did not "fit." Plate 1-17c is symbolic of another type of metamorphosis, that is, the beginning of a new life after the death of a loved one, divorce, or other traumas best left in history.

Tattooing can be used for magical reasons or to give strength during adversity. Plate 1-18a shows a shaman dressed in a wolf skin, a very powerful Native American symbol. Plate 1-18b is a Native American spirit catcher designed to catch good spirits and ward off evil. Plate 1-18c is a magical protective symbol borrowed from the Harry Potter series. Celebrities, especially professional athletes, likewise tattoo for magical reasons, but also, in some cases, as a documentation of one's life (Gottlieb 2003:59).

Plate 1-15: Male sexual displays. (a) The tenacity and power of the bulldog (art by Doug Romano); (b) the power but gentleness of the gorilla. (This gentleman charges women five cents to look at his big monkey (art by Kim Forest); (c) more abstract designs of power (art by Doug Romano); (d) the swiftness and power of the eagle (art by Raleigh).

Plate 1-16: Female sexual displays. (a) Celtic and nature designs on the small of the back (art by Melissa Robbe); (b) a floral and fish design (art by Doug Romano); (c and d) attention getters (art by Doug Romano).

a

b

c

Plate 1-17: (a and b) Metamorphoses—the butterfly tattoo is often (not always) a symbol of change. In the lesbian community it can represent a commitment to that change and thus is emotionally liberating and therapeutic. Butterflies are beautiful and free—a visual metaphor of release (art by Doug Romano); (c) the start of a new life (art by Kim Forest).

Plate 1-18: Magical tattoos. (a) Native American shamanic/magical design (art by Raleigh); (b) spirit catcher (art by Kim Forest); (c) a magical symbol from the Harry Potter series (art by Melissa Robbe).

Tattooing is also used to cover emotional and physical scars or birthmarks. Plate 1-19a and b show a cover-up of an older tattoo connected to a failed relationship. Tattooing over scars (self-induced in this case) left from an emotionally painful period in one's life (Plate 1-19c and d) not only modifies the appearance of the skin, but tends to moderate (if not eliminate) the emotional scars connected to a physical and symbolic loss (see Chinchilla 2002:31–34). This tattoo signifies a ritual rebirth through a retranslation of the emotional event and obliteration of the self-induced scars that represented that earlier experience. The tattoo also represents a termination

a b

c d

Plate 1-19: Repairing scars. (a and b) Before and after the alteration of an earlier tattoo attached to a scarred relationship (art by Doug Romano); (c and d) dressing up emotional scars (art by Kim Forest).

ritual signaling cure and a return. Western psychology and psychiatry and biomedicine in general rarely signal cure and have few ritual procedures for social reintegration, and consequently people often stay in the "sick" role. Western biomedicine (outside of trauma medicine) is a system of illness maintenance rather than health care (see Rush 1999:169–175).

Plate 1-20a and b show a cover-up of a physical scar left from a burn, but this also represents an alteration of the memories connected to the burn; while Plate 1-20c shows the balancing of a birth anomaly (an extra nipple) using the familiar yin and yang symbol.

Plate 1-20: (a and b) Repair of a physical scar (art by Melissa Robbe). (c) Under the left nipple is an extra nipple or subpapilla mammae. He decided to balance the birth anomaly with the yin-yang symbol under the right breast (artist unknown).

Finally, there is tattooing for art's sake (Plate 1-21a through d) or a primary desire to have art for decoration, display, or comparison, but there is usually some deeper meaning. It is of interest to note that those who simply walk into a tattoo studio and pick out flash or a design without any specific meaning other than decoration often regret the tattoo over time.

Plate 1-21: Art for art's sake. (a) Koi can have great symbolic value, including abundance and wealth, and as a personification of warriors and spiritual guides. There are three koi in this design, symbolizing abundance, strength, and spirit. He chose the koi because of its color and flowing beauty. Art for art's sake is usually part of the equation in most tattooing (art by Doug Romano). (b) Not everyone can have a Picasso on his shoulder (art by Kim Forest). (c) A beautiful woman in the moon (art by Melissa Robbe). (d) Playful and symbolic energy shine through from the monster located on this young man's calf (art by Raleigh).

Spiritual Tattoo

The body, then, can be seen as a focal point of identity, personal achievement, emotional healing, and group membership. The power of symbols on the body is suggested by the following description of a man several centuries ago: "In the spring of 1609, Simon Forman, a prominent London medical-astrologer, 'made the characters' of Venus, Jupiter, and Cancer on his left arm and right breast" (Rosecrans 2000:46). Rosecrans comments further (2000:46–47):

> According to Forman's calculations, Venus, Jupiter, and Cancer were the astrological bodies that governed his horoscope. By impressing the correspondent characters of these three celestial entities upon his arm and breast, Forman believed he would be able to *harness the power of his horoscope, and alter the course of his life. He particularly sought this power because* he wished to alter the destiny of his body in his life, and possibly in the after life. (emphasis added)

Rosecrans mentions two issues of personal importance. First, tattooing does alter a person's life; it forces a commitment to symbols, which can stand for all manner of thought and behavior. The tattooing of Christian symbols, for example, after a pilgrimage to a particular shrine, would have a very special meaning, an experience in the mind and on the body to see and meditate upon in the years to come. Second, scarification and tattooing can be useful for purging and sanctifying the mind and body and preparing for "life" after death (see *The Twelve Gates*).

Rosecrans goes on to say (2000:50), "In the early modern record, the largest subculture that advocated the philosophies and the practices of corporal inscription were the practitioners of the occult arts. For these would-be magi, the inking of the flesh was a very distinct and a very carefully recorded part of magical action." In this instance tattooing certainly is a statement of commitment, much more powerful than an oral oath. Saying an oath is of a different magnitude of obligation than having that

oath painfully inserted *into* your body. I personally found tattooing to be a significant mind-altering and behavior-modifying experience. Not only does a transformation of state occur during the tattooing process, but that transformation is maintained in varying degrees through time. There is a sense of having done something "important," a permanent mark always there to remind. One has painfully endured and reinforced time and again the ritual that represents a belief, a concept, and/or a commitment or attachment to a philosophy, person, group, or lifestyle.

Bradley (2000:150) offers some interesting points regarding attachments and symbolism.

> In cases such as Milne, the tattoos represented a bond between the body of the individual and the object towards which the individual's emotions were expressed. This object might, of course, have been a church, nation, regiment or a ship, but, as with Milne, it most commonly involved other people. Here tattoos acted symbolically as emotional signifiers implying strength of attachment and a token against absence.

In the above instance, a tattoo is indeed a blood sacrifice. But most of all it represents a commitment to ideas within which *people* are bound, for example, a person, a family, a gang, or a culture.

Psychotherapeutic Body Modification

In North America there seems to be a revival, or at least a more open attitude toward tattooing and piercing. Body modification can be a purely personal choice, requirement for membership in a group, and so on as discussed earlier. Tattooing, as mentioned, can also be used therapeutically, both emotionally and physically. The Iceman, as you will recall, had tattoos over joints shown to be arthritic during autopsy, suggesting that this is a very old belief and practice.

I am not advocating that anyone get a tattoo, piercing, or implant. All of these procedures are painful, and at least with respect to tattooing, permanent, but it is not evil, sick, twisted, or unusual—just painful and permanent. The transformation of state afforded by scarring and tattooing rituals is unquestionable, and transformation of state appears to be a necessary component in emotional and physical healing. As Berns reports for the Ga'anda of northeastern Nigeria (1988:65):

> Completing rites of personal transition not only makes young men and women eligible to marry and establish independent households, but to enjoy the rewards of spiritual protection essential to their productive and reproductive well-being. Rites of passage seem to prepare youths for accepting the maxim that powerful, controlling forces affect their future fortunes. It is possible that the excesses of pain and discomfort experienced during their ordeals induce a dimension of sensation whereby the presence and power of spirit forces are tangibly communicated. The experience of intense and repeated psychological or physical "shocks," from which the youths subsequently (but not always) recover, may palpably convey the structural complementarity of Ga'anda spirit forces that have the potential for benevolence as well as for retribution.

If you don't believe in the sanctity or efficacy of a ritual, then moving through it may have little or no transformative impact. Psychotherapy, if nothing else, has demonstrated the power of symbols and the self-fulfilling nature of our beliefs. If you believe that a rite will be transformative (even if you do not understand the details beforehand), if you desire that transformation, and if you trust the ritual master (the therapist *or* yourself), you then obtain the emotional (epiphany, catharsis) and oftentimes behavioral transformation. Some experiential trust-building exercises of the New Age Religions (see Taylor 1999) tend to be quite transforming of emotional and behavioral states, at least for a short period of time with

most people. The power of these rituals is magnified many times when there is a physical, "hands on" element as would be the case with physical deprivation (fasting, etc.), sexual magic, piercing, scarification, and/or tattooing.

The threat of pain is motivating; not many people like the experience, and pain is usually avoided. Pain does something to the psyche besides altering awareness, and this is extremely important in certain initiation rituals, for example, rites of passage. These rites are designed to maintain or bring systems back into some ordered or balanced state. In other words, information has to be *added* (tattoo, scarification, ritual beating, drug, or test of some type), *withdrawn* (circumcision, shaving one's head or beard, isolation, pathogen), or *modified* (a new dress code, food restrictions, celibacy) to maintain or regain order and stability. These three basic informational processes are to be found in all physical, emotional, and social healing (see Rush 1996). The pain of tattooing can be used to add, withdraw, and modify much of the initiate's learned beliefs and behavior. Those who undergo and live through torture likewise emerge with modified thinking and behavior. With modern-day tattooing, *and unlike torture,* you are in control of the duration of the pain, thus alterations in beliefs and behaviors can be self-directed, at your own pace, toward profound change.

Socially sanctioned and/or individually inspired acts of body modification can be very useful in instituting emotional and behavioral modifications. Body modifications, usually accompanied with elaborate ritual, probably emerged at the dawn of the Hominid lineage two million years ago. There was a recognition that social change could occur rapidly during a crisis, a drought, lightning strikes and subsequent fires, torrential rains, loss of a leader, and so on, and such crises force a system into momentary chaos out of which emerges a new order—life, death, and resurrection or reincarnation. The world has not been the same since September 11, 2001. We witnessed the initial disbelief and confusion, the subsequent blaming and distancing of groups (Muslims/Christians, Arab

world/Western World), a reformulation of laws, and a determination to rid the world of "evil-doers" and install democracy in the Middle East. Western nations had to modify many social factors for their own protection lest chaos prevail. Body modification is the micro-reflection of this same process, that is, adding, removing, or modifying information lest chaos prevail. We cover the body, we scarify, pierce, and tattoo to indicate membership in a group or a movement from status to status. We modify the body for magical, protective, and healing purposes. As Favazza (1996:231) writes:

> The importance of self-mutilation is clearly demonstrated and encountered with great frequency in adolescent initiation rites. Many anthropologists . . . generally have understood the purpose of these rites to be the acquisition by adolescents of new social roles and status necessary for the orderly preservation of communal life. The mutilations that the adolescents voluntarily accept are painful and often brutal: teeth may be knocked loose, the nasal septum pierced, the penis sliced open along the length of the urethra, large areas of skin scarified. These mutilations are integral components of the initiation rites and seem to serve several important functions. They heighten the drama and significance of the ritual, focus attention on the adolescents, and allow them to demonstrate their inner strength. They are also a warning that the social group has great power and will not tolerate revolt against authority; children are transformed into adults when they overcome their fear and allow themselves to be subjected to pain and mutilation. The intense emotions of the ritual tend to foster bonding between the adolescent participants and the adults who perform the mutilation.

So far I have been discussing alterations of skin or appendages with little or no attention to alterations of muscle, tendons, and bones. Plastic surgery on face, breasts, and butt, as well as weight lifting, running, aerobics,

yoga, and even anorexia and bulimia are all attempts (socially accepted or considered pathological) to modify the body along with one's conception of self.

Bulimia and anorexia differ from the other methods for modifying the body in that the behavior is secretive and not for public display. The behavior is not for public display but the result is all about looking thin for the public. For bulimics there is a sin of eating (gluttony) and then a purging of that sin. A high percentage of bulimics and anorexics self-mutilate, which is for public display. Mutilation of this type, usually considered pathological, is what you might call leakage of very deep and painful images, words, or all that stuff that spells rejection to the point of self-rejection and mutilation. As group animals we have an inner need, biologically programmed, to be with others. Symbols are so intimately connected to human survival that we depend on others to transfer these symbols through the generations. Humans have to learn the details of survival. It is through our interaction with these symbol carriers, our family members, friends, mass media, and so on, that we develop an identity. This identity is in large part dependent on the number of positive or negative messages of acceptance from members of these various social groups. Rejection equals death, acceptance equals life, and this is a human biological reality (Rush 1999). Self-mutilation, this leakage, is a message designed to gain acceptance, to indicate that the individual is "cut off" (information loss), or is evil and needs to cut away some "sin" (information removal), and/or that information (acceptance, etc.) has to be added, a "transfusion" so to speak. But the attention itself tends to reinforce self-mutilation, for at this stage there can never be enough attention. One way out of this cycle of repeated mutilation would be to alter the meaning of the acts (self-healing rather than self-destruction).

Self-mutilation studies dealing with what is considered pathological, that is, self-cutting of the arms, legs, face, ears, or removing an eye or testicle, show that these "pathologies" are analogous to socially sanctioned rites and

illustrate how primitive and basic this behavior is. As Favazza (1996:222) comments, socially sanctioned and pathological self-mutilation "serve an identical purpose, namely, an attempt to correct or prevent a pathological, destabilizing condition that threatens the community, the individual, or both."

Most therapies designed to "treat" pathological self-mutilators have not met with success (see Favazza 1996), although art therapy seems promising (see Milia 2000). However, if self-mutilation is an expression of rejection (death) or lack of acceptance from others, then a way out might be to prescribe the symptoms. This therapeutic way of framing the subject refers to "prescribing" or allowing the symptoms (cutting) to be acted out, thereby enacting a sanctioned mutilation ritual designed to bring the person into the group, away from the status of self-mutilator (alone, singular, and dead) and into the world as a respected member of the community. This is unlikely to happen in a medical system where illness (mental or physical) is seen as an individual phenomenon and is treated as such.

Magical Modifications

Tattooing, scarring, piercing, and so on can be a gateway to heaven and protection against demonic forces (see McCabe 2002). Such modifications symbolize allegiance to a group or spiritual force and provide proof of penance (purging) for wrong behavior. We alter our bodies for reasons of beautification or to be accepted and respected for our physical appearance. Whatever the motive for accentuating the skin, all share common ground, that is, the symbol and its magical power to encapsulate ideas for both display and meditation. There is an exhibitionistic aspect to the tattoo, scar, and piercing, as people, for the most part, want to show them off. Ironically, those tattooed often cannot really see their tattoos and it is up to others to do that for them.

In the next chapter I will explore the methods of modification, and in Chapter Three, I will return to the spiritual aspects of body modification reached through pain, suffering, and redemption, which are further explored in Chapter Four.

The Processes of Body Modification

Introduction

Nature is the original source of scarification, tattooing, piercing, and general modification of the flesh on two levels. First, nature through circumstances leaves its mark physically and emotionally when the thorn punctures, the bee stings, the fire burns, the sand scrapes, the rock cuts, when the predator gouges and bites, during gestation and birth (stretch marks, etc.), and through the aging process. Second, we have a natural ability to symbolize, using nature as a reference point, and we can insert these symbols into our bodies purposely and ritualistically, that is, the spots of the leopard, stripes of the tiger, and so on, to counteract our physical limitations. Magical thinking gives us hope.

While attending to wounds, ancient medicine men learned the nature and outcome of deep versus superficial wounds and burns. They would have noticed that when pierced by a sharp stick or thorn, residue on the thorn could remain under the skin as a dot or streak. They would have been aware of infection, healing, and the process of scarring. At some point they learned how to suture wounds with thorns, plant fibers (hemp bark fiber), hair, and the large mandibles of ants teased to bite into skin on either side of a cut, and once the mandible closed, the body of the ant would be removed (Thorwald 1963:211–212). Through observing animals we know that they lick wounds; the saliva can have an antiseptic quality to it, while the repetitive licking can help to dislodge dirt, plant material, and so on.

The Skin

The skin is the most important organ of the body for many reasons, not least of which is that various portions are exposed to view. First, the skin is one of the first lines of defense against bacterial, viral, and parasitic

infection, caustic substances, and mechanical injury. Second, the skin contains special sense organs (pain, pressure, touch, temperature) and sweat- and oil-producing glands. Third, it synthesizes chemicals and hormones.

The structure (Plate 2-1) of the skin is similar to a multi-layered cake. The layer exposed to the elements is the epidermis, through which protrude shafts of hair and sweat ducts. The top layer of the epidermis is called keratin, which is a very strong, waterproof material that flakes off in clumps of cells (rather than whole sections) and shows our relationship to the ancient reptiles and amphibians.

The next layer is the dermis and contains the hair follicle, sweat glands, sebaceous (oil) glands, blood vessels, and so on. Beneath the epidermis is a layer of fat. Cutting into the fat or muscle during scarification is likely to lead to infection, large scars, and slow healing. Skin thickness varies from approximately .25 to .5 centimeters. To give you an idea of the depth of the tattoo needle puncture, take a pair of tweezers and grasp a hair

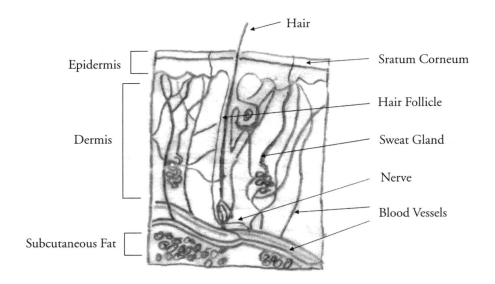

Plate 2-1: Structure of the Human Skin

right next to the skin and gently tease it out. The length of the hair from the tweezers to the end will be about .5 centimeters. As another example, acupuncture needles penetrate to similar depths, that is, .4– .5 centimeters. Tattooing past the dermis will lead to scarring and a bleeding of color into the fat, which blurs the image seen through the skin. Most types of piercing involve placing bone or metal pins or rings through the skin, avoiding the fat and muscle.

Ancient Scarification, Piercing, and Tattooing Equipment

Primitive tools would have included thorns, picks made of bone or antler, and small flint knives (reworked or retouched flakes). We have no skin, hides, or any indication of purposeful scarification, piercing, or tattooing until Paleolithic time, only nature's propensity to teach a lesson and leave its mark (accidents, bites of predators, etc.). Along with the cave and rock art there are some artifacts and suggestions of tattooing dating to the late Paleolithic.

With respect to tattooing, the basic material—either rubbed into the punctures or scarred area or administered during puncturing—was probably charcoal, and charcoal can appear dark blue or green under the skin after many years, especially if exposed to the sun. The description of the Pazyryk burial tattoos (see Chapter One) indicates that "tattoos were applied probably by needle pricks rather than sewing and would have appeared as blue marks on a white skin. The discoloration of the underlying muscle but not the fat layer between indicates that the tattoos were applied when the man was young, prior to putting on weight in middle age" (Pearson 2002:64). Without actual tattooing equipment it is difficult to determine if the pricking was done by hand or if the needles used were hammered into the skin, as is common in Southeast Asia and the Pacific. The hammering method (see below) is probably a more recent innovation and necessary when pushing serrated bone, representing several

needles at once, into the skin to make wider lines or do shading. I might suggest that the instruments used in Southeast Asia and the Pacific are probably analogous to the jaws of specific predators, for example crocodiles and sharks with undifferentiated teeth, if our model for such equipment is nature. We might predict as well that single pricking would be more common in areas where predator birds (the beak) and cats, dogs, bears, or pigs prevail with their singular dagger weapons and differentiated teeth.

It would appear from the Pazyryk burial that the needle pricks went through the skin and slightly into the muscle tissue. I can find no description of secondary scarring from infection, nor do I find a reference to a chemical analysis of the ink to determine if it was charcoal or other plant or mineral substances, although this has been done for identifying pigments in modern tattoos (Baumler et al. 2000). In any event, tattooing equipment amounts to ritual paraphernalia and was probably sacred.

Carbon (charcoal) and iron oxide are the most common materials used in tattooing. Black tattoos can fade into dark blue-green with age. From the description of the Pazyryk tattoos as blue, these nomadic people might have used other substances, possibly *woad* extracted from *Isatis tinctoria.* The Celts processed the leaves with water to obtain a red-brown mixture, and then the liquid was drained off to remove the vegetable material. The red-brown liquid was mixed vigorously with urine (ammonia) and allowed to settle. The liquid was poured off the top and the sediment again mixed with water, shaken, and allowed to settle. This might be done several times to obtain a fine blue-colored sediment, indigo. Although indigo is "[p]ractically insoluble in water, alcohol, ether, and diluted acids" (Budavari 1996:4978), it has antibacterial properties. "The ethanol extract inhibits *Bacterium pneumoniae, Shigella dysenteriae,* and *staphylococcus*" (Hsu 1986:204). We know that the Celts would cover themselves with *woad* mixed with fat (this helps in removing the dye) prior to battle. Having your body covered in an antibacterial paste would certainly be useful, at least with respect to some wounds. Our ancient ancestors were astute

observers of nature, and our adaptation of the constituents in herbs and minerals has resulted in the modern pharmaceutical industry.

Through trial and error, smell, taste, intuition—somehow they realized that you could soak certain plants in water and make a compress, and some plants, like *Isatis tinctoria,* not only soothed the wound but aided in healing. Such a magical plant they would want to keep nearby. Grieve (1992:853) states that, as a medicinal, *woad* has been used "as an ointment for ulcers, inflammation, and to stanch bleeding." The longer the human association with a plant, the higher the probability that the plant would be subjected to inadvertent things, like mischievous girls and boys, as a joke, urinating into mom's fresh-made poultices! How and when these Indo-European people produced this dye, the plant itself had been in use for a variety of purposes for some time. One might imagine how magical it was when our ancient herbalist wrung water and urine from the soaking poultice and his or her hands turned blue!

The cave paintings in France and Spain display two colors but a multitude of shades, from black to grey, and red to yellow. The latter shades are made from iron oxide (ochre), which is yellow when raw and turns red when cooked or heated. The colors can be mixed to form lighter shades, and clay can be added to red to produce brown. These iron oxide compounds have found their way into the cement and stucco industry as coloring agents for exterior surfaces, as well as providing the tattoo industry with coloring agents for the surface of the human body.

The knowledge of mixing pigments had been in the human library many thousands of years prior to the Indo-European time period. Most of the known tattooing from the time of the Iceman to the Ancient Egyptians was done with black, dark green, or dark blue pigments, keeping in mind that black can fade to a blue-green over time. My impression is that one does not find the variety of color in tattoos that is present in the cave paintings because black has a more specific symbolic reference than just the animal it portrays. How should one represent the active nature or personifications of nature, the thunder that stampedes, the lion

and hawk that hunt, and so on? (The Pazyryk tattoos depict mythical animals in movement with legs artistically placed for aesthetic reasons.) These tattoos, at least on one level, represent the hidden and often dark aspects of life, and black is one of those "colors" that represents death; turned outward, it represents the destruction of enemies. Charcoal or soot might have been seen as a magical by-product of fire, the remains of a sacrifice. In some cultures (for example, the ancient Egyptians), black has a regenerating quality, like falling into a black hole and emerging on the other side of something. (Osiris, the Judge of the Dead in the Underworld, is often shown with a black face and hands representing the fructifying force of the Nile.) The ink, when looked at from this perspective, had to be as special as the images it outlined, and I would not be surprised if there were proprietary blends of black ink, trade secrets handed down from generation to generation, just as the exact constituents of ink are still a trade secret in the tattoo industry today.

The basic processes of tattooing are relatively simple, involving a deposit of coloring past the stratum corneum and into the epidermis and dermis of the skin (Plate 2-1). The major differences between prehistoric and contemporary processes would be the sophistication of the instruments and sanitary conditions. A third difference is that most of us are not tattooed by a shaman, who first enacts protective rituals lest malevolent forces enter the holes in the skin, infest the ink, or attack the artist. While tattooing the sacred images, the shaman chants away evil spirits and instructs on the law and morals of the community, impressing with each pin-prick the necessity of being a good citizen. The pain must be endured or it is a rejection of community beliefs and practices, of growing up and entering a community of adults. So you bravely take it, experience an emotional and behavior change, and join the community.

Abrading the skin with a sharp object can be accomplished in a number of ways. A razor blade (stone, bamboo, glass, metal, tortoise shell, human bone) can be used to nick the skin, or grouped needles of bamboo, bone, or metal are tightly bound together and then hammered into the skin

with a mallet. With our modern technology (see Plates 2-27 and 28, page 129) needles are welded together, positioned in a tube resembling a writing instrument, and vibrated up and down with an electromagnet, puncturing the skin to a consistent depth.

What follows is a description of various methods of tattooing and scarring. Keep in mind that the method will be consistent with other cultural factors such as technology, myth, tradition, ritual/religious ideas, etc.

Pattern Cutting Method

Pattern cutting (Plate 2-2a) with a small sharp blade (metal or glass) is a common practice in Africa (specifically, the Tiv and Yoruba of Nigeria, among others). Much of this scarring is done for beautification purposes. The Yoruba, for example (Drewal 1988:83), "elaborate on what already exists naturally on the body, making marks that express Yoruba aesthetic preferences." Looking at the palm of your hand you can see these natural marks. They tattoo for other reasons, including remembrance of a lost friend often done on the face (see Plate 2-2b).

a

b

Plate 2-2: Pattern cutting among the Tiv and Yoruba (redrawn from Drewal 1988:84, 88, by Juliana Correa).

Facial modification for aesthetic reason is common in many cultures. Most North Americans do not see scarification as a form of beautification but readily accept plastic surgery to accentuate or decrease facial features that do not meet our standards of beauty. Instead of the *scar* being the mark of beauty, the scar is only an entrance to modifying fat, muscle, and bone underneath. We now have television programs dedicated to "extreme makeovers" *(Extreme Makeovers, The Swan),* and these programs have large ratings. With scalpels, lasers, suction devices, saws, hammers, drills, and lots of anesthetic, faces are lifted, noses are made smaller and straighter, jaws are shortened, cheeks are trimmed, and so on, so people can put their best face/body forward.

Prick, Lift, and Cut Method

There are numerous groups, especially on the African continent, who practice the prick, lift, and cut method of tattooing (for example, the Tabwa of southeastern Zaire, and the Ga'anda and Gabun of northeastern Nigeria—Plate 2-3). This three-part method of scarring first involves piercing the skin slightly with a bone or metal needle, lifting the skin so that it is now a raised area, and, using a sharp piece of metal (usually a locally made razor blade), nicking the skin and cutting into the dermis. Lifting the skin makes it easier to cut to the desired depth because it is pulled away from the underlying muscle. In most groups soot from the bottom of a pan or ground charcoal is rubbed into the wounds. Cicatrices, or raised areas of scar tissue, result from this type of cutting, with the raised areas representing traditional patterns of ancestral origin. The reasons for tattooing include rite of passage, status, and magic.

Plate 2-3c illustrates both traditional ancestor markings and relationship to this particular ancient tribal chief (the carved wooden figure in Plate 2-3b).

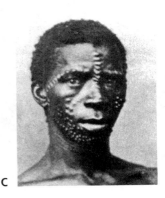

Plate 2-3: (a) A Tabwa woman of Southeastern Zaire; (b) tattooing on ancestral carving showing tribal relationship; (c) Tabwa face scarring. (From Roberts, 1988:42, 46, 47.)

Plate 2-4a shows another Tabwa woman exhibiting her tribal/ancestral relationship. This configuration begins as a line near the base of the spine that extends to the nape of the neck with a left and right line beginning at the inferior aspect of the scapula and extending at a 45-degree angle over the shoulders, with a duplicate of the pattern on the front torso. This would have to be an excruciatingly painful process done over an extended period of time that drives meaning "deeply into the bone" (Grimes 2000).

Pricking Method

The pricking process was the standard method of tattooing in Europe, from the coastal areas in the west all the way to Siberia and south into the Middle East. Modern tattoo equipment is based on this method, which involves pricking the skin (putting small holes in the skin) and either applying the ink at the time of pricking (as with modern equipment) or, after the pattern is set, rubbing in the coloring material.

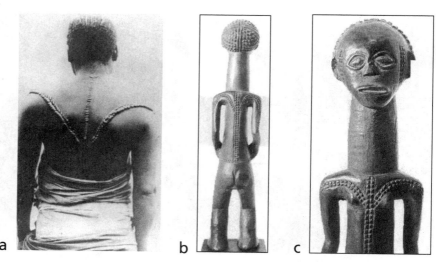

Plate 2-4: (a) Tabwa woman exhibiting her tribal/ancestral relationship. (b and c) The carving's markings mirror those of the Tabwa woman's. (From Roberts, 1988:44–47.)

The pricking method was also the common practice among North American Indians. As Driver (1961:142) comments about the Indians in the Southeast:

> Both sexes were tattooed by pricking the skin and rubbing in soot. The most elaborate designs were worn by warriors and chiefs, who recorded their various deeds in this symbolism. Face, trunk, arms, and legs were all tattooed.

The pricking method is also used on mainland Southeast Asia (Cambodia, Laos, Burma, and Thailand), but the instrument used resembles an old-style ink pen slotted to hold the ink (Plate 2-5c). Plate 2-5a and b represent some of the traditional tattoo designs and positioning.

Facial tattoos are common in many areas of the world but are usually considered to be symbols of gang membership in North America. For the Alorese, who live on the island of Alor located a short distance northwest

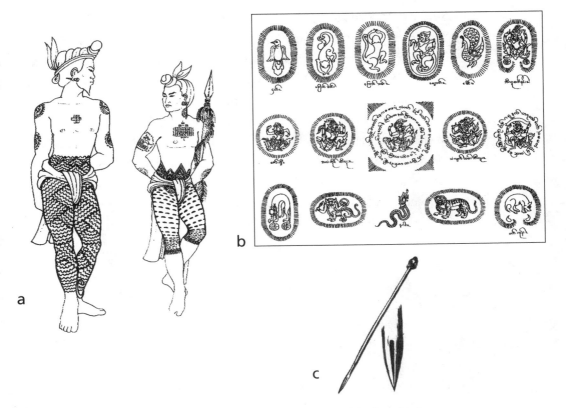

Plate 2-5: (a and b) Traditional Southeast Asia designs and positioning; (c) the tattooing instrument traditional to Thailand and Burma (a and b from van Dinter 2000:97, 98).

of Timor, facial tattoos are a sign of beauty and adulthood. At the end of the dry season, each girl whose breasts are beginning to develop "expresses the wish [to be tattooed] and collects the necessary materials. These are a thorn and finely ground coconut shell charcoal mixed with the juice of banana bark ... The girl lays her head in the operator's lap; a design is first traced on her forehead or cheek and is then pricked in with a thorn dipped in charcoal. The procedure usually draws a number of girls and adult women, all of whom discuss animatedly which of a limited number of simple designs will be used" (DuBois 1961:80–81).

Sewing Technique

The sewing technique, accomplished by pulling a thread blackened with soot through the skin, appears unique to Siberia and the native Alaskan people (Birket-Smith 1959:119). This style of tattooing was usually done on the face, with women receiving specific marks at the time of first menstruation (Gritton 1988:188). In Plate 2-6a and b we see drawings of a woman and man with similar tattoos. The woman, by the way, is wearing an elaborate set of labrets piercing the nasal septum and chin (the labrets are made of bone). Labret cords extend through the lips, rub against the teeth, and create distinctive wear patterns in time, probably an unintentional or secondary modification.

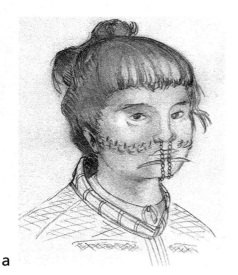

a b

Plate 2-6: Sewing technique unique to Siberia and Alaska (drawings by Juliana Correa). (a) Sewing technique on the cheeks of this Aleut female, along with a lower lip labret and a nose ornament made from strands of beads that hang down over the chin. The beads used (shell, coral, or amber) could be a sign of status. Because they cover the mouth, the beads could have had a medical significance or be intended to protect from evil spirits (a barrier of some kind), but they could have served to hide the teeth or enhance the mouth for aesthetic reasons. (b) Similar tattooing, but in a later period (1888 CE). These tattoos often represented success in the hunt (whales), and in that way they might also signify status.

Hammering Technique

The hammering technique is especially popular in Southeast Asia and the South Pacific (McCabe 2002). This technique involves tapping or hammering the blunt end of a stick into the skin (see Plate 2-7d); attached to it is a piece of serrated bone or bone point. This certainly must be a painful operation, quite laborious for the artist, but it may have actually shortened the process of tattooing compared to the repeated insertion of a single needle by hand. Stories of infections and blood poisoning with this technique are common, not because the technique is bad, but because of the sterility of instruments and work field, and post-tattoo care.

Plate 2-7a features examples of the designs common to Maori face tattooing. Plate 2-7b shows a mummified head with traditional Maori patterns. Contrast this with the fine-line drawing on the legs and buttocks

Plate 2-7: (a and b) Examples of Maori facial tattooing; (c) fine-line drawing on female, Ponape, Micronesia; (d) tattooing instruments (a, b, and c from van Dinter 2000:202–203, 252–253).

of this woman from Ponape, Micronesia (Plate 2-7c). Again, this method of tattooing is a matter of poking holes in the skin in a particular design and connecting the dots. Tools and techniques involved in this process are quite simple. First, draw the lines on the skin with charcoal. Second, dip these "pick-axe-style devices" (the one on top in Plate 2-7d is for fine lines and the one on the bottom for wide lines) into the ink, and third, while holding the handle of the tool, tap on the blunt end with a small mallet. The tool would be moved along the desired pattern using consistent tapping pressure and expert hand-eye coordination. Plate 2-8a is a close-up of young Borneo girls tattooing each other, using the hammering method; this plate also shows some of the tattoo patterns common to that area (Plate 2-8b). In fact, there are so many different variations that extensive cross-cultural influences are apparent. The young woman is having her hand tattooed with a pattern similar to that in Plate 2-8c.

a

c

b

Plate 2-8: (a) Borneo girls tattooing each other using the hammering method; the young woman in the center is having her hand tattooed. (b) Example of some of the motifs; (c) hand tattoo design (b and c from van Dinter 2000:121, 126).

Tortoise Shell Tattooing Tools

The Samoans tattooed extensively, using the types of designs shown in Plate 2-9a through d. One way of recognizing kin at a distance could be through specific colors and types of clothing. The same would be the case for tattoo patterns. As the reader will recall from Chapter One, there is a shift from painting deep in the caves to open-air engravings, and probably more body decorations, especially symbols that identify the wearer as belonging to a particular group.

The tools used (Plate 2-9e) are made from tortoise shell (right) and human bone (left). At the top of this tool is some thread reinforcement, as this was the part of the tool pounded upon, forcing the serrated edge into the skin. There were two sizes: one for large areas and one for detail.

Plate 2-9: (a–d) Samoan tattoo designs; (e) tattooing instruments (a–d from van Dinter 2000:188, 192–193).

The Hawaiians had their own distinctive style of line configuration; it is somewhat less ornate (Plate 2-10a). They did, however, practice tongue tattooing (Plate 2-10b), often when a close friend or relative died. This could mean that, over time, a person's tongue might be covered with dots or dashes. Thus, each time this person spoke, he or she would be symbolically communicating with the deceased as well.

Piercing and Implants

As mentioned in Chapter One, the most common location for piercing is the lobe of the ear. Basic ear piercing takes little technical expertise; anyone can push a needle through the ear lobe. Understanding symmetry and piercing in other areas, however, takes a great deal of technical and artistic experience. Piercing can be accomplished with a variety of sharp pointed instruments, including bone, thorns, fish bones, or needles fashioned out of metal (gold, bronze, iron, etc.). Modern equipment is made from stainless steel (Plate 2-11a). The piercing device (needle) and needle holder are sterilized, the ear is wiped with alcohol, then a cork,

Plate 2-10: (a) Tattoo designs of Hawaii; (b) tongue tattoo (a—from van Dinter 2000:239; b—drawing by Juliana Correa).

Plate 2-11: (a) Modern piercing equipment; (b–e) examples of a variety of unique types of piercing from finger and fingertip to arm, and (e) to cover a scar on the navel (piercings by Matt Bruce).

potato, or cold apple (for example) can be placed in back of the ear lobe, and the needle is pushed through the lobe and into the waiting object. Blood is wiped from the ear then a sterile stainless steel, titanium, or gold ring is placed through the skin. Other metals, like silver and gold- or silver-plate, are not acceptable, as they can corrode. Plate 2-11b through e are examples of unique piercings done by Matt Bruce of Victoria, B.C. Plate 2-11e is of interest. This woman had colitis and went through fifteen operations without success. She never wants to go through another operation and so decided to engage imitative magic, with a continuous over and under suturing technique, to not only close this chapter in her life but to alter the image of the scar.

Eyebrow (Plate 1-12b), tongue (Plate 1-13d), and labial piercing (Plate 1-13b) are done much the same way. There are a number of piercing points on the penis (Plate 2-12), although the Prince Albert is the most popular (Plate 1-13c). Belly button piercing is accomplished by grasping the edge of the skin flap and pushing the needle through skin pulled away from the body.

The purposeful implantation of objects under the skin, not in or through the skin, but between the skin and the muscle (sometimes under the muscle), must be recent in origin and had to await the understanding of sterility. Opening the skin, pushing a bacteria-laden object under it, and then suturing the cut closed would surely invite a life-threatening infection. Most implants are undoubtedly worthy examples of a level of thinking gone far beyond the practical. Many of the implants I have seen remind me of armor, barriers, or even weapons that repulse (Plate 2-13a), as they equally mirror the mechanical or machine man, cold and unapproachable.

On the other side, implants for enhancing lips, breast, buttocks, and thighs are designed to attract interest and to correct those "flaws" we inherited from mommy and daddy. In other words, the implant in Plate 2-13a accents the implant, while the implant in Plate 2-13c accentuates the breast. Our ancient ancestors recognized their flaws as well and tattooed, scarred, or painted themselves in the nature of those superior in

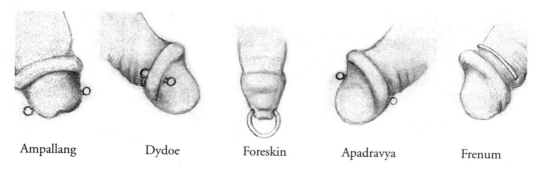

| Ampallang | Dydoe | Foreskin | Apadravya | Frenum |

Plate 2-12: Various penis piercings (drawings by Juliana Correa).

Plate 2-13: (a) Under-the-skin implant on top of bicep muscle, an accentuation of the implant rather than the body (from Mercury 2000:69); (b and c) under-the-muscle implant (before and after) to enhance the breast, a sexual display.

strength, speed, and agility. Although our beliefs about what constitutes flaws and deficiencies have changed over the years, we always use our bodies as the medium of expression. Our bodies present our strengths (and weaknesses) to the world; any body modification that symbolically enhances strength and/or detracts from weakness would have definite survival value. For one thing, it forces a person or a group to acknowledge its weaknesses, and it also allows that weakness to be symbolically overcome by a story or myth.

Penis implants are designed to attract but certainly you cannot expose your penis in the same manner as women display their breasts. In the Middle Ages the cod piece—a piece of cloth laced to the front of a man's pants allowing more convenient urination—certainly drew attention to that part of the anatomy. A number of current underwear manufacturers are making men's briefs with a pouch for that slight bulge look. Males in many tribes around the world dressed with a penis sheath, a tube into which the penis was inserted, and then this tube (a foot long or more) was tied up around the waist. Modern medicine goes the penis sheath one (or two) better in actually enlarging the penis. One method of penis enlargement is the implantation of fat under the skin to enlarge its width. Another procedure is the placement of small plastic pellets in a symmetrical pattern around the shaft of the penis (Plate 2-14).

Piercing takes on special significance in a number of cultures and subcultural groups. The Hindus of India are well noted for their piercing during religious festivals as a means of enduring pain and suffering, removing bad karma, and ending the cycle of death and rebirth.

Plate 2-14: Penis implants. A sharp piece of bamboo or a scalpel is used to cut the skin and insert small (hopefully sterile) plastic balls (such as those used as ammunition in toy guns) in a symmetrical manner around the shaft of the penis. Here the implant is accentuated but, unlike the arm or breast, it cannot be exposed or accentuated in public.

Native American Indians used another ritual, popularly called the Sun Dance, which in some variations (Lakota) included piercing the nipples or skin on the chest or back, hooking a piece of bone through the skin, and tying the two ends to leather thongs suspended from a tall pole (Plate 2-15). A cottonwood tree was chosen for the pole. It would be hit by a particular man (or each of the men), ceremoniously chopped down, and transported to its proper position. Once upright, the pole is made ritually complete with paint, buffalo hide, representations of man and the buffalo, and so on. This is the *axis mundi* around which the universe, in the form of a lodge, was constructed. This pole, then, represents the center of the universe from which all came forth and to which it will all return. The tree under which Siddhartha Gautama (Buddha) meditated for forty-nine days and reached illumination—the Bodhi tree or *Ficus religiosa*—is likewise the *axis mundi*, just like where you are sitting or standing right now is the *axis mundi*. We *are* all "that"; each of us is right at the center, that spiritually illuminated place, but most do not know it.

Plate 2-15: Painting by George Catlin (1796–1872) of the Sun Dance Ceremony showing the warrior suspended by his nipples. The warrior would meditate on the pain and usually have visionary experiences.

Before partaking in the Sun Dance ritual, those who have chosen to do so will fast for several days and dance. This leads to exhaustion, low blood sugar levels, and usually vivid dreams.

> One aspect of the ceremony included piercing the flesh of male dancers who had pledged to undergo the sacrifice. Conducted by a holy man on the final day of the Sun Dance, the process was done in various ways. Mato-Kuwapi (Chased-by-Bears), a Dakota from the Santee-Yanktonai bands, provided an explanation of the piercing of the flesh offerings to the ethnologist Frances Densmore who included it in her publication *Teton Sioux Music.* Mato-Kuwapi stated: "A man's body is his own, and when he gives his body or his flesh he is giving the only thing which really belongs to him." The participants concluded their sacred ceremony with sweat lodge purification. (Hirschfelder and Molin 1992:286)

As Hirschfelder and Molin (1992:284) comment:

> The sacred ceremony is held to pray for the renewal of the people and the earth, to give thanks, to fulfill a vow, to pray for fertility and plenty, to protect the people from danger or illness and for other religious purposes.

The Sun Dance, considered barbaric by missionaries and government agents, was banned in 1893 (although some groups had already stopped the practice), and anyone participating in the ritual was subject to arrest. In 1934, however, the ban was lifted.

The Sun Dance represents a blood and flesh sacrifice. Usually enacted during times of stress—for example, war or the death of a loved one—this act, this sacrificing of one's self, is comparable to Christ on the cross and the dismemberment of Osiris in the Egyptian tradition. From the *Vedas* of the Hindu tradition we learn of the sacrifice of the cosmic man,

Purusha. Purusha had the form of a man but with a thousand heads, a thousand eyes, and a thousand feet.

> The gods and sages came from Purusha, but they pinned his vast body down for a sacrifice. In their rituals, Vedic priests gathered around a sacred fire and made offerings of oil, grain and clarified butter. The practice is explained in the myth: the hymns say that when Purusha was sacrificed, the clarified butter thrown into the fire became the season of spring, the fuel that burned was summer and also the act of offering, autumn. The result of the sacrifice was a great supply of clarified butter, which the gods formed into all the birds and animals that fill the Earth and all the forms of sacred verses known to priests.
>
> Then Purusha was cut into many pieces, from which the entire universe was created: the sky came from his head, the Earth from his feet and the air from his navel. The moon issued from his soul and the sun from his eyes. From his mouth came Indra, king of the gods, and Agni, the god of sacrificial fire; his breath became Vayu, the god of wind.
>
> The four social orders or castes likewise issue from Purusha: the *brahmin* or priests from his mouth; the *kshatriya* or noble warriors from his arms; the *vaishya* or traders and farmers from his thighs; and the *shudra* or servants from his feet. (Loxley 1998:28)

Among the Aztec we encounter a similar creation myth:

> Before the first sun had risen, before the first dawn, the gods assembled themselves at the ceremonial city of Teotihuacán. For four days they performed penances around the central fire, symbol of the divine center. Their sacrifices were intended to conjure the world into being. It soon became clear that a great sacrifice would be necessary to succeed in such an ambitious endeavor. So, in a blissful

moment of inspired self-sacrifice, two of the deities hurled them-
selves into the fire. The gods then halted their rites and looked
around for where the sun would rise, sensing that the immolation
might have been enough to create the dawn. One of the gods,
Quetzalcoatl, faced the east, and there, off in the distance, the sun
rose just over the horizon. Thus the world was made through the
self-sacrifice of two deities, through offerings to the central *axis
mundi*. The first act of Cosmogenesis, of creating the world, had
been accomplished. (Jenkins 1998:28)

A giving of self, a giving back, a personal sacrifice of human flesh, is as
old as culture itself, and whether it is made abstract, as in the wine and the
wafer of the Catholic tradition, or is a more direct enactment as in the
Sun Dance, these are spiritual acts that go far beyond the practical and
reasonable (Western scientific standpoint). They are an attempt to make
contact with that which is everywhere, that from which we all emerged,
and into which we will all return. These rites also make clear that one
person's approach to spirituality is another person's romp with demonic
forces, and still others might just label such rites insane.

Branding and Skin Stripping

Being burned with fire must go back to the early explorative origins of
fire use but was certainly rare before that time. It would have been an
entirely new, unexplained experience around which a story must emerge
and evolve. Many anthropologists once thought that fire was a necessary
cultural component that accompanied *Homo erectus* in their trek out of
Africa some 1.8 million years ago. This assumption, however, has been
brought into question. First, there is little tangible evidence to support
it, and second, *Homo erectus* did not need fire in order to walk out of
Africa. In all likelihood *Homo erectus* left Africa following predators that
provided food.

Fire may have been used like any natural resource they came across, that is, treating fire as something to scavenge. But once you have fire, what do you do with it? Do you burn down a tree or set the savannah on fire? Perhaps it was used at night to keep predators at bay, but that would require keeping the fire burning all night. This means scavenging pieces of wood—lots of wood—and transporting fire when they moved. Primitive humans may have solved these technical issues early on, but one would expect to find more evidence of fire pits depending on what the fire was used for. We cannot assume that, if early people used fire, it was used to cook food, and why would anyone want to do that? What would they cook? There is another problem, however, in that fire alerts predators to your whereabouts, and it becomes a matter of waiting until the fire burns out before predators waltz in and have a meal.

The continual use of fire would require a very intimate knowledge and utilization of the environment, and such might, indeed, have been the case. Wood would have to be experimented with and processed (broken, chopped, etc.). People would have to develop an understanding of the different characteristics of wood, that is, how easily materials catch fire and how long a material burns, especially if you are going to transport fire. In the course of experimenting with these materials, new uses would emerge. No fossilized wooden artifacts have ever been found. Moreover, fire is such an important resource that it would have to go hand in hand with stories or myths of its origin. Most anthropologists are not willing, with the evidence we have, to go as far as perpetual fire use, wood working, and fire myths—any fire myths would require a language or at least a proto-language.

Indisputable fire hearths do not show up in the archaeological record until approximately 200,000 years ago, but it would seem that since our first contact with fire, people have accidentally burned themselves. The earliest use of fire was probably more "spiritual" than anything. Our ancient ancestors could certainly reason that, just as humans are born from other humans, and leopards are born from other leopards, fire is born from the

flickering lights in the sky (sun, stars)—"a child from the sky," perhaps the first sun god, one of the "bright shining ones." Fire has life to it; it flickers and dances and can move from spot to spot. The fire will eventually disappear and either go "back to the sky parent" or "down into the earth" (the underworld), and to prevent its disappearance, it has to be stolen, contained, and tamed with a story.

Outside of accidental burns, purposeful branding or scarification through burning the skin can at least be traced back to the early stratified societies where there were slaves, and proof of ownership was necessary for "proof of purchase." Branding in this case represents the symbolic binding of one person to another, and, of course, not all societies valued human life as something to be bought and sold against the person's will. Besides the concept of ownership or punishment, branding could have served all the purposes listed for tattooing and scarification in general.

The ancient Egyptians branded cattle as well as human flesh. Branding of human flesh was also done by the Greeks, Romans, Mayans, Aztecs, and other cultures where people were property and required a mark as proof (especially in urban areas where individuals are more anonymous and can slip in and out of the crowd). Right alongside branding for ownership purposes was its historical use as a form of punishment, leaving a sign for all to remember. Contemporary branding, in some cases, carries a similar proprietary message and is often combined with a message of submission. In most cases, however, branding holds the same symbolism as a piercing or tattoo, being a mark of some change or transition in the life of one branded. Human branding irons can be similar to those used on cattle (usually much smaller). Or stainless steel wire or metal sheets of various sizes can be bent to a desired shape (Plate 2-16), heated, and pressed against the skin; this is called strike branding. With the invention of the cautery pen, which has a thin, red-hot tip, fine-line drawing is now possible. Depending on the skill of the artist, brands can last a period of several years to a lifetime.

Plate 2-16: Branding and skinning instruments. (a) Propane torch, vice grips, and star (the intended design for "strike" branding); (b) cautery pen (electrical) with a red-hot tip for drawing the fine-line brands or branding into previously tattooed work to create special effects; (c) scalpel used to strip skin. (Photos provided by Matt Bruce.)

Branding actually has some advantages over scarification and tattooing, though these were more significant in the not-too-distant past than in today's germ-phobic world. The first advantage is that the heat sterilizes the instrument, cauterizes the skin, kills bacteria, and the burned flesh acts as a bandage—as long as the area scorched is not too great or too deep. A second advantage is that branding is a quick procedure requiring little preparation. Plate 2-17 shows examples of branding. A major difference between branding and tattooing is that in branding it is good to agitate or pick at the scabs that cover the scar, while in tattooing one should avoid picking at or agitating the scabs.

For those not into heat and branding there is always skin stripping (Plates 2-17d and e). Skin stripping hasn't changed much since it was introduced as a technique of punishment and torture thousands of years ago. Quite simply, you peel the skin off the body in some sort of pattern. The peeled areas scab over as they do in branding or tattooing. Healing in scarification, branding, skin peeling, and tattooing can take a month or so and up to two years.

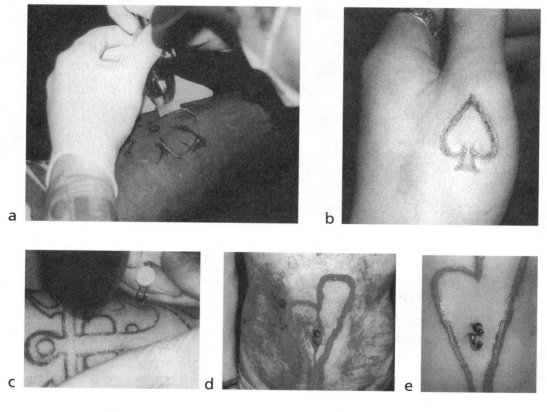

Plate 2-17: Example of brands. (a) Strike brand on already-tattooed skin; (b and c) cautery pen brands; (d and e) skin stripping. (Branding and skin stripping by Matt Bruce.)

Mouth/Lips and Tooth Modification

There could be no more diametrically opposed ideas of beauty in Eastern and Western cultures as there are in regard to mouth and teeth displays. Characteristically in the West the lips are accentuated in shades of red (and other colors, like black for Gothic), either applied on a day-to-day basis or made permanent (tattooed). Usually the color does not go beyond the upper and lower edge of the lip proper.

As a starting point for the West, the ancient Egyptians, at least those depicted in figurines, statues, and paintings, spent a great deal of time on physical appearance. Head hair was a problem because of recurrent lice infestations, so men often shaved their heads and women cut their hair short and wore wigs. There have been suggestions of hair being connected to magic properties (as in the Samson myth) and erotic impulses.

Face makeup was worn by both males and females in ancient Egypt, with *kohl*, a fine paste made of lead sulfide (galena) mixed on a slate palette, applied under the eyes of males working outside, while females used *kohl* on eyelids, brows, and for accentuating the eyes in general. *Kohl* is the Arabic word for this black eye makeup used in Egypt since at least the time of the Old Kingdom; it has replaced the Egyptian words *smet-t, stem-t,* and *mestem-t* (this term also refers to a substance used in medicine). Lead sulfide was mined near the Red Sea, and the use of makeup, as evidenced by cosmetic palettes made of siltstone from the Black Mountains of the Wadi Hammamat east of Luxor and adjacent to Quseir on the Red Sea, can be traced back to 5000 BCE (historic times for the Egyptians do not begin until approximately 3000 BCE). "From as early as 5000 BCE until the First Dynasty some 2,000 years later, palettes were popular at all levels of society. They reflect the prehistoric Egyptians' love of ornament and display" (Wilkinson, 2003:91). The early palettes were simple rectangular pieces of slate, but during the Naqada I period (4000–3500 BCE) they became quite elaborate (Plate 2-18a).

Makeup went way beyond *kohl* and included paints made from a wide range of material for creating different colors or shades, with blue from powdered lapis lazuli, reds and browns from ochre, and black from charcoal or copper oxides. The lips and eyes are considered zones of erotic attraction, and Egypt may claim the distinction of being the first culture to use lipstick. Using red lip coloring is thought to imitate the vaginal lips, as they engorge with blood and become pink or red during sexual arousal.

On the down side, however, after many years of eating bread containing high levels of grit (from the grinding stones and desert sand), there were numerous dental problems, including cavities and gum disease along with bad breath, which was covered up by chewing myrrh.

As a comparison, during sixteenth-century England, face makeup became a mark of status. White lead-based paints were used to create a pasty-white complexion with red lips, a sign of being indoors and not doing manual work (Plate 2-18b). During the Elizabethan era many indi-

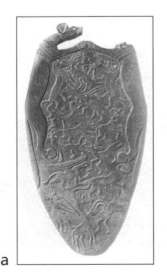

a b

Plate 2-18: (a) Palette for mixing makeup, Naqada I period (4000–3500 BCE); (b) Elizabeth I, *The Pelican Portrait,* Nicholas Hilliard c. 1572 (Walker Art Gallery). Note the idealized pasty white face and hands, signs of nobility showing that one didn't engage in manual labor.

viduals of the court were slowly poisoned through the use of these lead-based products, which turned the skin gray over time.

In our own time women use artificial blush on the cheeks (both as a signal of innocence and for sexual arousal) and lipstick. Fat, pouty lips are currently popular, and medical techniques are available for inserting fat into the lips in an attempt to emulate a certain ideal which, again, is seen by some as an imitation of vaginal lips engorged with blood, although others would say it is simply for aesthetic reasons. Whatever the purpose, the coloring attracts attention.

The ideal in the West, at least since Egyptian times, is the accentuation of lips and eyes, but in the West teeth should be white and straight, with the white symbolizing health and cleanliness, while straight teeth represent an ideal of order and the correction of nature's flaws. Tooth straightening in the West is most often seen in middle- and high-school students (Plate 2-19a through c). The procedure is usually a long-term (and costly) process requiring that the individual return to the dentist at regular intervals to tighten or loosen braces. Filling in cavities, the removal of old mercury-based amalgam fillings (which darken with age), and the construction of dental bridges or plates are all commonplace attempts to maintain an aesthetic smile. White straight teeth, however, is not the ideal in many Eastern cultures.

Among the Alorese, both tooth blackening and filing are the norm for aesthetic beauty (Plate 2-19d). Tooth blackening occurs during adolescence and is accomplished by placing on the teeth dark soil mixed with:

> a fruit resembling a small green fig. The resulting paste is smeared on a strip of banana bark which each child cuts to fit the size of his mouth. The preparation of each day's supply takes the better part of an afternoon. For at least seven nights, and often ten, the children sleep together in a field house, with the paste held against their teeth by the flexible bark strips . . . On the last day or two of the period those who are to have their teeth filed go through the ordeal.

Plate 2-19: (a–c) Before and after shots of tooth straightening in North America, beginning at age nine and completed at age fourteen; (d) among the Alorese, both tooth blackening and filing are the aesthetic norm. With the incisors and canines filed away, the tongue protrudes through the teeth. (Redrawn from DuBois 1961, by Juliana Correa.)

The same person who prepared the dye usually does the tooth filing. The subject's head is laid on the thigh of the operator and wedged against his side with his elbow. The jaws are propped open with a piece of corncob. The six upper and six lower front teeth are then filed to half their length with an ordinary knife blade which has been nicked to resemble a saw. Apparently experience makes it possible to avoid the root canal . . . The whole operation takes about

two or three hours . . . It is undoubtedly painful but, as in tattoo-
ing, it is bad form to admit it. The result of this filing means that
even when the back teeth are occluded, the tongue will show pinkly
through the gaping front teeth when a person smiles. This is con-
sidered definitely attractive. (DuBois 1961:83–84)

Tooth filing and staining is common in Southeast Asia, but in the New
World tooth modification and staining are historically reserved for particular
classes of people. Among the Aztecs, for example, "one cosmetic was pro-
hibited to the respectable: the reddening of teeth with cochineal was iden-
tified with the vulgar and the sexually dissolute. Prostitutes, with no such
inhibitions, habitually stained their teeth" (Clendinnen 1991:193).

At the time of the Aztecs there were numerous surrounding groups
who treated their hair and teeth quite differently. In the province of
Oxitipan, a conquest of the Aztecs, and referring to the Huaxteca: "They
filed their teeth (so they took the shape of gourd seeds) and colored them
black" (Berdan and Anawalt 1997:141). According to Franciscan Fray
Bernardino de Sahagun, who gives us firsthand documents of Aztec cus-
toms, the Aztecs saw the Huaxteca as "defective" (Dibble and Anderson
1974:186):

The defects of the Huaxteca: The men did not provide themselves
with breech clouts, although there were many large capes. They
perforated their noses with palm leaves. And when they were
enlarged, they inserted there a gold palm leaf stem, or a reed from
which emerged a red arara [feather]. They filed their teeth; they
darkened them with red or with the *tlamiaualli* herb.

The Mayans also practiced tooth modification (Plate 20a and b). "Teeth
in the Maya area were 'decorated' by filing the incisal edge of incisors
(also occasionally canines and premolars), drilling shallow holes for inser-
tion of jadeite or iron pyrite on labial surfaces, engraving labial surfaces,

Plate 2-20: (a and b) The earliest dental decorations found in Middle America were discovered at Cuello (Early Bladen 900–800 BCE—redrawn from Saul and Saul 1997:45); (c–f) examples of jade inlay, Pre-Classic (100 BCE to 300 CE) to Late Classic Maya (300 CE to 700–900 CE). Also note the cranial deformation (e), especially the frontal bones. (Photos c–e are from the Regional Museum of Anthropology, Merida, Yucatán, 2004; photo f is from the National Museum of Anthropology, Mexico City, 2004.)

or a combination of the above … The earliest dental decoration to be found at Cuello (and perhaps in the Maya area, so far) appears in an Early Bladen (900–800 BC) female" (Saul and Saul 1997:45). Also note the jade inlays in Plate 2-20c, c2, d, and e. Plate 2-20d shows inlays (jade has fallen away) and skull deformation. Note the flattened frontal bones, accomplished by laying a board across the forehead of this person when just an infant in a vice-type arrangement. As Fray Diego de Landa comments (2004:87–88):

The Indian women raised their children very harshly and kept them completely naked. For four or five days after the child is born, they laid it face down on a small bed made of rods and put its head between two boards: one over the back and one over the forehead. They bound these and left the child there suffering until after a few days the head was flattened and shaped in the way they all had them. The pain and danger was so great for the children that some almost died, and the present writer saw the head of one burst open behind the ears; the boards must do this to many.

Through an analysis of tooth enamel, there is some justification in speculating that tooth modification among the Maya occurred during a similar time frame as the Alorese, that is, sometime in the early teens. The differences lie in the types of modifications, which include notching incisors in characteristic patterns rather than filing the teeth in straight lines. During the summer of 2004, my wife and I drove throughout Mexico visiting various temple sites and neighboring towns. In both the cities of Oaxaca and San Cristobal there were numerous examples of silver inlays in the incisors of indigenous Mayan peoples, mostly female over the age of forty. These ladies sell handmade garments (hats, embroidered dresses and skirts, shawls, and so on), like to smile, but do not like their pictures taken. On the other hand, we saw more than a few young Mayan females, ages fourteen to twenty, wearing braces to straighten teeth!

Lip modification, as mentioned, was and is accomplished by applying paint to the lips, usually not exceeding the edge of the lip proper. Permanent makeup has become popular in North America, which includes tattooing eyebrows, eyelids, and lips. Lips (usually) are tattooed to the edge in the West, but in other cultures the edges of the lips are exaggerated.

Accentuation of the mouth, however, takes on a new dimension among the Ainu on the northern Japanese island of Hokkaido (Plate 2-21a). Though not practiced much today, as there are few Ainu left, women would enlarge the outline of their lips by tattooing way beyond the margins,

resembling the lips of a clown, blue-black in color. This process began in childhood and was complete by the time of marriage, with lips extending back to their ears. The purpose of this symbolic enlargement was to protect from evil spirits and was not purely aesthetic or sexual. The mouth is both a creative (through speech) and destructive symbol (through chewing). In Hindu mythology deities such as Kali, the destroyer goddess, are shown with a large gaping maw, protruding tongue, and canines dripping blood (Plate 2-21b). The Ainu turn this around so that the evil spirits see the living as devouring forces to avoid. Moreover, it could also be understood that it is through the mouth that one contacts and manipulates the spirits, and a larger mouth has a larger voice.

a b

Plate 2-21: (a) Ainu women on the Japanese island of Hokkaido enlarge the outline of their lips by tattooing way beyond the margins, resembling the lips of a clown, blue-black in color. (b) In Hindu mythology, deities such as Kali, the destroyer goddess, are depicted with a large gaping maw and canines dripping blood. In her left lower hand she holds the severed head of her consort, Shiva.

Head Deformation, Hand Mutilation, and Foot Binding

The aesthetic takes many forms, one of which is head binding for the purpose of deforming the skull (plagiocephaly). Skull deformation can happen naturally during gestation, especially if large fibroid tumors are present in the womb, and unintentionally by binding a child's head too tightly in a scarf, hat, or to a cradleboard. In some manner or other (most likely the by-product of another behavior), skull deformation became a ritual behavior in many societies in diverse areas of the world. The ancient Egyptians were once thought to have practiced skull deformation but this is more likely a problem of "artistic rendering" (Hornung 2001) of images on walls and tombs at the time of Akhenaten (ruled from 1353–1335 BCE). In Plate 2-22 we see Akhenaten and his wife Nefertiti and their children with artistically rendered deformed heads. This type of body modification (rendered in art, not the actual body), unlike the modifications of photos of models in modern magazines for sex appeal, is, in part, a statement of ego, of Chakra Three in the Kundalini Yoga system (see Chapter Three), and of winning and possessing. Akhenaten, it would seem, saw himself as the Sun God, Aten, just as the Pharaoh was the living son of Re. He also banished the Theban priesthood, banned the worship of any other gods, and eliminated all competition to his power.

These deformations, however, represent a visual interface with "that," the Aten, the energy of the universe, and this could be seen as a spiritual act. There is an idea here of *tat tvam asi,* or "I am that" energy. We interpret those rays of the Aten coming down to just Akhenaten and Nefertiti (from an artistic perspective the rays cannot extend to the children), but might that not symbolize "the family" or anyone who worships the Aten? A great many people followed Akhenaten to el Amarna, some out of pure loyalty who quickly converted back to the traditional system when he died (or left). But to many more he must have sold some rendition of "new heaven, new earth," a new age where you bypass all

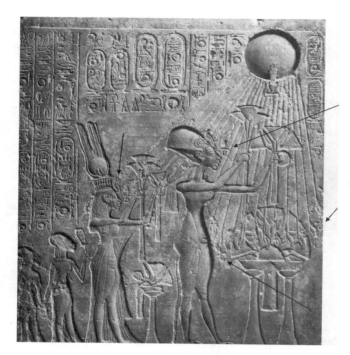

Plate 2-22: Akhenaten and his wife Nefertiti and two daughters with artistically rendered deformed heads (limestone altar stela, Amarna period). All of the rays of the Aten do not end in a hand with an Ankh, just those that come down to the faces of Akhenaten, Nefertiti, and to a position near Akhenaten's genitals-thus, perhaps, bringing life to sexuality and rebirth. There is another Ankh in a hand, probably to balance the image (limestone slab cut from larger piece, Eighteenth Dynasty, Amarna period, now residing in the Egyptian Museum, Cairo).

the gods and goddesses and go right to the top; the Aten listens to all. If you count the rays of the Aten containing *ankhs* you will find four—one in front of Nefertiti at the level of her nose, one in front of Akhenaten's eyes, just a little above his nose, and one in front of his genital area, which artistically and symbolically balances or amplifies the lotus to the right of his right leg. The fourth ankh is all the way on the right, appearing to be in the same line as the genital ankh and lotus, and the palm of the hand holding the ankh is turned toward Akhenaten, but it may be there simply to balance the image. Numerous *ankhs* can be found within the hieroglyphs above the figures. Note the similarities in the body shapes of Akhenaten, Nefertiti, and their children.

An analogy to Akhenaten's deformities might be seen in Plate 1-3c, *The Immaculate Conception* by Zurbaran (1598–1664), wherein life flows from the Mother of God (the Earth Mother) as it does from the energy of the Aten—both symbols of the energy that pours forth the bounty of

life in all its forms. In the Christian tradition Mary's sexuality had to be covered up and stripped away; there can be no connection between sex and spirituality. Sex is nature; nature is corrupt and needs correction.

Returning to Akhenaten, Aldred (1996:173) comments,

> Although Akhenaten encouraged no change in the conceptual view of reality that Egyptian artists had cherished since the Archaic Period, some idiosyncratic distortions were introduced, undoubtedly at his promptings, in the portrayal of the persons of the king, his chief queen, Nofreteti, and their daughters; and even these traits tend to be moderated in the later years of his reign.

The practice of head deformation is found throughout ancient Europe and remained a practice,

> especially in Holland and France, until the middle of the nineteenth century. . . . In Normandy, handkerchiefs were tightly and painfully wound around the heads of children. Because these constricting bandages were rarely removed, they served as breeding grounds for lice and many of the children developed skin ulcers. In regions of Limousin and Languedoc the molded heads of women were quite distinctive; the molding was caused by tight-fitting bonnets that produced a pleasing head shape and supposedly enhanced the development of those parts of the skull linked with intelligence and memory. (Favazza 1996:86–87)

In the latter cases at least the skull binding was done not simply for aesthetic reasons but ostensibly to improve the intellect.

Skull deformation was practiced by many groups in the Americas, including civilizations that flourished in the Late Formative (Paracas 100–300 CE) and Early Classic (Nasca 300–500 CE) periods in Peru. The purpose here may be aesthetic but more likely represents a sign of status.

An even more ancient people, the Chinchorro of Chile (7000 to 2000 BCE), likewise practiced head binding.

> As ornamentation for the head, the Chinchorro children and adults wore headbands made of thick multiple camelid fiber yarns. The tight headbands worn during infancy created a circular depression around the head in the still-malleable bones, producing a permanent skull deformation of annular shape, lasting throughout the individual's life. The cultural practice of elaborate artificial skull deformation became commonplace in later agropastoral communities from this area, with all kinds of shapes and even increased height of the skull. Thus, the local origin of annular skull deformation may be traced back to the Chinchorro culture to about 2000 BC when headbands became evident. The Chinchorro people did not practice any other modification of the head, such as perforated ear lobes, as did later agricultural groups from Africa. (Arriaza 1995:63–64)

With the Chinchorro it would appear that the head deformation may have simply been a by-product of using tight-fitting headbands, in a similar manner as occipital head flattening results from the use of cradleboards. Many North American Indian groups used cradleboards, and in temperate climates infants spent a great deal of time trussed up with the back of the head pressed against the board. Referring to the Northwest Coast, Driver (1961:138–139) makes the following comments.

> Intentional head deformation was practiced in the central part of the area and was of two types: compression of the forehead and back of the head by binding to a cradle board; compression of the entire head in a ring above the ears by binding with hide or flexible plant material. The heads of slaves were not deformed, and this provided a ready way to distinguish them from a free man. In the northernmost part of this area head-binding was not practiced, but

slaves who had been obtained by capture from the south usually had deformed heads. Thus the rules of identification were reversed.

Regarding the Indians of the Southwest, Driver (1961:142) states: "The head was intentionally deformed by pressure from a bag of sand or a buckskin-covered block of wood applied to the heads of infants. The cradle board was hollowed out slightly to receive the back of the head, and the infant lay on its back on this board with its head lower than its body and bag or block pressing on its forehead."

Usually cradleboards are quite elaborate and painstakingly crafted by the mother or a group of women villagers who present it to her as a gift, a form of symbolic protection, a womb outside of the womb, so to speak. Cradleboards may have started off being magical or simply practical devices during family transport or when it was necessary to free up another hand. In any event, they first show up among the Anasazi (Southwest United States) around 1000 CE and probably evolved from slings or nets combined with the idea of a bed or nest.

Hand mutilation, whether purposeful or intentional, is illustrated in hand prints from Gargas Cave, Southern France (Plate 2-23), dated to approximately 25,000 BCE. Clearly the distal phalanges of the index and second finger of the left hand are missing in (a) In the second image (Plate 2-23b) it appears that the distal phalanges of the first three fingers are missing. Again, it is impossible to determine if this was purposeful, the result of an accident, perhaps frostbite necessitating their removal, special hand signals, or other "artistic" rendering.

Hand mutilation is found in many societies, past and present, including the Dani tribes of New Guinea and numerous African groups. The Dani live in the central mountains of West New Guinea. Among these people the women tend the pigs and gardens, and although the young unmarried men may work very diligently clearing the land, the male occupation is that of warrior. These people are in a constant feud with neighboring tribes. "[D]eaths caused by illness, age, or accident are less important

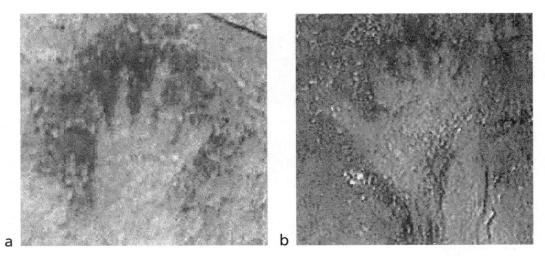

a b

Plate 2-23: Hands with what appear to be missing digits, but other researchers suggest that these are perhaps hand signals (Gargas Cave, Southern France, 25,000 BCE).

than those resulting from enemy action" (Gardner and Heider 1968:93). When warriors die they become ghosts, and because people die on both sides, the ghosts wage war with the living; in short, ghosts need to be placated. Part of this ritual appeasement involves lopping off the fingers of the deceased's female relatives. The caption to picture 253 (Gardner and Heider 1968:100–101—see Plate 2-24) reads as follows:

> These young girls with bandaged hands have just lost one or two fingers early on the second day of the funeral ceremony. After the hand has been numbed by a blow to the elbow, the fingers are chopped off with a blow from a stone adze. Like pigs and shell goods, the fingers are gifts considered necessary to placate ghosts. Although nearly every Dani girl loses several fingers, as a woman she does a wide range of work, from gardening to making nets, with great manual skill.

Plate 2-24: Young Dani girls (New Guinea), after fingers have been removed in honor of deceased relative to ritually appease ghost (Gardner and Heider 1968:100–101).

I think it safe to say that by the look on these little girls' faces, this was not a spiritual act to them, and it may or may not be understood as such for many years to come.

In Africa we encounter numerous groups who practice finger mutilation for a variety of reasons. When a Xhosa child (South Africa) is ill, a finger joint might be removed as a treatment method. For Hottentots an amputated finger signals engagement or marriage.

> In West Africa finger amputation was sometimes performed on corpses. If the deceased had been impotent, his little finger was cut off and inserted in his anus to horrify the dead man so much that his spirit would seek reincarnation as a woman so as to have children in a new life. (Favazza 1996:133)

On the other side of the world and referring to the Maya of southern Mexico, northern Guatemala, Belize, and western Honduras:

New research sheds light on the cruel fate that awaited official scribes for Maya kings who had been conquered by rivals. These scribes—the rough equivalent of today's public relations writers—would have their fingers broken and then be executed after their kings were defeated in battle. "The conquering Mayas were not interested as much in the executions as they were in this seemingly bizarre practice of destroying the scribes' fingers," said Kevin Johnson, assistant professor of anthropology at Ohio State University.

"By breaking the fingers of scribes, what they were really doing was muting the ability of scribes to write politically powerful texts for their defeated kings." (Grabmeier 2001)

Obviously finger mutilation among the Maya is less than a spiritual act but serves to show how powerful symbols can be, especially when influencing public opinion.

For modern-day finger mutilation myth one need only turn to Tolkien's *Lord of the Rings* series, *Fellowship of the Rings,* where, in the beginning, when rings of power were cast and given to the elves and dwarves of Middle Earth, one ring was cast clandestinely by Sauron, a ring that could control the others. This ring is removed from the index finger of his *right* hand when his finger is chopped off by Isildur after Sauron kills his father. Through that act the energy of the universe (concentrated in the ring, with Sauron as its vehicle of release) is discharged into the world, where it is capable of doing good or evil, and with this release of energy, the story begins. An ending of one time and the beginning of another is accomplished by an act of violence, as was the case when the two Aztec gods threw themselves into the sacrificial fire so that the world would begin. The Aztecs needed a second sacrifice, however, in order to get this creation moving and creating. The second sacrifice involved all the gods.

In the final episode of the series *(The Return of the King)* there is another finger sacrifice, this time by Frodo Baggins. Frodo is the Bearer of the Ring and has second thoughts just as he is about to destroy it in the sac-

rificial fire (Mount Doom). Instead, he places it on the index finger of his *left* hand (recall that the ring was removed from the right hand of Sauron). But this was to be short-lived, for Once Smeagol, now Gollum, jumps on Frodo, bites off his finger, removes the ring, and then he and the ring fall into the volcano. As the ring melts, Sauron's citadel collapses, Mount Doom erupts, and the energy of the ring's destruction is released into the world where it creates a balance of power. As the mountain disintegrates, our two heroes (Frodo and Samwise) take their leave, are rescued, the king is returned to power, and balance is established. This sacrifice represents the completion of a round where justice prevails and order is restored.

Mutilation can take many forms but all permanently change the body. Foot binding was practiced in China from approximately 1000 CE until it was outlawed in 1910. No one knows the exact origins of this type of deformation but somehow it caught on as a sign of beauty, submission, and erotic fantasy for men. Foot binding of this extreme nature is found nowhere else in the world, but we do see (as mentioned in Chapter One) unintended foot modification in the case of all ill-fitting and impractically "stylish" shoes in the West. High heels and pointed-toe shoes have deformed the feet of many American women.

Weightlifting and Yoga

Overall body sculpting is best expressed in the sport of bodybuilding. The goal of bodybuilding is to develop some overall "perfect" expression of the human body, bulging and ripped, frozen in movement. Weightlifting and bodybuilding hover around two ideas—health and aesthetic appreciation of the body. The display of bulging muscle is a display of health, strength, and ego. This type of physique, though, is not considered ideal in many areas of the world. The Nuer, Masai, and Dinka of Africa, for example, prefer the ideal male figure to be tall and very thin, and among native Hawaiians, heavy but less sculpted. Bodybuilding is an outward

expression of an inner need to turn the ego *outward,* to be admired and accepted in much the same way that women seek when they acquire large breasts through surgical implants. Turning that ego *inward,* however, can likewise lead to body modification.

Hatha yoga practitioners share a similar interest in health and body aesthetics; the similarity ends there. Yoga is primarily mental sculpting, using the body as a point of meditation or as a mechanism for correcting years of improper use of one's physical and mental self, thereby returning the body to its natural, perfect condition—to its symbolic "source." At the same time the yoga workout cleanses the body of toxins, not just from unhealthy foods and drugs, but unhealthy or "toxic" thought patterns and behavior as well, for it is not enough to simply exercise the body.

This type of yoga is often attributed to Patanjali, who lived in India around 200 BCE, but it undoubtedly predates Patanjali by a thousand years or more. The postures in Hatha yoga and the philosophy surrounding this behavior developed over the course of many centuries. However, the act of standing or sitting in uncomfortable postures may have originated as a method of doing penance either on one's own (working off karma) or at the behest of the community for some infraction of the law. The goal of doing penance is to cleanse one's self of a thought and/or behavior.

Standing on one leg while the other is thrust back, arms thrust forward, the chin held up, for long periods of time, is painful, greatly increases heart rate, and can lead to dizziness and nausea. In Bikram Yoga this is called *tuladandasana* or "Balancing Stick Pose." The pain and discomfort experienced in this and in most poses in this system are a form of cleansing, with the pain experienced as a sacrifice. With continued practice of the postures, less pain and discomfort are experienced, and muscles and tendons stretch and the skeletal system realigns. Any emotional pain connected to these muscles (muscle memory) can likewise be purged.

As one continues in the practice, the instructors talk about bad habits

and how your body devolved to its dilapidated condition. You are purging your harmful lifestyle, and pain and discomfort are a necessary part of the process. Again, the pain and discomfort serve to remind you of the ways you abused your body. The physical pain puts you in touch with emotional pain, and as the physical pain subsides the emotional pain subsides as well, and health (both physical and mental) returns.

During the early development of Hatha Yoga, certain health benefits were recognized *as well as the ability to focus the pain and discomfort inward to sculpt the mind and remove fear and desire.* Practitioners could recognize that the mind is not the body; they separated the illusion of the world, *maya,* from the real world. Pain is difficult to ignore, but by reducing all unnecessary muscle tension one can decrease the pain and discomfort. Stress (pain/discomfort) and relaxation are essential ingredients for entering a trance state and/or having an out-of-body experience, visions, and so on, which are enabled by yoga and other traditional healing practices.

But yoga does more than sculpt the mind, for through stretching muscles and tendons and stimulating organs, combined with concentrated breathing and profuse sweating, the outer appearance of the body changes as well. Fat and toxins are lost, bulky muscles become long and thin, and over time (assuming regular practice and a diet high in fruits, vegetables, and nuts, and low in flesh and refined foods), the body becomes thin and highly flexible, the ideal (it would seem) in the Hatha yoga tradition.

Our super-heroes in the West (Superman/Superwoman, Spiderman, Hulk, and so on) change the nature of their bodies when they are properly uniformed. Superman, once in his warrior garb, becomes unrecognizable as the "mild-mannered reporter" Clark Kent. In the case of the Hulk, changes occur when the hero is brought to anger, an anger that is difficult to control. Here modification is caused by the forces of nature ("improperly" applied) and not by the State or as a result of one's free will. This represents a reversion to our animal nature, neither good nor evil, but certainly large and powerful.

Scarification in Hell

Here is an example of a scarification or tattooing in Hell (Plate 2-25), perhaps better called engraving. This was taken at Ghost City, Fengdu, on the Yangtze River, China. The city of Fengdu has been underwater since the damming of the Yangtze, but fortunately Ghost City is up on the cliffs and should be safe—for a while.

Even in death one cannot escape torment to the body. Ghost City is a temple complex representing ideas from Confucianism, Daoism, and Buddhism, but the representations of Hell come from Buddhism. The Four Kings of Hell find their counterparts in the Four Diamond Kings of Heaven, who guard the Register of the Living and the Dead. Yama, the Hindu ruler of the dead, becomes Yan Luo, overseer of the Fifth Court of Hell. The point is that in death the harsh realities of one's behavior in life must be purged with pain and suffering, be this scarification of the flesh,

Plate 2-25: (a) Scarification in Hell, Ghost City, Fengdu, China (photo taken by the author, 2002. (b) Hell demons torturing wicked souls (from postcard, Fengdu, China).

a

b

perpetual beating from thuggish demons, or dogs grabbing and ripping at one's flesh.

Upon exiting the Domain of Hell at Ghost City (with proper passports) you walk past a room where there are assembled small models of the most horrific tortures imaginable. Although I could not take photographs because of the reflections on the glass and wire mesh, images displayed in Plate 2-25b, taken from the bottom of a postcard, show much of it. You see people being ground up, boiled in oil, frozen to death, forced to ingest molten lead, burned at the stake, limbs cut off, and so on. Make no mistake; these were real-life punishments, not just figments of the imagination, and such acts still occur in a number of places in the world today.

Modern Tattooing and Piercing Equipment

One of the standard questions asked about tattooing is, "Does it hurt?" All tattooing hurts, and tattooing in some areas is more painful than others; no two tattooing sessions are the same. What people really want to ask is, "What was the pain like?" or "What was your experience?" The pain can be experienced in a number of ways depending on the area of tattooing and one's mental ability to moderate or accentuate sensations. If tattooing is used for cleansing or purging guilt, sin, and historical trauma, one might want to go as deep as one can into the pain (see Chapters Four and Five). Or, to lessen the experience of pain it's possible to relax into it, which can lead to disassociated states (trance, hypnosis, out-of-body experience).

Modern tattooing equipment emerged shortly after the invention of the light bulb. The first electric tattooing machine was patented in 1891 by Samuel O'Reilly. His idea was apparently the offshoot of an invention by Thomas Edison that used a needle to poke holes in paper.

Europe, the United States, and most industrialized areas of the world use commercially made, electric-tattooing tools or instruments ("tool" is primitive and "instrument" is civilized). In Plate 2-26 you can see the

Plate 2-26: Modern tattooing instrument

major components: the electromagnet and the needle bar, which hooks to the armature bar and is inserted in a proper needle tube. The rubber bands maintain tension on the needle to keep it steady in the needle tube.

The needle tube is dipped into the ink, which flows up into the needle tube and is pulled out as the needle is vibrated in and out by the electromagnet—resulting in impregnation of the skin.

The needles (Plate 2-27) are soldered onto a bar, of which there are two general types: one that is linear and one that has dovetailing on the end—this is called a shader bar. The linear needle set-up is for line drawing of different thickness, while the shader is for shading.

Plate 2-28 shows the set-up with ink in ink holder, along with a scoop of A & D Ointment, which is rubbed onto the skin to inhibit bleeding and allow the needle tube to move effortlessly over the skin. Tattoo ink is composed of inert materials (for example, charcoal), but the specific constituents are, for the most part, a trade secret. To the left is a glass with soap solvent for washing the needle and tube before going to another color, and below that, in the little paper cup, sterile water.

Plate 2-27: Needle tubes (on far left) of different sizes to accommodate various needles shown on right. The shader needles (several needles welded together) are wide at the tip (two on the far right) while the fine-line needles are to the left of those.

Plate 2-28: Tools of the trade: ink, A & D ointment, soap, sterile water, and tattooing instrument.

Some Technical Issues

Before tattooing begins, the skin must be prepped. This is done by first shaving the target area when necessary, and then wiping alcohol over the surface. Next, a solvent (Mennen Speed Stick, for example) is rubbed on the skin and the flash or design is delicately put in place the same way as a temporary tattoo. This is allowed to dry for a few seconds, and then Vaseline or A & D Ointment is applied to the area. The alcohol obviously kills germs on the skin, but the Vaseline or A & D Ointment, again, serves the dual purpose of preventing drag as the needle tube moves over the skin and cutting down on bleeding.

The dermis and epidermis can only hold so much ink, and going over and over the skin can lead to large areas of heavy scabbing and possible scarring. Most tattoo artists will usually tattoo the outline of an image during one session, wait several days for the ink to "settle down," and fill in color during subsequent session(s).

When coloring, the procedure is to fill in the areas for dark colors first (all dark blues or reds), similar to the paint-by-number products available at art stores, and then move to medium and finally the light colors. The reason for this is that sometimes the colors can run into contiguous areas, and if you start with the light areas first, these could end up being darkened by run-in.

Sometimes the skin simply will not hold ink. The cause is usually attributed to "bleed-out," where the blood coming out of the skin does not allow the ink to go in. Another possibility is that the A & D Ointment, used as a skin lubricant, is dragged into the skin with the ink, encapsulates the ink (the ink is water-soluble), and squeezes out of the holes left by the needle. In any event, this is easily corrected during subsequent touch-up sessions. Always wait for the skin to completely heal before touch-ups—this can take several months.

Tattooing tools or equipment often impose limitations on the finished product. In cultures using the pounding or pricking methods there are sometimes limitations as to the color used (but not always—see McCabe

2002), which is often simply black. Fine-line tattooing is certainly possible, but more so with modern equipment. When I first showed Kim Forest (my tattoo artist) drawings of Egyptian Gods, she thought that the detail was beyond her capability. I told her to do her best, and she was able to do some very fine, detailed work, quite tedious and time-consuming, but very beautiful and artistic. In fact, I gave Kim a great deal of leeway as to color combinations, except in specific areas. The ancient Egyptians conceptualized colors as having magical significance, and you have to admit that a line drawing somehow lacks the power (in most cases) of images that are colored in special ways.

Tattoo Speak

Every profession comes with its technical jargon, and tattooing is no exception. Although I expected much more in the way of esoteric words, the average person would understand most tattoo studio slang. *Flash,* for example, refers to the artwork or drawings that cover the walls of tattoo shops. Flash refers basically to "display" or what is available ready-made, and the variety seems unlimited. There are professional artists who make a living creating new and dramatic drawings of skulls, snakes, large-breasted women, elves, cats and other ferocious animals, as well as cultural themes (North American Indian, Asian, Egyptian, etc.). There is something to capture the imagination of everyone. Certainly most tattooists can draw or modify any requested art, as was the case for my tattooing.

Keep in mind that drawing on a flat surface is far different than drawing on a leg or around an arm, as the image has to be stretched, and squares become warped in order to maintain a proper perspective. In some cases consideration has to be made for movement of skin as you are walking or posing. In short, all artists do not make good tattoo artists. We have been slow in the West to recognize tattoo artists *as* artists due to the guilt of associating flesh with art (sex and spirituality). As we read in Leviticus

19:28, "And a cutting of the soul ye do not put in your flesh, and a writing, a cross-mark ye do not put on you; I am Jehovah."

Once the flash is selected, a *transfer* is made on tracing paper similar to that used in the old Gestetner copy machines. The area to be tattooed is wiped or "wetted" with a solvent (Kim, as mentioned, uses a Mennen Speed Stick), and the transfer is placed on the wet surface in a similar manner as non-permanent tattoos. An outline is thus transferred to the skin and often modified using a felt or ballpoint pen. The outline is then used as the template for the internal content of the tattoo. *Color* and *shading* are added sometimes during the same session, but, as was usually the case for me because of the fine-line drawings, these refinements can be added during another session. As mentioned, the skin can only take so much ink at any one time, and separate sessions avoid ink blending or *bleeding* into unwanted areas.

The place of tattooing used to be called a tattoo *parlor,* but these days this has been replaced with tattoo *shop or* studio (parlor is "primitive," studio is "civilized").

Another common word is *virgin* or someone who has not been "pricked" before. Virgins are usually given instructions about general sensations and are often talked through the early part of the experience by more sensitive artists. During my more than 150 hours of tattooing there was usually one or more individuals being worked on in adjacent rooms, and only once did I hear whining, crying, and gnashing of teeth. Most people can take the pain if the artist has a good bedside manner. Another term used for a neophyte is a *blank.*

Virgins are instructed not to scratch, pick, or dig at tattoos, as this will *jack them up* and leave raised scars due to infection and further abrasion of the skin. Usually upon completion of the tattoo, artists will cover the area with an over-the-counter antibiotic, and then affix a bandage. Clients are also told to keep the tattoo covered and not to bathe for at least eight hours, and not to go swimming for several days. I used Terramycin ointment for the first twenty-four hours, which can be prescribed by your

local MD or veterinarian, to ensure rapid healing with no infection. After that I covered the tattooed area with a good-quality skin cream, like Nivea Extra Enriched Lotion, one of the St. Ives products, and if you want the best use the Pear Body Lotion by Modern Organic Products (MOP), until the scabbing totally sloughs off. Also, exposing the tattoo to the sun will result in fading over time, so sun block is necessary to prevent color deterioration.

To be *on someone* is a phrase used in reference to time. For example, Kim was "on me" anywhere from one to four hours at a time. Sometimes an artist will be "on someone" for up to eight hours, although this would be a bit much for me, and I would assume for most artists as well. I was able to tolerate about four hours of pain and in some case much less. I have talked to those who had eight-hour experiences, and it did not sound all that appealing. I did talk to two individuals who had gone to their respective physicians and obtained topical anesthetics for deadening the pain. The use of anesthetics is not a standard practice for most tattoo artists, as this would turn tattooing into a medical procedure.

Tattoo artists also classify clients in terms of difficulty or maturity. For example, one artist told me that at her shop they use the name "Mary" to refer to one of two things: a female or male who was either annoying or immature, and/or someone who brings along a spouse or significant other to egg them on. "No one ever wants to take these clients because they are usually a hassle, they are there for the wrong reason, and the whole time you want to talk them out of it. Although other studios might not use the name 'Mary,' the reference is well known."

The Future

The modern, electric-driven machines are certainly not the end-all in tattooing equipment. Air-driven machines or even lasers might be the processes of the future. Or perhaps salacious-type chemicals could be mixed with colors, with these chemicals sinking into the skin (much the

same as DMSO used for sports injuries) and depositing the color at some depth, depending on the strength of the chemical. A solvent then could be applied that would set the color. Another solvent could be used to remove the tattoo at a future time. This is only speculation on my part, as many solvents are poisonous, carcinogenic, or both.

As history has shown us, however, cultural beliefs and behaviors have a way of reversing themselves, and perhaps in the next generation tattoos will go from "cool" to taboo. Expression of self through one's body, however, is as old as humanity, and it is unlikely that individual expression through tattoos, scarring, piercing, and so on will ever be eliminated from the cultural appetite.

Mehndi and Body Painting

Mehndi is the ancient art of drawing designs primarily on the hands and feet, but the arms, legs, face, and other areas of the body are decorated as well, without the permanence of tattoos or scarification (Plate 2-29). The semi-permanent orange-brown ink or dye used is henna, which comes from the leaves of *Lawsonia inermis.* Small kits can be purchased on-line and at book and specialty stores; they include ink, designs, pen, and a brief history. Mehndi-style artists are often found in malls and at special events, and it appears that the appeal is more feminine than masculine. Mehndi offers semi-permanence, similar to the commercial temporary tattoo.

Mainly an art form or decoration in the West, for Moslems and Hindus around the world this form of body adornment is exclusive to women, with the process and preparation passed down in a matrilineal fashion. In these traditions, not only is this decorative, it is a sanctification of the female body or the female mystery of life-bringer, for her hands touch the sky, while the feet point in the opposite direction and symbolize the underworld or death (recall the Pig Goddess and Amunet in Chapter One). Applied on special occasions (e.g. marriage), Mehndi gives a sense

a b

Plate 2-29: Mehndi hand and foot painting. Refer to Roome (1998) for techniques and symbolic values of designs. (Pictures from Groning 1997:178–179.)

of the illusion of life and its *impermanence:* fresh designs will fade but reincarnate in an endless ritual cycle of renewal. During the ritual application, stories are told and the next generation is educated in the ways of their caste or tribe. These symbols and associated meanings are memorized in time and act as anchors for recall during the next application and eventually the next generation. The body is the palette of life. The gentle process of drawing on the instep and around the ankle, as well as the wrists and hands, is indeed hypnotic, and in this altered state a great deal of information can be imparted.

In contrast to this feminine habit, Driver (1961:142), discussing the Indians of the Southeast United States, notes, "[p]ainting in a wide variety of colors and design all over the body was resorted to for war, mourning, ball games, and other ceremonial occasions, mostly by men."

Body painting is a timeless fashion and occurs on an everyday basis in most areas of the world. In North America there is lipstick and

foundations, eyeliner, and nail polish, and in times past there were various "beauty marks" or black dots below the left or right eye and between the nostril and the upper lip. The preference for left or right probably had to do with eye dominance. The dot gets the attention of the male, without direct eye contact, and the female can then get a good look at the man's eyes—often indicators of health and certainly the soul—without necessarily inviting further communication.

In a similar way as Mehndi, fine makeup and well-tended hair are not only signs of status but are necessary to make a good impression, to show that you care about yourself and how others perceive you.

In many of the tribal cultures of New Guinea and the South Pacific, as well as Africa (Groning 1997), body painting is part of ritual dances and other ceremonies that are secular and spiritual at the same time. In North America we sanction body painting during Halloween—what the Celts called *Samhain*—our one culturally recognized opportunity to modify and paint on our spiritual selves.

Overview

In Chapter One, I gave a general outline of prehistoric and historic tattooing, scarification, and piercing, emphasizing the time depth of these behaviors. Many motives were considered including group identity, personal expression or growth, rebellion, and magic, but with an emphasis on the therapeutic possibilities.

Chapter Two was an overview of the props and methods used in piercing, scarification, branding, and tattooing rituals. In Chapter Three, I will consider themes or beliefs that have led many to *and* through pain and suffering to eventual redemption. In the West, and especially in the Christian and Islamic traditions, redemption in practice is not all that easy—you have to work at it. By comparison, in Pure Land Buddhism, all you have to do, especially in the hour of death, is call the name of the deity (in Japanese, *Namu Amida Butsu,* and in Mandarin Chinese, *Namo*

omitofo, which translates into "Veneration to the Buddha Amitabha") and you will be reborn in *Sukhavati,* on a lotus blossom open to your level of spirituality. *Sukhavati* is not a place or location but a state of consciousness in life as well as death. This is the fast way or *tariki* ("other power" in Japanese)—the acceptance of a reality that is both within and surrounding us. Amitabha is not to be compared to a savior like Jesus, but to a metaphor of enlightenment, a realization that you are already enlightened, that paradise is not a place but a state of mind that is ever present and merely masked by your illusion of the world, *maya.*

Wishing, praying, hoping, and subservience to a god as a method of approaching spirituality are not enough for some. Instead, paradise is to be found through one's own efforts *(jiriki)* without the aid of a priest, minister, mullah, guru, or shaman. This is the subject matter of Chapter Four. But first let's look at the nature of spirituality in Chapter Three.

Spirituality

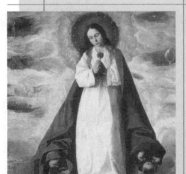

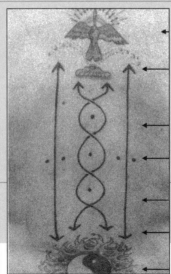

Introduction

All myths and religious traditions reference something beyond the self, some energy or "spirit" with which we are connected in possible ways. This could be a direct connection, as in the Hindu tradition (*Tat tvam asi*—"You are it," you are God, you are that energy) and the Christian tradition's John 10:30 ("I and the Father are one"). Other traditions suggest a creator God or Goddess (or both), a master craftsperson who constructs the universe and all within but stands outside of his or her own creation. You are not part of this god—Yahweh, God, Allah—and your relationship is one of submission. Still others maintain that all came from nothing or a singularity that one day exploded into the observable universe. The word *spirit* or *spirituality* is connected to most of the contemporary personal development movements (spiritual psychologies that blossomed out of the early encounter group workshops of the 1960s and '70s), which often claim no connection to any specific tradition. One might assume, then, that spiritual psychology is "secular spirituality."

Until very recent times, and through literal interpretations of the Bible and other texts, it was widely believed that good spirit emanates from superhuman beings or superordinate agencies who are in a constant struggle with evil spirit or energy used to do evil. These beings are personified with white beards, perhaps lightning bolts, horns, and so on. It would seem, at least from one level of analysis, that if you follow the rules, you can obtain good spirit; and if you do not, the energy is taken away and replaced with negative or evil spirit. Spirituality in this sense can be seen as a commodity to be obtained and lost and maybe even traded, as in the case of the sacrificed hero whose energy is released through death and dismemberment and traded for the sins of the world (Osiris, Christ). We could define all this as *economic spirituality* but at a cosmic level.

Spirituality is a nebulous term, and I'm not sure that any two people experience the word in the same way. For example, tattooing, scarification, and piercing are often characterized as a "spiritual" experience, peculiar to the individual, and difficult to express in words. I certainly felt a sense of calm after a tattoo session and somewhat lethargic for the next twelve to fifteen hours. My interpretation, however, was that these after-experiences or side effects were the product of endorphin dumping, a.k.a. exhaustion, leading to "loss of energy." Pain does alter awareness and alters physiology, but I'm not sure this should be confused with some infusion (or removal) of energy, back and forth, between self and the spiritual force(s) in the universe. The energy source of your awareness, however, does not care if you are in pain or having a good time—it just is. Pain/stress, however, can alter whatever awareness precedes or coincides with it; pain can be manipulated to purge events, emotions, and your demons. Our ancestors were using pain for these purposes thousands if not hundreds of thousands of years ago.

Hindu, Buddhist, and Jainist Traditions

In the *Mundaka Upanishad* (3.1.8) of the Hindus one reads, "Eye cannot see him, nor words reveal him; by the senses, austerity, or works he is not known. When the mind is cleansed by the grace of wisdom, he is seen by contemplation—the One without parts." The "One without parts" is a metaphor for "something" or energy not seen or heard. We have no language or linguistic formula for describing what the Hindu tradition would equate with the term "spirit." However, if you cleanse your mind with wisdom (remove your fears and desires), you can be one with this spirit, *atman.* The Hindu, as well as Buddhists and Jainists, are not terribly interested in perceived dichotomies such as good and bad, right and wrong. Their interest lies in ignorance and illumination. *Proper* knowledge is what leads one to illumination. What kind of knowledge? It is the separation of the "real" reality from the illusion of the world *(maya)* as expe-

rienced through one's senses. In the Buddhist tradition illumination is reached through the eight-fold path, that is, by experiencing one's life the "right" way (dharma or Buddha Dharma) and by eliminating one's fears and desires and extinguishing ego. Perfect illumination is, in a sense, aspiring to nothingness and being one with *atman,* the spirit of the universe.

Islam

In Fundamental Islam, as in fundamentalist Christianity and Judaism, God is rendered as male and, although untouchable, has on special occasions communicated to humankind directly and indirectly (through secondary sources such as angels, specifically Gabriel). The God of Islam demands ultimate obedience and shows no mercy to those who disobey his laws. Spirituality can be seen as deriving from being obedient. In the Qur'an we read of this tangible spirit in Surahs XVII:85, LXX:4, LXXVII: 38, but in Surah XL:15, the spirit is more of an essence than a tangible body, and in Surah XLII:52, the spirit appears to be more of an attitude compelling one to the right path.

For many in the Islamic community, Allah is somewhat tangible, the father looking after his children, although publicly they might express the same idea as the Hindus—i.e., God is intangible except in what one experiences as the *result* of this indefinable force. These are referred to as "signs" of God (see Qur'an, Surah 30:20–25).

Christianity and Judaism

In a similar fashion as in Islam, all levels of believers, both Fundamentalists and the less dogmatic Christians and Jews, tend to hedge and see a possible tangibility to the "spirit" or God. In the Old Testament (e.g. Genesis 12:1–4), Yahweh speaks directly to Abraham. In Exodus 3:1–21 and 4:1–17, God reveals himself in the form of a plant-god, a burning bush that is not consumed by the fire.

With Christianity we learn of a tangible God similar to the God of Abraham in that Jesus in this tradition is the living son of God, in the same way that the Pharaoh was the son of the Egyptian God, Re. This is a confusion of the symbol with its reference or a confusion of the denotation with connotation, in a similar way that God resides in a church, temple, or mosque and the only people able to interpret the word of God are religious clerics of one persuasion or another.

These traditions represent an orthodox or organized concept of "spiritual" or spirituality, a type of experience that can only be obtained through traditional practices of prayer and, within Judaism, Christianity, and Islam, subservience to a male deity variously called Allah, Yahweh, Jesus, or simply God.

The concept of "spirit" has likewise changed as the deity common to the three major Western traditions becomes more and more aloof over time. The idea of a "presence" must go back many thousands of years, as noted by the early anthropologists, and when this presence was discussed it had to be personified or personalized, forcing the "presence" into a tangible, touchable category that mirrored us and our behaviors. In monarchies, theocracies, and dictatorships the god or gods are tangible entities representing the inequality between heaven and earth, just as there is inequality between ruler(s) and subjects: "Your kingdom come, your will be done on earth as it is in heaven" (Matthew 6:10); as above, below. In monotheistic traditions, that is, Judaism, Christianity, and Islam, this tangible god in the sky, with a nasty disposition and lightning bolts, can only be submitted to in the same way as you once had to submit to your country's ruler or die. Your body was property of the state, and I'm not sure much has changed.

Spirit and Mood

In another vein, we can say that a person is in "good spirit" or in a good mood, which may or may not have anything to do with being possessed

by a god-type spirit. But some people do believe that there are evil spirits, personifications of energy, that make life miserable by placing barriers before us, possessing us, and forcing us to write bad checks. Our secularized version of this is Murphy's Law, where what can go wrong will go wrong. We often believe that people give us our mood, our spirit, and our bad behavior, which boils down to statements of blame and emotional irresponsibility. Without emotional responsibility (Rush 1999), you are always in a position of reacting to the world rather than being an active participant. In the Fundamental Islamic tradition there is the belief that women give men erections. The woman is the active principle, one to be feared and covered from head to toe with clothes. Such irresponsibility, that is, believing that others give you feeling/emotions, draws one down to the animal level, *muladhara,* the lowest Chakra level in the Tantric Hindu system (located at the base of the spine). This is essentially where you sit, the end point, *Al Qaeda,* which derives from the word *qa'dah* (a basic sitting position during prayer) or *al-qadir* (an attribute of Allah, i.e., the powerful). *Al Qaeda* translates into "the base," and there is nothing spiritual here only fear (of being caught or killed), the desire to kill or destroy all opposition, and the drive to hang on to life.

We also imbue people with spirit when they take on a job or do as they are told by a superior as in, "That's the spirit!" Here we are referring to right-mindedness or thinking in a direction that benefits someone else (and at times that might be us).

Drugs and Spirit

Alcohol has been scripted as an evil spirit, the drink of the Devil in modern times. In other cultures we encounter similar beliefs, such as the concept that a spirit can reside in a sacred object or plant. It is reasonable to assume that early man, time and time again, came upon plants and fungi that led him or her to believe that a spirit resided in a plant, or perhaps that the plant was the conduit to the spirit world. This certainly was the case in the

Hindu and Zoroastrian traditions. Such beliefs are still found today in these traditions, as well as in certain circles of Judaism, Christianity, and Islam (Merkur 2000, 2001; Ruck et al. 2001; Spess 2000).

Not understanding the nature of hallucinogenic substances, it is easy to appreciate the belief that some spiritual, superhuman, or superordinate agency resides in specific plants or fungi. Consuming these plants would certainly give the impression of tangibility and substance to another place or world, and the energies it harbors within.

Moreover, certain types of plants (*Atropa belladonna, Datura inoxia,* and other Solanaceae species) contain atropine, scopolamine, and other alkaloids, and their ingestion in proper dosage leads to an experience of shape shifting (lycanthropy), or total "body" modification to some animal. Perhaps the origin of werewolves and vampires is connected to ingesting these types of plants.

Rationality and Spirituality

I have read that the building of the pyramids in Egypt or the cathedrals of Europe were not rational acts, and that the lives and resources given up in these endeavors were immense. Even in retrospect we cannot know what could have happened had there been different myths supporting these traditions. The ancient Egyptians believed (at least in some measure) that through their mummification, tombs, and grave goods the Pharaoh would resurrect and pilot the celestial barque across the heavens by day and the internal realm at night (the "night journey"), locked in battle with Apophis, the symbol of disorder or chaos. Said another way, the ancient Egyptians believed that the spiritual essence (energy) personified as self (Pharaoh) would resurrect and make sure that the sun always rises, the Nile overflows its banks (but not too much), and the stars stay in the heavens. In the West, with our "rational" minds, we are told that the sun will rise every morning in the east because of gravity and centrifugal force (scientific terms for this energy), suns are thermo-

nuclear furnaces (more terms for this energy), stars come and go (have a birth, life, and death), and that gravity, thermodynamics, and so on keep things in their natural order. All of these myths, however, are saying quite similar things: 1) there was some sort of creation or coming into being; 2) life came out of this creation; and 3) there is a death. They differ mainly in content. Comparing across the millennia as our technological and informational base accumulates, we keep redefining and refining our stories about the mystery of life and death.

Rationality tends to be ethnocentric. In fact, the ancient Egyptians were doing what they thought they had to do in order to maintain life and consequently the status quo. The Mayans and Aztecs offered human sacrifice to keep the sun in the sky in their rational world. We would not necessarily consider these behaviors rational, but they are certainly spiritual in the sense of supernatural cause and effect. In both cases the myths direct the science (as it does in the West); there can be no science without a myth to direct and support it.

The Greeks were perhaps the first to articulate that reason and the spiritual or supernatural needed separation if we were to develop any knowledge of the physical world and each other. In other words, cause and effect had to be proven, and it was inadequate to say that thunder was a deity rolling boulders around in the sky.

Creativity and Spirit

An old concept connected to most of the spiritual psychology groups (see Chapter Four) is that of purging sin, or removing negative energy, which ideally leads to more creative thinking. From one perspective this may be true. If you are not troubled with your thoughts you can turn them to other, more creative endeavors. From another perspective, creativity is your spiritual self or that which is connected to a larger power (God, Allah, Shiva, Atman, etc.)—possibly a power that can be of assistance or hear your prayers. Many also think that one's intuition represents a

connection to the spirit or energy that informs all; intuition in this case is like a micro-prophecy sent from above (or below).

Intuition and Spirit

We all have episodes where a little voice tells us something, and we had better listen to it. It is like we have Jiminy Cricket or Big Fly as our guide. Or we dream or think of acquaintances or loved ones, and they call on the phone. This may not be so much intuition as it is a statement about the interconnectedness of all things. Intuition is conceptualized in some spiritual psychology groups as coming from the heart. Being "in your head" is considered a negative condition in many respects and is discouraged during training through ridicule. "Being in your head" as a negative reference is usually drawn from the hip when an initiate approaches critical thinking, or questions the meaning or purpose of a process during training sessions, or asks others about their experience. This is a process of discovery about self and others, and some (e.g. Steinsaltz 1980) would consider it a spiritual act.

Perhaps our only spiritual connection is our intellect, our rational mind, and these groups (including Judaism, Christianity, and Islam) effectively shut that off. As Steinsaltz (1980:4–5) states:

> The world in which we ordinarily live, with all that it embraces, is called the "world of action"; and it includes the world of both our sensual and our nonsensual apprehension. But this world of action itself is not all of the same essence and the same quality. The lower part of the world of action is what is known as the "world of physical nature" and of more or less mechanical processes—that is to say, the world where natural law prevails; while above this world of physical nature is another part of the same world which we may call the "world of spiritual action." What is common to these two domains of the world of action is man, the human creature so sit-

uated between them that he partakes of both. As a part of the physical system of the universe, man is subordinate to the physical, chemical, and biological laws of nature; while from the standpoint of his consciousness, even when this consciousness is totally occupied with matters of a lower order, man belongs to the spiritual world, the world of ideas. To be sure, these ideas of the world of action are almost completely bound up with the material world, growing out of it and reaching farther, but never really getting out of it; and this is as true for the heights of the most far-reaching and encompassing philosophy as it is for the thought processes of the ignorant person, the primitive savage, of the child.

From this point of view then, consciousness, intellect, and the ability to reason allow us to move past the physical and mechanical world to that of the spiritual environment. This focus on the heart and not your head stems from an old Egyptian idea that the heart was the center of consciousness, and thus it was usually left in place during the embalming process. It is your heart that jumps around during emotional arousal, not your head, and during the embalming process the brain itself was unceremoniously frappéd and poured out through the nostrils. This was done with an instrument, similar to a bent coat hanger, that was pushed through the bone at the back of the eye and then twirled around, liquefying the brain.

Intuition appears to be unconscious *logic* that develops as we experience our world. Intuition is not something given to you, or that comes about by getting in touch with your spirit, or because you believe in a God or are a good person. It is alive and well in every living thing. The problem is we sometimes do not pay attention to our intuition or internal logic, and instead let our emotions guide our behavior. This is then the opposite reaction, of being in your heart and relying on your emotions or your "animal" nature as a major signal for action.

In much of life's adventure it is important to think things out logically and not give in to emotions or your heart. Yes, be in love and enjoy a

sunset, a good lamb chop, or have great sex. If you operate logically you move toward health, happiness, and nonhurtful behavior. It is the unil-luminated people, those who act out of anger, hate, frustration, and even love (we can love people for very foolish and stupid reasons) who often make very poor life decisions. Heightened emotions alter blood flow in the brain, by decreasing flow to the frontal lobes (the seat of social and log-ical processing) and moving it to the back of the brain (the base, *Al Qaeda*), readying us for flight, fight, and fuck modes.

Thinking logically means moving away from fear and desire, with the result being sensitivity, tolerance, and mutual fairness, without losing yourself in the process.

Competitive Spirit

During my research I was asked if, in my opinion, I thought that certain types or categories of body modification were more spiritual than others. In other words, would getting breast implants or a sex change operation be more spiritual than tattooing, scarification, or piercing? My initial response to this is that it depends on your definition of spiritual and the motives involved. "Spirit," for most interviewed, was considered an energy that goes by various names. Then I began to look for a model that might help place the behavior and motives on a continuum of "spirituality." There are many to choose from, but the first model coming to mind was that presented in Kundalini Yoga. Kundalini Yoga or Tantric Yoga is a meditative system found in the *Santana-dharma,* the "eternal religion" of Hinduism. Kundalini refers to the female serpent energy, or creative power of all the gods, that resides at the base of the spinal column. Through breathing exercises, concentration or meditation, purification exercises, and various body positions (Hatha Yoga), this energy *(Shakti)* is awak-ened and ascends through the six Chakra centers. With intense practice it eventually reaches the seventh Chakra, at the top of the head but out-side the body. At this point there is a uniting with Shiva, a symbolic man-

ifestation of all the divine energies (wisdom and bliss) that are largely asleep in most human beings. Each Chakra has a spiritual relevance or reference (Plate 3-1). Certain symbols (lightning bolts, weapons, deities, etc.), colors, sounds, and category of female energy or Shakti govern each Chakra in the Tantric tradition. "Shakti" refers to the primal energy that informs all; it is the energy that creates, sustains, and dissolves all that you experience.

The Chakras refer to ductless glands in the body, body/mind connections, and spinal correspondences. As the individual meditates up through each Chakra, a special bliss *(ananda)* is experienced, along with mental or psychic powers and knowledge. A full description of the Chakras can be found in Avalon (1974). In recent times these Chakras have been compared to concepts in Western psychology (Campbell 1990:153–169).

Chakra One —*Muladhara,* or base root. The geographical position (Plate 3-1) on the body is at the level of the base of the spine between the root of the sexual organs and the anus. Here you can imagine a Kundalini Serpent, about as big around as a boar's hair, wrapped three and one-half times around a phallus representing Shiva, who dances, creating and destroying.

The god symbolizing this Chakra is Brahma, the personification of Brahman or Atman, or that which is everything and nothing at the same time. All is created at this point, and Brahma is about to open his eyes on the four faces that look to the four points of the compass, illuminating the world.

At this Chakra, consciousness and awareness are almost inert; here you are just hanging on to life, symbolized as a puckered-up anal sphincter muscle *(Al Qaeda).* At this level one is simply reacting to life: "Everything happens to me." All behavior is totally ego-centered. In Western psychological terms, this is Behaviorism or simple reaction and conditioning.

Body modification you encounter at this level would include sex change operations where there is an all-consuming preoccupation with the biologically based but socially conditioned concept of self/body and its

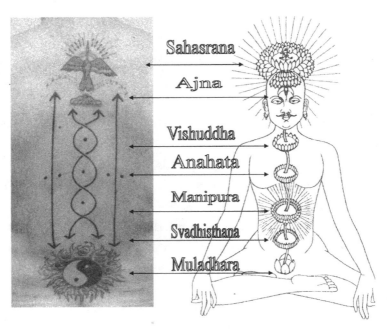

Plate 3-1: Chakras

manifestation in a state unsuited for existence. All life will end unless parts are removed and added; nature is corrupt and needs to be corrected.

On the other hand, a sex change could be seen as a type of purging, of removing "that" which has sinned or is offensive: "If your right eye causes you to sin, gouge it out and throw it away. It is better for you to lose one part of your body than for your whole body to be thrown into hell. And if your right hand causes you to sin, cut it off and throw it away. It is better for you to lose one part of your body than for your whole body to go into hell." (Matthew 5:29–30) This implies that nature is corrupt and needs correction. Purging is only the first stage toward spirituality and, in itself, is not a spiritual act. It is the behaviors/thoughts that flow from such an action that are either spiritually directed or not. For example, a sex change for an imagined better sex life or to feel better about one's self does not qualify as a spiritual act. If the operation is performed as a prelude to public service, to healthy, helpful, and nonhurtful behavior, or

devotion to a deity then this might qualify as a spiritual overture according to this Tantric tradition. If fact, most sex change operations are performed to correct nature and have little to do with spirituality at all. Ritual castration, however, could be seen as a spiritual act.

Breast implants, tummy tucks, and nose jobs are also represented in Chakra One, especially if these are done for ego gratification, or correcting nature, and not for sexual reasons (see "Chakra Two").

Obesity as a form of body modification is likewise a preoccupation of ego—immediate gratification, the unquenchable thirst to be loved and accepted, anger toward self and others acted out through chewing, digesting, and excreting those others in a changed form. Many would like to pin their extra pounds on genetics, but most obesity is an information management problem—in other words, too much information in (food), too little information out (energy burn, exercise).

The acts of homicide or suicide bombers would be considered highly spiritual in the Islamic tradition but not in Hinduism. In the latter tradition, killing yourself or giving yourself for another (as in the practices of *seti*) is a very sensitive spiritual act, but to take the life of innocent others is an act of ignorance *(avidya)* and will accrue bad karma, which will have to be beaten out of you while a soul between lives, and "worked off" when you reincarnate. With such an act you will probably come back as an egg in a fly.

Chakra Two —*Svadhisthana,* Her special Abode, Self-Place. This Chakra is at the level of the sex organs and is about sexual desire. Many people find themselves at this level lusting after others. At this point we are with Freudian Psychology and "sexual addiction," where your life is structured around your next orgasm and, of course, the associated frustrations when it does not happen. Desire and fear are all wrapped into one.

At the level of Chakra Two you are into action and not simply reaction. A whole range of body modifications fit into this category, from breast and penis implants to tattoos designed to advertise sexuality and attract

others—for example, the Celtic design on the small of the back, the butterfly on the ankle, or a woman's face or full body on one's back as a sign of sexuality in male prisons. This would likewise include tongue, nipple, ear, eyebrow, penis, and labial piercing, as the purpose is to attract attention or accentuate sexual pleasure.

On the other side, sexual energies can be utilized to ascend the Chakras (see Saraswati and Avinasha 1996). Thus, body modification for sexual enhancement might also be considered a prelude to spirituality if that energy is used to ascend to the other Chakras.

Chakra Three —*Manipura,* Full of Radiance, Jeweled City. At this level you are into possessing and winning. This is the Adlerian psychological position of master of the universe. This is the materialist position, often called "Yuppie" in our culture, of networking people to gain an economic advantage, prestige, and status. The gods of this Chakra are Shiva, in his destroyer personification, along with his consort Lakini or Kali, Black Time or Black Death.

Bodybuilding fits into this category where there is a preoccupation with self in comparison to others; bigger, better, and stronger—nature needs to be corrected and made better. "The most" has also become a goal with some who desire to be known as the most pierced, most tattooed, most sexually active, or the one who can stand the most pain and discomfort. The goal is belonging, and the simplistic belief is that the more you have (money, muscles, tattoos, etc.), the better you fit and the more you will be loved, accepted, and respected. I recently told an IRS agent that I was not interested in accumulating things—that is, cars, boats, houses, and wealth in general—and she responded, "That is un-American!"

The Chakra Three level is where you also encounter piercings, tattoos, spiked hair, lipstick, and clothes style as a sign of rebellion against parents or society, and other symbolic gestures that "I can make my own choices; I won't be told what to do or be placed in a mold." Often, however, the piercing or tattoo is a mark of belonging to a subculture, and

the real reference of this Chakra is a sense of belonging to a status within a group.

It is at this level that one can become aware of limitations, that obtaining things is perhaps not what it is all cracked up to be. ("The fool who persists in his folly will surely become wise.") But there were times when you felt total bliss, an unexplained positive glow, and it is just there and not directly connected to anything or any event, at least at the conscious level. Another example of this is when you daydream and for a moment or two there is nothing but calm, no fear or desire, and you understand the significance of a flea. Daydreams put emotions on hold, where everything and nothing happen at the same time. You generate your emotions as you experience your world, and therefore you are not your emotions because you are the generator. You generate them as you experience and re-experience your world, and it is through these emotions that you can ascend to Chakra Four, through that center place of one hand clapping. You do this quite simply by disconnecting events from emotions. The event is neutral; it is your interpretation and your feelings surrounding events that can be transcended (see Chapters Four and Five).

Chakras One, Two, and Three represent our animal nature. Chakra One is the will to life and a fear of death. Chakra Two is sexuality with all the desire/lust directing one's thoughts and actions. Chakra Three is the desire to be loved, accepted, and respected by collecting/ accumulating material objects, things, and people.

> People living on the levels of Chakras 1, 2, 3 are living on animal levels. Animals, too, cling to life. Animals, too, beget their future. Animals, too, fight to win. So people on these levels have to be controlled by social law, *dharma*. Just think of what our popular religions are concerned with—prayers for health, wealth, progeny, and victory. That is asking the gods to serve your animal nature. This is popular religion. It doesn't matter what the god's name is . . . What is it the popular world wants? It's health, wealth, and progeny, and

it doesn't matter what the god's name is. So that's the one religion, the one popular religion all over the world no matter what the name of the god is. The job of the priests, those in charge of the historical temples, is to get the name of their god linked up with this thing [health, wealth, progeny], and the money pours in like crazy.

Think of the first temptations of the Buddha: the temptation of lust, Cakra 2; temptation of fear, Cakra 3; and the temptation of duty, dharma. He had gone past this. We're not in the field of authentic religious life, in the field of the spiritual birth, until we come up to Cakra 4. (Campbell 1990:160–162) (Campbell is using the softer form of Sanskrit or Pali. Chakra is the usual spelling.)

Chakra Four —*Anahata:* Soundless Sound, Not Hit. At this point we are at the spiritual level symbolized by the heart. We encounter the same symbol in the ancient Egyptian tradition that made its way into the Christian tradition (specifically Catholicism), that is, the Sacred Heart. For the Mayans, Toltecs, and Aztecs the heart is the ultimate sacrifice to the god, for without the blood sacrifice the sun would not rise.

Anahata means "not hit" and this is where you encounter the riddles or *koans,* the statements of meditation popularly associated with Zen Buddhism. The design of the koans is to reveal the limitation of words and thought to express certain ideas or experiences. For example,

17. Ta-sui's Turtle: A monk saw a turtle walking in the garden of Ta-sui's monastery and asked the teacher, "All beings cover their bones with flesh and skin. Why does this being cover its flesh and skin with bones?" Ta-sui, the master, took off one of his sandals and covered the turtle with it. (Senzaki 2000:28)

Both Christ and Buddha were born at the level of their mother's heart, which refers to their spiritual birth and is not intended as a statement of biological fact. In the same way, a born-again Christian does not go

through a second animal birth, but is born again into the spiritual aspects of Christ.

Here we experience love, for example, as a feeling that goes beyond a pretty face and large breasts (Chakra Two). It is the feeling one has for a pet (for example), a feeling that cannot, due to fear of rejection, be directed at another human being. This is love just because, and here we encounter art for art's sake, a feeling about something or someone that cannot be expressed. Witnessing a beautiful sunset or rose and then placing this on your body as a point of meditation or reference that no word has touched would be considered a spiritual act. Thus you use the emotions to appreciate that which is beyond the physical, with no fear or desire for the object of meditation. Emotions at this Chakra are not designed to make a decision; they are the vehicle, the body, poised for spiritual interaction. At this point you have left the animal body behind.

> People can go so far, as I said, going up that *pingala,* line, as to reject altogether their bodies which have fallen into a secondary place. The problem is to come to this realization through the body, so that it's in the body that the spiritual life is realized. (Campbell 1990:165)

Scarification and mutilation have been and are used as marks of identity with the suffering Osiris or Christ. It is the suffering that wipes away sin and guilt and all the evil in one's self as a prelude to understanding *maya,* the illusion of the world. It is not the pain or the experience of the body that is important—this is all secondary—it is the realization that all pain and suffering are transitory, and that beyond this is an active stillness, a singularity, a center place where words, action, and inaction have no place and no meaning.

Circumcision is certainly considered a spiritual act of submission to Yahweh or Allah in the Jewish and Islamic tradition, but the reference is to a mark of commitment or membership in a group. In this tradition

and in this context, circumcision belongs to Chakra Three. Circumcision at such a young age (eight days old) cannot be a spiritual act for the child. Circumcision is required for membership in the group, much the same as tattoos as required for membership in many urban gangs.

Chakra Four can be approached with extended pain (scarification or tattooing). If the candidate for illumination can both focus on the pain and become totally relaxed, he or she will leave the body behind and experience a singularity where there *is* no experience. It is more like a vibration. This can be worked up to by focusing on the pain and making it more intense, and if you can increase the intensity of pain then you can likewise decrease the sensation. Second, if you can moderate the pain then the pain, in a sense, is an illusion. And third, if you relax into the pain (relax all your muscles beginning with the face), the pain—and all sensation—seems to melt away. Relaxation interferes with your experience of pain, and your pain interferes with your experience of relaxation, thus creating a neutral state of oneness. Here you are using the body as a vehicle of release, a comparison point for a part of your mind that is separate from your body, that part of your mind that goes beyond the physical world and all its limitations.

Chakra Five —*Vishuddha,* All Purity or Purgation. This is the purging or sublimating of the animal/physical system. Here the energies, instead of projecting outward to conquer or impress others as in Chakra Three, are projected inward to conquer one's self. Here we deal with demons and fear, lust and desire, and see them for what they are—illusions. And just as Shiva is a representative of that transcendent energy, the destroyer of ignorance, his wife (at this level) is Kali, who represents the primitive, the destroyer of our animal nature—she severs the head from the body. This would be comparable to the Greater Jihad of the Sufi tradition, where instead of waging war on others (considered the Lesser Jihad) you turn inward and conquer yourself.

Here is where extended scarification or tattooing could be used to purge fears and desires, to purge all the troubled past now that you realize that your experience of the world has been an illusion (Chakra Four), and that *you* created the pain and sorrow. Just as Chakra Four is a point of illumination, a point of understanding that your interpretation of events is yours and it is merely an illusion, Chakra Five allows that realization to turn inward and reinterpret the troubled past without saying yes or no to it; you still the water. Here you are sublimating your animal nature and preparing yourself for the next level. This is the night journey, explained in detail in a companion volume, *The Twelve Gates.*

Many of the body modification models, that is, scarification, skin stripping, tattooing, extended piercing, and Bikram Yoga (and other Hatha traditions) can be used at this level to conquer your demons and limitations.

Chakra Six —*Ajna,* the vision of god, the guru's command. Once you conquer yourself, then you can turn your energies to god or that energy from which you came and to which you will return (Atman, Brahman).

Here we encounter Shiva in another personification—Parama-Shiva or Hamsa and the goddess Hakini (Shiva's wife at this level). The goddess predominates at this level, exhibiting the same paired opposites as dancing Shiva but with six heads—including yours!

> The word for gander in Sanskrit is *hamsa.* When you breathe in you hear *ham,* when you breathe out you hear *sa.* Your very breath is telling you all the time you are that hamsa. When you hear it not as ham-sa, but as sa-ham, it means, "I am that." This is a meditation on the breath. Every breath is telling you that what you really are is this spirit that informs the universe. (Campbell 1990:154)

At Chakra Six you are connected to your body only by breath, and you can imagine yourself seated in this breath, this bubble, with a dark mass

below your physical body (all karma from past lives is dissolving away), and above, a light, illumination.

At this point all is still; your *aham* (ego, I) has no fear or desire. "I" can meditate on the Atman from which it came. There is that realization, *Tat tvam asi* ("That thou are" or "You are it"), "I am that God," "I and the Father are One" (John 10:29–38). Scarification, tattooing, piercing would have little effect because the body is not there, only the breath

Chakra Seven —*Sahasrana,* The Thousand-Petal One. This Chakra is located at the crown of the head and is not part of the physical body (it is the "mind")—there is no ductless gland at this "level." This is what the koans are about. This isn't a place or a level or anything, but it is really every place and everything. This is that which informs all.

At this level one joins with Atman, "I and the Father" become one. Campbell (1990:168) tells the story attributed to Hallaj:

> ... of a moth seeing a night lantern, and it wants to get to the flame. But the glass keeps it out. It batters itself all night long, and then goes to its friends in the morning and tells them what a wonderful thing it has just seen. They say, "You don't look the better for it." This is the condition of the yogi, the ascetic knocking himself to pieces to get through. The moth goes back the next night and, by luck or device, does break through. For an instant he has achieved his goal and is the flame. That instant is an eternal instant beyond time and space. That is the goal here, to remove the barrier. Bang!

Plate 3-2 is the image of Thich Quang Duc, a Buddhist monk in Vietnam who, on June 11, 1963, became a human torch in protest against governmental and Christian Catholic interference in their tradition.

Husayn ibs Mansur al-Hallaj was a martyred Sufi mystic of the tenth century, and his death (in Baghdad, 922 CE) illustrates perfectly the ulti-

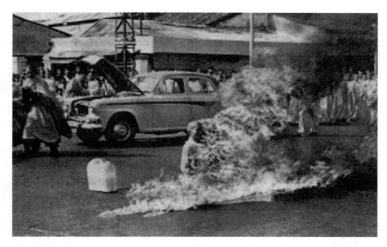

Plate 3-2: Thich Quang Duc, a Buddhist monk who became a human torch in protest against governmental and Christian Catholic interference in their tradition (June 11, 1963).

mate form of body modification for spiritual life. The master storyteller, 'Attar, insisted that Hallaj was killed because he had experienced union with God and was unable to restrain himself from crying out, "I am the Truth!" *(ana al-haqq)*. He described the execution of Hallaj as follows:

> They cut out his tongue, and it was the time of evening prayer when they cut off his head. While they were cutting off his head, he smiled, and gave up his soul. Men shouted; Husayn had taken the ball of destiny to the end of the field of satisfaction. From each of his limbs, the cry arose, "I am the Truth!" The next day, they said, "This will cause more trouble than when he was alive." So they burned his limbs. From the ashes came the cry, "I am the Truth!" Just so, at the time he was killed, every drop of his blood that fell spelled out "Allah." They were stunned. They threw the ashes in the Tigris, but the top of the water the [ashes] still said, "I am the truth!" Now, Husayn had said, "When they throw my ashes in the Tigris, Baghdad will be in danger of the waters flooding it.

Spread out my cloak on the water; otherwise it will destroy Baghdad." When the servant saw this, he took the master's cloak to the edge of the Tigris, so that the water became still again. The ashes became silent. Then they gathered his ashes and burned them. Not one of the people of the path has had such a victory. (Ernst 1997:70)

At this Chakra you are one with the universe, simultaneously aware of everything and nothing. There is no more illusion; just everything and nothing. The practice of *seti* ("of becoming something") would qualify as a spiritual act in Hindu tradition because the woman is joining with her god, her husband, on the funeral pyre, thus becoming a complete union. Giving one's life for another human or for a god would qualify except in those cases where the act was designed to hurt others who are not in the direct field of play (suicide or homicide bomber), or if it is part of your job and you are getting paid for it (Secret Service Agent, bodyguard).

My Definition of Spirituality

Reasoning, according to Steinsaltz (1980:9–11) would be considered a spiritual exercise because it places us above the animal world and thus our animal nature.

> In addition, man—because of his many-sidedness, his capacity to contain contradictions, and his gift of an inner power of soul, that divine spark that makes him man—has the capacity to distinguish between one thing and another, especially between good and evil. It is this capacity which makes it possible for him to rise to great heights, and by the same token creates the possibility for his failure and backsliding . . . Every mitzvah [any Jewish religious obliga- tion or any good deed] that a man does is not only an act of transformation in the material world; it is also a spiritual act, sacred

in itself . . . More precisely, the person who performs a mitzvah, who prays or directs his mind toward the Divine, in so doing creates an angel, which is a sort of reaching out on the part of man to the higher worlds.

To me "spiritual" has nothing to do with one's relationship or subservience to a deity or personified force in the universe. This type of thinking places the individual in a subservient position to energy because you can only be less than "it," never part of it, and certainly never its equal. Moreover, believing in all-powerful Gods is a conditioning story (Matthew 6:10 "Your kingdom come, your will be done on earth as it is in heaven") that can lead to subservience to a ruler in the real world, the physical world, and subservience to the flesh, and this has little to do with spirituality.

Spirit, in my mind, refers to the energy that informs all things. This energy was available and part of the Big Bang of between 8 and 20 billion years ago (and countless times before), and it is with us today. This energy is neutral in the same way that the gas used to light your stove can be used to cook foods as well as manufacture illicit drugs. The heat will burn your hand as well as cook your food. It can provide warmth and yet burn down your house.

Going beyond this, if there is a spiritual essence, a living force that created the universe, then this is an intelligent energy or force. Your spiritual nature, as conceptualized in this manner, would then be your *intelligence,* your ability to think logically and to put aside the destructive emotions that trigger irrational behaviors—the type that hurt and hinder social relationship and cooperation, and poison our air, lands, and sea. But *beyond* intelligence and rationality, which belong to the physical world, there is the energy itself. It is both part of the physical world and separate from it. It is neither good nor bad, right or wrong, and it is that from which we came and back into which we will all flow. The spiritual world is simply that energy that connects all, seen or unseen, heard or not heard, felt or not felt.

Pain, Suffering, and Spirituality

Spirituality, or the transcendence of one's animal nature and the experience of an energy beyond the self to which all are connected, can be approached through the body in many ways—for example, meditation, exercise, chanting, sleep deprivation, drugs, and above all, pain and suffering. I do not recommend pain and suffering. Instead, meditate on it or pray for it and maybe illumination will come to you like health, progeny, and wealth. Many, however, desire a more active part in their spiritual growth and have turned their energies of winning (Chakra Three), lusting (Chakra Two), and just hanging on (Chakra One) into a designed process of spiritual enlightenment, the subject of Chapters Four and Five.

Pain, Suffering, and Redemption

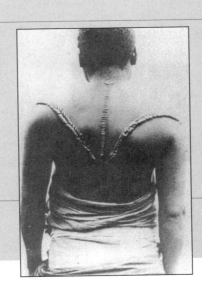

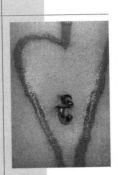

Introduction

Myths in diverse cultures inform us that life comes from death, that the shadow of the moon is the dying of the moon, cleansing away the old and bringing in the new. Animals that lose something and grow it back (bull elk, deer, peacocks, lizards, snakes) symbolize reincarnation or resurrection. As a scar or tattoo heals, the skin sloughs away, in the same manner as that of the shedding snake. For sure, then, one who has been scarred or tattooed dies to his or her old self/flesh and, through the symbolism of tissue regeneration, is reborn.

Another standard motif encountered in the hero myths is the belief that the candidate for redemption, the hero, has to overcome an ordeal through a cleansing or purging process. In fact, purging "sins" is such a common procedure in religious systems around the world that one might conclude that the need to relieve one's self of social guilt resides within our group nature (see Rush 1996, 1999). Even self-mutilation, perceived as a pathological condition by Western-trained psychologists and psychiatrists, is an attempt at self-healing (Favazza 1996:232).

In the Christian tradition (Proverbs 20:30), "Blows and wounds cleanse away evil, and beatings purge the inmost being." We read in Jeremiah 4:4, "Cleanse your minds and hearts, not just your bodies, or else my anger will burn you to a crisp because of all your sins. And no one will be able to put the fire out."

Deuteronomy 17:7 tells us, "The witnesses shall throw the first stone, and then all the people shall join in. In this way you will purge all the evil from among you."

1 Corinthians 5:7: "Purge out therefore the old leaven, that ye may be a new lump, as ye are unleavened."

Turning the metaphor slightly, and adding a purpose or long-term effect, 1 Peter 1:22 notes, "Now you can have real love for everyone because

your souls have been cleansed from selfishness and hatred when you trusted Christ to save you; so see to it that you really do love each other warmly, with all your heart."

In the Islamic tradition, purification in a general sense is a simple procedure, which, however, requires a lifetime commitment. The procedure is to submit to Allah, pray five times each day, give alms to the poor, and, if possible, go to Mecca at least once in your life. For the Fundamentalist Muslim, dying in the "service" of Allah, as in the case of homicide bombers, cleanses one of all past sins (through martyrdom) and guarantees that the sacrificed enjoys a favored place next to Allah in heaven. From the Qur'an we read, "Those who believe will stand alongside (the Prophet), their light streaming on ahead of them and to their right. They will say, 'Our Lord, perfect our light for us, and forgive us!'"

Hell, as found in many cosmologies, is the place for purging one's "evil" deeds enacted during life. In Hinduism, Zoroastrianism, Islam, Christianity, and Judaism (although not of major concern in the Jewish tradition until more recent times), hell is for those who can't follow the rules—rules invented by priest-kings and codified (written down) in a different place and different time, rules designed to control people and direct their energies toward common goals, usually in the best interests of the priest-king.

For Christians hell is for removing "the sins of the fathers," and this "removing" is eternal. In the Christian ideology all are born evil, and redemption can only come from baptism (circumcision in the Jewish tradition) and, at death, from the most horrible torments and tortures. In the Christian tradition, you're toast!

In the Islamic tradition, any disbeliever in Allah, or one who has not followed the creed, will face a fiery hell (there are at least seventeen references to hell in the Qur'an). But, "Truly, God loves those who repent, and He loves those who cleanse themselves" (Qur'an II:222). The different levels of hell indicate the divisive nature of Islam (as well as monotheistic traditions in general), with the first level of hell reserved for believers

in Allah, the second for Christians, the third for Jews, the fourth for Sabians, the fifth for magi (Zoroastrians?), the sixth for Jains, and the seventh for hypocrites (all other various and sundry disbelievers). Even in hell one can acquire a spiritual disease if in close contact with "outsiders."

The Buddhists believe that hell is for the spiritual failures, a place where they will be torn to pieces after each lifetime until they reach illumination (see Sadakata 1997). In Hinduism, a spiritual failure is one who does not follow his or her *dharma* or cosmic law according to the appropriate caste. In the Christian tradition these laws are generally stated in Matthew 6:10, "Thy will be done on earth as it is in heaven." The laws are invented by the priest-kings but attributed to higher powers, powers that cannot be questioned, and thus the invented laws are not subject to question either. Anthropologists call these "mythical charters." All religious traditions have them, and they are designed to create legitimacy or "who's on top."

Reference to purging of sins through confession occurs at least fifty-five times in the Old and New Testaments. In Ezra 10:1, for example: "As I lay on the ground in front of the temple, weeping and praying and making this confession, a large crowd of men, women, and children gathered around and cried with me." Crying with others does seem to be cathartic in some cases, but without a recognized or agreed purpose or outcome, most people simply have a good cry, and the catharsis fades into a less remembered past. According to Vingerhoets and Cornelius (2001), crying is less cathartic than previously thought and may increase physical and emotional tension. If crying and catharsis went hand in hand, then those people who cry the most should be the most emotionally stable—but this is certainly not the case.

It is quite easy to initiate and sustain laughter or crying in groups ranging from five to twenty-five or so people. As synchronicity is part of our group nature, the laughter or crying is contagious and easily directed by the group leader or leaders through the stories we tell. Our stories and myths direct our emotions and vice versa (Giovannoli 2000), as any

moviegoer can tell you; we are truly bundles of nerves with emotional outpouring directed by our myths, our expectations, and our illusions *(maya)*.

Matthew 2:22—"But if your eye be clouded by evil thoughts and desires, you are in deep spiritual darkness. And oh, how deep that darkness can be."

Matthew 12:35—"A good man's speech reveals the rich treasures within him. An evil-hearted man is full of venom, and his speech reveals it."

In the *Mahaparinirvana Sutra 560* (Buddhism) we read, "If one hides the evil, it adds and grows. If one bares it and repents, the sin dies out. Therefore, all Buddhas say that the wise do not hide sin." As mentioned in Chapter Two, Hatha yoga, attributed to Patanjali (ca 200 BCE), may have evolved out of maintaining specific tiring and painful body postures as a means of doing penance for sins without causing death. (Suicide out of anger, resentment, frustration, or depression would not be a good thing in this tradition because you will be back doing more nasty things to people.) By doing penance it is believed that one can stop the endless round of life, death, and reincarnation. Most of the postures in Hatha yoga are quite exhausting and even painful for many people, but, through these spinal postures, exercises, and the compression of organs, health benefits were revealed. This idea of doing penance by maintaining exhausting and sometimes muscle-atrophying postures is possibly of Jainist origin, and must have a long season predating Patanjali by many, many centuries.

In the *Laws of Manu* 11:228 (Hinduism), it is stated, "By public confession, repentance, penance, repetition of holy mantras, and by gifts, the sinner is released from guilt." The part about gifts is of interest, for to this very day one can "cash out" on sin, as money buys redemption, not only in Hinduism and Buddhism, but in the Western traditions as well. And just as money buys redemption for infractions of the spiritual laws, it does the same for secular offenses (as above, below).

In Taoism's *Treatise on Response and Retribution 5* (and this is perhaps my favorite) we find, "If one has, indeed, done deeds of wickedness, but

afterwards alters his way and repents, resolved not to do anything wicked, but to practice reverently all that is good, he is sure in the long run to obtain good fortune—this is called changing calamity into blessing." This is quite similar to the "negative confession" discussed below.

The idea of cleansing—in a really dramatic, verbally abusive manner—is found in Christianity as well as in other traditions and cultures (see Herdt 1981, 1982, for what he calls "radical socialization"). This old concept is echoed in some of the "experiential" personal development training available in North America since the late 1960s, which evolved out of encounter groups and includes Scientology, EST, and so on (see Taylor 1999). Although most of the personal-development groups disavow any direct connection to Christianity or any other organized religion, one can identify many elements borrowed from the Biblical as well as Hindu and Buddhist traditions. Purging is one of them. This is accomplished during "training" by confessing one's sins and guilt, often under the intense pressure of verbal abuse. Susan Campbell, using less verbally abusive techniques, makes the following comment (2001:xvii):

> (W)hen you go deeply and patiently into an experience, feeling it fully without escaping into a control pattern, it changes! I'm not kidding. The way out is to go deeply in. You will discover the truth for yourself as you engage in the practices—I call them truth skills—suggested in this book.

The way to truth in some of these New Age spiritual movements is to overcome the control phase and force yourself to reexamine who you are, and this is done through some pretty intense verbal abuse. With the help of staffers and fellow "inmates" or initiates, you are to realize that you are a sinful, rotten, selfish, terrible, nasty, evil person who is not fit to live. There is intense pressure to go deep *in*—all this rejection equals death (see Rush 1999). It taps into a universal fear of being outside a group. For millions of years our survival depended on group support,

and outside the group you will surely become the food of another animal, who will gnaw on your bones and eat your liver (this leads to all the wonderful stories we tell our kids so they won't be too much of a pain in the ass for society when they leave the front door). When you are labeled a jerk, asshole, dick-head, bitch, whatever, this places you in a position of "not good enough" and you are outside the expectations of the group; the only way back is to change your ways—re-birth. "I should die and be reborn!"

Part of the purging often includes intense outward expressions of anger, through crying and rage, directed at all those "others" (parents, spouses, kids, bosses, rapists, muggers, teachers, seducers, murderers, and so on), those rotten people in your life—your mirrors, if you will. They should symbolically be wrestled with, hit, punched, and clubbed to smithereens. This is called catharsis and is intended to release all the demons, your limitations, and, again, bring you to a "new heaven, new earth." But is this true? Does crying and beating pillows and so on really lead to release or catharsis? (This idea, by the way, has been part of our folklore since the days of Aristotle.) No, there is no evidence or experimental database to show that this is so, and, on the contrary as mentioned earlier, crying and rage often increase emotional and physical tension (Vingerhoets and Cornelius 2001), with possible negative effects on the immune system. There may be a detoxification element connected to crying, as toxins are found in all fluids leaving the body (sweat, urine, feces, tears, spit), although I do not believe that anyone would seriously recommend crying as a major method of detox.

An aside. The fact that *Homo sapiens* have tear ducts in the first place is a bit of an enigma. We are the only primate with tear ducts, and the only other animals I am aware of that also have them are marine mammals. Perhaps one can justifiably say that human tear ducts are designed for our special brand of emotional release or catharsis through tears. Perhaps we acquired these tear ducts because of an intense relationship with ocean food, or maybe as a visual signal that something was wrong, that is, an

accentuation of the sorrow revealed by facial gestures and prompting sympathy and guilt. With a very dependant infant, the ancient ancestors who could gain more of another's energy through tears might have a survival edge. Tear ducts are an environmental adaptation or secondary effect of some adaptation, perhaps for swimming and diving for food sources in the ocean (Morgan 1990), and not something necessary for catharsis. I personally think that tears are a signaling device: "Help me, I'm in trouble, and I'm being submissive—see, I'm crying."

Verbal purging, pounding pillows, and wrestling (and being restrained by group members) with those demons in your life—as is the case in many of these "spiritual psychologies"—alone may not necessarily lead to the desired emotional change of "peace on Earth." Why not? One possible reason is that there is little or no clear retranslation of the event or events in history connected to the emotional outpouring. You may hear and learn that you are a good person, but this is not the same as retranslating specific important events. Retranslation can lead to a more "positive" or at least *less definite assessment* of perceived negative treatment or situations in the past (Rush 1999). Likewise, making an event ambiguous (forcing it into a permanent state of beauty as discussed below), even without full retranslation, seems to lessen a perceived event's impact along with the internal looping and tension. During the training processes connected to these spiritual psychologies, events and the connected feelings (however rearranged over time) are brought to the surface as if confession is all that is necessary. The retranslation (reframing) of specific events, however, is the basic process encountered in psychotherapy all over the world. Without retranslation you end up with gaping wounds, formerly sutured and encapsulated in the psyche. Now that the "truths" have been told, there is a consequent dependency on the group for their help in closure. Closure may not happen unless retranslation is close at hand in time and space. Never hesitate to retranslate—this is your mantra for helping people exit traumas. But rarely is there closure, only more workshops to attend with the hope of the magical awareness that falls out of the air and

closes the wounds forever. For these types of spiritual groups, the goal cannot be therapy in the sense of exiting old traumas. The goal, instead, is to bind the individual to the group, resulting in the formation of a cult, which *excludes* the uninitiated. A cult is simply a group of followers or members who subscribe to some code (some spiritual-energy essence); such people can be manipulated, if the proper creed or set of instructions is followed. The stated purpose, however, is to bring the follower to a "new heaven and new earth" (Isaiah 65:17), breaking with the unproductive and miserable past (formerly called limitations, sin, guilt, etc.) and moving the initiate toward endless possibilities of creativity and "personal growth." The spiritual psychologies of past centuries, often referred to as the "mystery religions" (e.g. the Eleusinian mysteries of ancient Greece and similar ceremonies in ancient Egypt), can also be seen as systems of initiation or indoctrination processes designed to bind the individual to the group or the ideals of a group. Weiser (1991:xi) comments in the foreword to *Egyptian Mysteries: An Account of an Initiation,*

> If initiation is seen as a method for altering states of consciousness, obviously it can still be meaningful today, because many people are aware that another and greater existence lies behind their prosaic everyday lives. If you have ever been in love, you know that the monotonous grind of reality can change at a stroke into a world of glowing joy, simply because you've met someone special. This is no sensory illusion. It is a real state that we could live all the time if we did not let ourselves be overwhelmed by drudgery, frustration, desire, or loss of morale . . . Initiation is aimed at a lasting renewal. This is the difference between esoteric study on the one hand, and modern therapeutic methods on the other. For where modern psychology endeavors to help people feel more comfortable with themselves, esoteric studies show that behind human endeavor lies a world of unlimited psychic possibilities and content. Self-knowledge is the first step in the discovery and control of that

world—a constant renewal can only be acquired by means of step-by-step development, which is characteristic of initiation.

These various spiritual psychologies are primarily rites of initiation and only secondarily therapeutic, but they represent a modern-day version of those mysterious rites and rituals of the ancient Egyptians, Greeks, and Romans.

Social and Self-Flagellation

There are numerous examples of harsh rites of passage in the literature; the rites of the Arunta were discussed in Chapter One. The point is not so much about purging sin as it is purging a former status and the behaviors thus associated. A rite of passage is designed to move the individual from one status to another, for example, a boy to a man. If you do not go through the rite or ritual, then society (or the group) will not sanction the status. You must "graduate" in order to be a member in good standing in a culture as well as a cult.

We can see the vestiges of rites of passage in our educational and other secular systems, for example, obtaining a driver's license. For most enculturated North Americans these rites, however, are designed to bind us to the *idea* that you can become a *self-responsible adult* (see Rush 2002). Obtaining a driver's license, then, is a secular ritual, signifying that you have passed the test only; it does not guarantee self-responsible behavior. This type of ritual is different from the classical rites of passage as found in many cultures around the world. Classical rites were usually designed to bind the individual to the group and self-responsibility may or may not be part of the philosophy.

Many historical rites of passage, especially for the men but at times for women, are harsh by today's standards. These include sub-incision (as practiced by the Australian aborigines), scarring, tattooing, piercing, hallucinogenic and sense-deprivation experiences, and so on. These practices, usually found in preliterate societies, are not designed around the

ideal of building a self-responsible adult so much as anchoring the individual to the group and group survival. Self-responsibility means individualism and the individual taking responsibility for his or her own behavior. True self-responsibility equates with illumination in the Buddhist tradition. You can construct your own rules of living as long as they are healthy, helpful, and non-hurtful. So, how does one begin the transformation, the metamorphosis, from historical enslavement to future illumination?

Purging and Revelation

Pain, in many traditions, is the prerequisite for purging unwanted behavior, past history, or sin and guilt. Once the individual is purged or cleansed, he or she is in a position to receive the revelation or illumination and to understand more clearly his or her purpose and possibilities. Some traditions, like Islam and Christianity, allow all manner of inhuman behavior toward others as long as there is an asking of forgiveness. Even repeated murders, rapes, robberies, and physical and emotional abuse toward others are forgiven by accepting Allah, Jesus, or God as your savior; that's all that is required—your soul is redeemed.

The ancient Egyptians had an interesting idea about confession. Positive confessions informed the Gods of improprieties and decreased one's chances of acceptance into the underworld. To admit one's sins, therefore, was not the appropriate thing to do; instead you should clean up your life, begin anew, and no longer lie, cheat, steal, or otherwise do harm to others. You thus become a new person and thereby can rightly confess the negative—that is, "I have not lied, cheated, stolen, etc." Now some may think this is cheating, but it is not. You do not have to go through beatings or public humiliation to purge sin. Once you *say* you are that person, you *are* that new person; you really are not the person of yesterday. Take, for example, the words of John 1:1—"In the beginning was the word,

and the Word was with God, and the Word was God." In this biblical statement "Word" and "God" are synonymous, and if you have the ability to speak words, you *are* God, with the ability to create a new you. Change truly does come from within. But unlike the Christian and Islamic traditions, if you backtrack on your confession in this Egyptian mindset, your heart might give you away, and *Ammut,* a major underworld bogeyman (actually, a bogeywoman), will consume your heart, which you need in order to exist in the netherworld. Once Ammut eats your heart, there is no coming back in any form, spiritual or otherwise.

When an individual realizes that he or she can simply confess sins for salvation (Islam, Christianity), this opens the door to repeated sins and repeated confessions. With the Egyptian method, however, you clean up your life and you keep it clean—or else; there is no second chance. But there is another issue.

Labeling people, as Goffman (1963) recognized years ago, can actually lock them into not only a group membership and the attached social stigma, but into behaviors as well. In Alcoholics Anonymous, the initiate must confess that he or she is an alcoholic, which keeps that person an alcoholic and offers an excuse should he or she revert back to the old ways. Although this is not the intent of AA, it does represent a problem of labeling by society and self. There are various negative labels that we affix to people (see the *Diagnostic and Statistical Manual of Mental Disorders* or *DSM-IV* for the variety of sophisticated name-calling utilized by the psychological/psychiatric community), and many of these labels, once applied, do not allow the individual to reintegrate into society or become self-responsible (see Rush 1996, 1999).

Again, there is no evidence that confessing sins does anything to change behavior; what changes behavior is *changing behavior,* and this appears to be best initiated through a reinterpretation of life events so that the individual can discontinue the associated thought loops and move on. All is impermanent, all is illusion.

Pain and Awareness

Pain alters awareness; it is a focal point that turns us inward, into the psyche. A physical beating can profoundly change one's attitude, one's beliefs about "self" and the world, and any marks left can be a continual reminder. With a malicious beating or torture it is difficult to predict the outcome. However, pain and/or punishment within a specific ritual process, and especially with the consent of the initiate, directs awareness so as to impart a specific symbol or cluster of symbols (for example, how people should think or behave), with an emphasis on or amplification of his or her relationship to the group and the spiritual world.

Circumcision, practiced by the ancient Egyptians and symbolizing the snake shedding its skin and being reborn, is a standard ritual practice in the Hebrew tradition, representing a commitment to Yahweh and his laws. This is still practiced in North America today within both the Islamic and Jewish traditions. Outside of a religious context, this could be considered child battering or wounding, as there is rarely a medical reason for circumcision. Make no mistake. Circumcision is a form of body mutilation or scarring for the purpose of anchoring a commitment to a set of mythic themes and thus binding the individual to a group. Body mutilation, scarring, or tattooing alter the psyche as well as the body.

Self-flagellation, on the other hand, is self-directed pain, usually for the purpose of purging, and although perhaps prompted for a socio-spiritual ideal (e.g. in Hinduism to avoid being reincarnated, among Christian groups for purging sin, etc.), it is always a personal experience. Tattooing, in one of its uses, can be seen as self-flagellation, but not necessarily a personal form of punishment. It can be used instead as a tool to gain access to and retranslate unpleasant and/or traumatic events in history, to initiate one's physical healing, to experience out-of-body travel, and so on.

Let me make it clear to the reader that using pain to purge pain, trauma, sin, guilt, or past history is surely not for everyone. Self-inflicted pain

used in this context is considered pathological by many, and even highly ritualized and religiously sanctioned physical abuse can be seen as pathological as well (see Favazza 1996). Using pain to promote emotional and physical healing is not to be taken lightly. It demands that there be clear objectives, appropriate symbolism, and designed outcome(s). Pain is not to be used if one is on drugs, to punish one's self, or to obtain sympathy from others.

Although purging with pain can be accomplished on one's own, in some cases it is appropriate to have a guide or at least someone who can help put the appropriate symbols together. In Chapter Five, I outline a process of using tattooing as the source of the physical pain—the conduit to emotional healing and spiritual living—although you could resort to branding or other forms of scarification. Piercing is less appropriate (in most cases) in that the duration of pain is usually too short to allow focus and obtain the desired outcome.

Purging Emotional Pain and Trauma

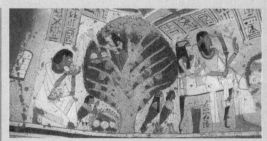

Introduction

Being in touch with your mind, body, and spirit (or that energy that informs all) means being in touch with, or having a memory for, what often are the extremes of sensual awareness. Our emotions seem to be the "stuff" used for information storage and retrieval. Our mental processes appear to tag events with emotions, seven of which might be universal and have evolved out of the neural hardwiring of these emotions, which leak out during arousal and are expressed along cranial nerves that innervate the face. As we live our lives we attach emotional meanings to events, people, places, and ideas that we see, hear, feel, taste, and smell, and these get somehow placed in categories that are augmented over time.

Your brain also changes experiences. As new data come in with age and experience, many events are automatically retranslated. Most people simply use conscious logic to move past the hurt or confusion; others use drugs or meditative states; others still use metaphor or myth to reach understanding or illumination. Models and behaviors for handling our senses and/or conceptualizing them have deep roots in human history and prehistory.

Pain, however, can be associated with differing memories in history—memories of our childhood such as the scraped knee, the neglect, or in later years the failed marriage, children we neglected, the cat we kicked all can be attached to pain. When the mental you is sorrowful, the physical you is experiencing the same thing. Your feet are not doing the Charleston while your mind is in deep sorrow over the death of a loved one. When there is a match between body and mind, this is communicated to others as "congruity." With a mismatch (smiling while telling someone you are angry), it is termed "incongruent." The point is that our bodies are not separate from our minds and that physical pain can help to bring out and release very painful memories (as emphasized in Primal Scream, Rolfing, etc.).

Pain and Transformation

In the early 1970s through the late 1980s, my research interests were human ritual communication and information processing. During this time I came to specific conclusions and then utilized in a number of environments this knowledge of what happens when we talk and listen through specific practices (verbal and nonverbal tools or skills). My conclusions were that we know perfectly well what incantations are invitations to stress and which are invitations to relaxation. Culture is wrapped around what we choose to stress and relax ourselves with, and so there is variation from group to group, but deep inside we know that, universally, rejection (from a parent, sibling, god, etc.) means death. Society taps into that core awareness for its means of control. My interest was emotional pain: how it is generated and directed by both the individual and his reference group. My early studies of the 1960s brought me in contact with volumes of historical and ethnographic data of people and groups using *physical* pain openly in formal rituals for catharsis. These ceremonies appeared to be quite stress-evoking but then offered great release by directing emotional energies away from socially disruptive behavior and toward socially cooperative ritual. These rituals appear to balance the community through intense group involvement legitimizing status change (girl/woman, child/adult) or renewing obligations to a god, ancestor, and so on. Pain and suffering (from scarification and tattooing) are a focal point of the energy; the initiate takes on the suffering of the community. It is through the sacrifice that negative energy or force is channeled away, and to emotionally show pain and suffering might let the demons back in; you have to take it and like it.

These ceremonies are painful, and no one in the audience (the background onto which the ritual is displayed) turns away. They encourage the ritual, they get into the rhythm of "it," the renewal of the community through a shared experience of pain, the pain of death and coming back, in a slightly different form but in balance. Of course the individual

knows he is being watched; he plays to the crowd, and perhaps for the first time in his life he does not cry out or shed a tear-like those before, just like the ancestors. He shows that community that his body is their body (he is no longer in the terrible twos or a bratty teenager), and he does this willingly, just as the pig (in our myths at least) gives its flesh willingly.

As he holds back he learns to interpret his pain differently, the experience or awareness of the pain changes, and it is at that instant that he realizes something has changed in him. With the cutting, pricking, and bleeding, with drums beating, voices all around, and the smell of his own blood and sweat he realizes his connection to the community and the spiritual realm, the ancestors who invited him to this rite of passage.

How does such a painful act transform? It transforms in a similar manner as life's traumas, by rendering the individual (or group) momentarily helpless. And when you are helpless, you dance and create, like Shiva, and at the same time destroy and leave behind the old, which is responsible for bringing in the new. The initiate is taken over by the experience; all "free will" or ability to act independently is stopped. If someone had attempted to hold this young person down on any other day and put scars on his or her body, there would be a real fight. In the ritual context you are the "pig," you are absolutely helpless and your rational mind freezes at least for a moment (in most cases much longer). This is called "breaking process"; I call this a "social singularity" where the past is ripped away and the future is yet to come. Life for the initiate stops (death) to begin again (life or rebirth) either as the physical or emotional pain subsides or perhaps the completion is reached of a ritual process designed to bring the system back to balance. The completion is the social "Big Bang," a new heaven, new earth. In nature we see this cycle over and over and over again, that is, a beginning, middle, and end, and within this we experience happiness and sorrow, life and death. Harsh initiation rites are direct and dramatic reflections of beauty and horror being analogous to poles of a magnet where one is the continuation of the other.

Emotionally painful ceremonies are relatively easy to observe and are what

I would call "rituals of rejection" or "emotional circumcision." They lead the person through transitions to victory, a conquest much more mental/symbolic than is the more permanent (mental *and* physical) scarification or tattoo; ideas and verbal commitments can fade into the past—tattoos and scars are permanent. Either way, emotional and/or physical pain alters awareness, and altered awareness is a primary ingredient in hypnosis and trance states (Preston 1998:14; Rush 1999:158–164) a phenomenon found within the context of most healing traditions. Let me say this again: pain, in a similar way as pleasure, alters awareness and opens a door to change. Pleasure and pain are vehicles for change. And where do we experience pleasure and pain? In our minds, and *through* our bodies. Your body is your vehicle for redemption. And what is this redemption? Visits to the spiritual world to eventually understand that there is an existence beyond the physical one, and that this existence has nothing to do with fear and nothing to do with desire. At this level there is no pain or sorrow, "poor me," a victim, anxieties, or concerns. It is a place of no mind but it is everyone's mind, still and calm, at least for the moment. As you go to this "place" time and again you begin to develop and nurture a sensitivity to others, and life in general, when engaged in the physical world. And as you come and go during the experience you begin to realize how precious life is in the physical world, because in that other realm there is absolutely nothing—and everything—happening at the same instant. But there is no time. It is not a field of action, or inaction—words fail at describing this "realm"; no tongue has touched it.

Pain is difficult to ignore, and each culture appears to have sanctioned ways of administering and expressing pain. In many of the spiritual psychologies emotional pain is accessed through a process of total rejection during training rituals—rejection to the point of breakdown with crying and rage, with hopelessness and fear tumbling forth. Any messages (nonverbal, verbal), either direct or indirect (see Rush 1999), of acceptance, of a higher power, or one's commitment to the group are readily accepted by most during this controlled focus. These rituals of emotional mayhem

are exhausting, as are all good rituals, and they are designed to drive the message "into the bone" (to like one's self, to believe that there is a God, to be a willing servant to an organization). Along with absolute rejection, other methods of surprise or shock (breaking process) are woven into the rituals. A common practice is to have an initiate close his or her eyes, and while the group leader builds an image for the individual in the mind's eye, staffers bring a large mirror into place. The initiate is unaware of what is going on and is about to be emotionally shocked. When opening the eyes the initiate usually sees him or herself in a different way for perhaps the first time. (This is similar to some of the processes suggested for the Eleusinian mysteries in Greece of 2,500 years ago and the Egyptians 2,000 years before that.) The basic reaction to seeing one's image is crying, not laughter. We learn in our culture that change comes from hard work, pain, and suffering. The initiate is socially required to cry.

This and similar processes are very old and indicate an ancient knowledge of how stress and shock alter awareness by stopping the thinking processes and creating confusion—a singularity. The brain as a system feels threatened with confusion; helplessness means death. Messages delivered during this confusion and then reinforced after ritual completion (with support and kind words, high levels of touching to further anchor one to the group; in some cults this goes as far as ritualized sexual behavior) can lead to new ways of experiencing or appreciating the world around you. The initiate in the above mirror example is a willing participant who is caught unawares, but willing or not, we all receive and plant messages that bolster or degrade group-worth or how you see yourself with respect to others. This is happening from the moment you are born until the day you die; all is illusion, all is impermanent.

You can use meditative states on a regular basis (once or twice a day) and by consciously stopping thought patterns, the resulting thought processes seem to alter brain waves over time as well. This is a long but rewarding process.

Another method is to combine stress/pain with relaxation to develop

a working meditative state where in you can actively access traumas, ancient history, evil deeds, and then retranslate these events, throw them out, or make them ambiguous (you add, remove, or alter information in your mind—see Rush 1996).

Confessions of "sins" and life changes usually take a great deal of work. Breaking old thought forms and habits is not an easy task. Conservatism is built into our mental processing structures as a means of maintaining some illusion of stability, control, or power over nature. When stability and control melt away, madness and disorder or chaos can come to the surface, and only an ordering, reordering, or retranslation of the symbols will bring us to the light. It is analogous to life, death, and return (see Rush 1999). It is important to realize, however, that purging sin is not, in itself, a spiritual act. It is what comes out of the act that might be considered spiritual. Purging, like asking for forgiveness, is the first step.

Tattooing: Pain, Purging, and Profound Change

Purging through physically painful ceremonies is a little more difficult to observe and document in North America than the emotional purging noted in spiritual psychologies because the pain-centered ceremonies are usually secret. Again, pain alters awareness and this awareness can be directed toward emotional issues and their sensual connections (visual, auditory, kinesthetic, etc.) or references. Tattoo therapy is extreme by anyone's standards, and it should only be engaged with full knowledge that the procedure is painful *and* permanent. I'm not talking about a small rose on your shoulder or "Bite Me" on your ass; this process requires the spilling of significant amounts of blood and inserting a significant amount of ink into the skin.

The procedure of using tattooing is simple enough, but it requires a great deal of forethought and honesty with one's self with respect to what beliefs and behaviors to alter. Keep firmly in mind that you cannot fix anyone else; you can only fix yourself and your illusion of the world. Moreover, you

cannot fix that which you cannot or will not acknowledge. What follows is the description of a process I constructed for myself in what began as a research project and turned into an experience that went way beyond ink under the skin—one that was painful but willingly entered into, although I questioned my motives and sanity many times. I cannot describe in so many words how I am different, although friends and family say I seem more relaxed with less anger. I am also not sure how I used to think about the world; I certainly do not have much fear now regarding my surrounding and world events. When you retranslate an event or belief it is like changing the content of a file. I suppose that there is a ghost of the original file in there somewhere, as a possibility of thinking or behaving, but I have no way to access it. Certain thought patterns—for example, starting to feel angry over some little stupid thing—get short-circuited; it just isn't important. My body is certainly different, and even though I cannot see most of the hieroglyphs (and those I can see are viewed by me either upside down or reversed in a mirror), I never feel completely undressed even when I am without clothes. There is a real change in how I perceive my body.

Through tattooing I also remolded my myth of death, and rather than having a blank, empty place past the dark gate, I fashioned another realm, another life, an *underworld,* a chthonic realm, "The Field of Reeds (or Rushes)," where there is "beer and bread, leopards are beautiful cats, and all is love and spirit." This is a really nice place to go when you die, "the temperature is great," but how do you get there? That myth is detailed in *The Twelve Gates.* Getting past the demons of history, those monsters of the past all self-created as you experience your world—this is the first step.

Historical Information for Reframing or Retranslating

Therapy, either self- or other-directed (seeing a therapist), involves being honest with your self. What are those thoughts and behaviors that represent limitations and regrets? Do you drink too much? Are you overweight and

use anger to chew up the world, perhaps using weight as a barrier to others, or maybe you are "weighting" for something to happen in your life? Do you cut on your body to purge your guilt only to find that it doesn't last, that the ugliness is still there, now as a scar, which needs to be hacked apart again hoping for new heaven, new earth? Do you worry about being loved by parental figures? Was there molestation, rape, or emotional or physical brutality? Perhaps you lack humility or integrity through lying, cheating, stealing, or maybe you can't maintain an intimate relationship with another. Perhaps you are depressed over the loss of a loved one or are in a dead-end job or marriage, or possibly you have seen horrifying events that trouble your dreams. Maybe you are afraid of people or phobic in other ways (fear of flying, driving, going over bridges). What is it that you bother yourself with? All these traumas, all these fears and desires are possible points of transition from the old to the new. *Remember, these are your emotions and events. You* put these events into your mind, it is *your* translation of the events, and it is *your* emotional reaction and storage. If you believe that others give you feelings, from love to rage, it is best that you keep going to temple, church, or mosque and pray for illumination, and read no further. Unless you realize that illumination come from you, from within, and not from the outside, you can never go past your animal nature. Your emotions are your own and they are your passport to a spiritual life.

Make a list of all those things that you bother yourself with: think about it. What are all your fears and unrealized desires? Revealing your dark side, your shadow—this is not easy but it is the most important step. If you cannot be honest and upfront with yourself then go no further. Just look at others and see what you do not like—that is what is inside you. Make a list.

Your next step is to choose the image(s) that will absorb your pain, reframe it, or at least make your historical issues ambiguous.

Choosing a Theme

Tattooing is permanent and it is obviously important to choose images you can live with. These images will be part of you *forever*. Not only should the images be appealing, but the images, theme(s), or myths represent your release. Beautiful landscape scenes are most appropriate for real horrors in life, the murder of a friend or relative, a rape, brutal parents or spouses, or other traumas. It is interesting that those ladies who have had mastectomies usually choose landscapes, plants, fish, birds, and so on to absorb and heal their altered bodies, rather than skulls, crossbones, or other macabre images (see Mifflin 1997 for examples). I chose Egyptian myths and images because there is something there for every occasion.

Go to a library or bookstore and review works of art from different cultures or belief systems, such as Chinese, Japanese, Celtic, Christian, and so on. I don't recommend skulls and crossbones while erasing traumas regarding death *unless the death image can be made ambiguous with surrounding representations*. For example, death does not mean quite the same thing in Mayan or Aztec art, for out of death comes life. Mayan and Aztec mythic symbols are horrific to say the least, but they could be a wonderful choice. For me, however, the Aztec and Mayan images are just too powerful.

It is important to study the myth connected with the images you choose, and if the images are of your own creation, make sure there is a positive outcome to the story/myth. Your tattooing should tell a story, with a beginning, middle, and end, a story that takes you past the old symbolic references that have bound you to an unhappy, unproductive, torturous existence, *a history that you created*. You need to build a story that brings you out of the old and into the new. Any competent psychotherapist can help you with this, not the humanistic brand who simply listens and shakes his or her head. Look for one who is into archetypes (Jungian therapists) or someone trained in the Milton Erikson-type storytelling processes.

Placement

Once you have chosen the images, colors, and story line, your next step is placement. As there is still some stigma attached to tattooing in this country and our values change over time, choose a place that is inconspicuous. Remember, this is your personal, private experience and not something you will necessarily want to share with the world, for once you go though this process and you approach it seriously, the old story—the old trauma(s)—will never need telling again. You will be free of it ("new heaven, new earth") with a new story to tell about the "art" on your body, a new myth just under your skin and not crushing your soul. The trauma will be forgotten or certainly minimized, and no one, especially you, wants to hear the same old broken record.

The most inconspicuous areas are your lower back, around the buttocks, groin area, and upper thighs. Many of these areas are the most painful to tattoo, and this level of pain allows you to get really deep down emotionally. This is tough work, exciting perhaps, but it is not fun. Purging of "sin," the demons, your limitations, is serious therapy, one that is results-oriented; you will be changed in mind and body.

Choosing a Tattoo Artist

The artist you choose is of the utmost importance. Do not simply go to any tattoo studio; shop around. Talk to people—find out where others have gone and what their experiences were. Check out the artist's portfolio and hygienic practices, that is, are there clean floors, neat desktops, and so on? While in China my wife and I examined studios in Beijing and Shanghai, and although they were probably safe, the overall hygiene left something to be desired. Tell the artist what you intend to do; show them your art (flash). Show them this book and get a feel for the person. You will become connected to this person as an energy and creative source, not as an object of sex or carnal desire, but as a vehicle of release. Choose carefully.

Some artists like to talk while they work, or there could be people coming in and out of the studio, or the telephone may ring. These are all distractions to say the least, but most artists will understand and keep distraction to a minimum.

Processing Trauma

Once you have chosen the demons to purge, themes, the flash, made a proper decision as to placement, and have chosen your artist, your hard work begins. If you are a "virgin" (one who has never been pricked), here, in general, is what you can expect. The first part of the process is to outline your images or flash. When the tattooing begins, a good artist will rub Vaseline or A & D Ointment on the skin. This allows the tube of the instrument to glide on the surface of the skin, it slows down blood flow, and it causes a slight desensitization of that area. Applying the Vaseline should be done gently but firmly so that you will know where the ink is about to flow. (Most artists will do this, as it is part of their ritual process— tattoo artists are highly ritualized.) At the same time you will hear the buzz of the machine, and then you will experience perhaps a pricking or burning sensation, which in the beginning may seem quite painful. Embrace the pain; play with the pain. Close your eyes and, if you tip your eyes down and to the right or left, you may experience that the pain will intensify. If you move your eyes to mid-line and concentrate on the buzz or perhaps some music playing or a voice in the next room, the pain will lessen somewhat; and if you tip your eyes up and to the left or right, you can focus on all matter of images, some of which will lessen while others will serve to increase the pain sensation.

As time goes on, perhaps five or ten minutes, and depending on the level of pain experienced, endorphins (opiates of the brain) will be released and the experience of the pain will change (usually diminish). It is easy to "trance out" at this point by simply tipping your eyes up slightly and focusing on colors. Blues, fuchsia, or even red seem to be the easiest for

me to imagine, although swirling gray is fine. Women seem to have an easier time seeing colors, and some men may have to work at this. When you trance out, however, you cannot accomplish good therapy. The pain can be regained or enhanced by simply looking down and to the right or left (some people will experience more pain by looking down left, others down right).

You will notice that as the pain increases there is a tendency to frown and tighten up other muscle groups in the body. Be aware of this and allow yourself to relax these muscles. Relax them all so that your body feels like it is hanging off the needle; the more you relax the more you can accomplish. So here you have the two basic components of hypnosis: stress (the pain) and muscle relaxation. You are ready to go.

For therapeutic purposes go into the pain by tipping the eyes down to the left or right, depending on which side allows a fullness for the pain, and at the same time relax the muscles in your forehead, jaw, and face. Relax your shoulders and unclench your fists. Relax your mid-back, your lower back, right down through your legs to the tips of your toes. Relaxing under pain is not easy; it takes practice, but when you do relax you can go into a controlled trance or hypnotic state. This might take a couple of sessions to learn how to relax into the pain. Here you have a glimpse of the spiritual realm. Through the process of relaxing into the pain you reach a point of no experience as the relaxation cancels the pain and the pain cancels the relaxation. Hold it there just as long as you can. This is the sound of one hand clapping. Before you purge your demons your mind has to be in neutral with no fear or desire.

Next, bring up the situation or trauma, the images, sounds, smells, or sensations that you desire to transform. This means going with your eye movements from down left or right maintaining the pain, and then accessing the remembered event in history—the death of a loved one, the intense rejection, rape, or beating. You will notice that muscles tense, and it is important to *retain* the image and at the same time *reduce* the tension on the muscles, which internally cancels the "tension" on the memory. This,

in a holistic fashion, changes the meaning of the event, and once you change the meaning of an event, its foundation or original meaning collapses.

Next, lift the eyes up to the left or right (whichever side allows the clearest image of that to be placed under the skin), and hold them there for several minutes of the tattoo experience.Continue to eliminate any muscle tension. You will experience an interesting phenomenon as you combine the physical pain of the tattoo with the image or sound in history; the historical recall changes, and it almost, in a word, evaporates.

This is tough work, and some might benefit from a third party leading them through the images, sounds, and so on, and then to the art being tattooed in a specific location.

One final note: Do not engage this process while under the influence of drugs, including alcohol, marijuana, amphetamines, cocaine, Prozac, or any other prescription mind-altering drug. *All* will interfere with the effectiveness of the process. If you are a frequent user of these drugs, including prescription mind-altering drugs, they are part of your problem with life. Using pharmaceutical drugs to simply mask symptoms (physical or emotional pain) is the irresponsible practice of medicine and leads to addiction.

There is a second part to this purging of emotional pain and trauma. From this point forward and without the pain of tattooing (scarification, etc.) you can extract the good experiences from your history and what in these events helps you survive today. What are the strategies that are healthy, helpful, and non-hurtful, allowing you to relate to others in a low-stress, sensitive manner? These thoughts, feelings, and strategies are there for you now and, although you did not know they were there, those alternative and more positive interpretations of these traumatic events were with you all the time as well. As the Buddha stated, we are all illuminated (Buddha consciousness), we just don't realize it. We can do magical things with symbols and our minds. We can alter meanings, allowing us to exit even the most horrific of experiences, and get on with life rather than living in a past that no longer controls us.

Pain and Physical Healing

Hypnotic and/or trance phenomena revolve around intense focusing: the sound and words of the therapist in Western hypnotherapy, the eccentric behavior of a Siberian shaman, or very intense dance, as among the San Bushmen of South Africa. In this respect, focusing on pain can also be useful for physical healing. There are at least two possible methods to this procedure. The first is simply to focus on organs or conditions of the body (cardio-vascular, skin problems, liver detox) and, using your imagination, visualize healing or rejuvenation conjoined with the pain. Keep in mind that we have a belief in our culture that success is attained only though blood, sweat, and tears. The metaphor of spiritual tattoo is the removal of the old self, physically and emotionally, and allowing the beauty inherent in the aches and pains of life to come through in *your* sacred writings, your tattoos or scars. Mind-body healing is not a new phenomenon and has been discussed by the psychological, anthropological, and medical communities for many decades (Rossi and Cheek 1988; Rossi 1993). Trance states are common in most healing traditions and are used to create a transformation of state leading from the old to the new, from the trauma of history to emotional, physical, and social balance.

A second possible procedure corresponds with using acupressure points and connections to organs as a process of focusing and ideally healing. During tattooing around my thighs and waist I could connect pain to sensations in different organs in my body. The liver, kidney, and testicles, for example, would vibrate, or at least that was the sensation I experienced, and I focused healing attention on each particular organ. As the tattooing continued over the following weeks I attempted to connect acupuncture points with sensations in other areas of the body. A difference is that only one needle (or group) is involved at any one moment at any one point of the skin in tattooing experience (unless you are being worked on by two people), while with acupuncture several needles are usually employed in different areas.

With tattooing, when I could feel sensations in some organ in my body, I focused my attention to that area and simply imagined healing taking place. This could be with the use of colors gently draping and rejuvenating an organ or perhaps soldiers moving in to remove any cells that are of the wrong color, in the wrong place, or containing holes where cancer cells might hide.

Many people are under the impression that they are healed by doctors, herbs, pharmaceutical medicines, or surgical procedures, but this is not the case. The body heals itself, assuming that there is proper nutrition and nutrient absorption. In trauma surgery, bleeding needs to be stopped and wounds closed, but the body is the eventual healer. Your mind is your doctor; the body will usually heal itself if there is trust in your healing capability and you know how to direct it. Mainly for economic reasons, or simply out of ignorance, we have been deluded in Western culture to believe that the medical doctor, the USDA, the FDA, and pharmaceutical companies are our saviors, the seat of our healing in a similar fashion that people are led to believe that God resides in a church, temple, or mosque and can only be accessed through a minister, priest, or religious cleric. Healing and God are within you; own your God and own your health.

Perhaps tattooing is an extreme method for focusing healing thoughts. Keep firmly in mind that neither the physician nor the drug cures; it is the mind-body that heals given proper nutrition and toxin removal. In the case of tattooing, you are using pain as an intense meditation point of healing. The mind is joining the body in the cooperative quest of healing and spiritual immortality.

Dream Work

The pain induced during piercing, scarification, and tattooing will usually lead to periods of intense dreaming. These dreams could occur that night or the next night, and usually within three nights. Dreams are

curious neurological events that may or may not be connected to unconscious and repressed memories or to archetypes. They may or may not be connected to processing out the garbage of the day. Dreams might be the product of neurological repair during which memories are transferred to new tissue, and because we are internal without a social context as a reference point, the "mind" builds one onto which it assembles a story. In our conscious life many of the pieces assembled would not make any sense because they are out of context. But the mind does not care, and the constructed context seems perfectly normal at that level of awareness. The message here is that the "mind" knows that there are other possibilities outside of our senses. The mind is that part of us that connects us to everyone and everything in the universe, and if you would like some insights into the mind, look into the dreams that come from your pain experiences. There are many models you can use to examine your dreams, including Freudian, Jungian, and so on, and there are many books on dream analysis and dream symbology. You could choose to utilize these philosophies, with or without simultaneous tattoo experiences.

There is, however, another method that was very popular in the early 1970s and which may be a more useful and direct way of acquiring insights into you and your perception of the world. The process is called Gestalt dream work, popularized by Frederick Perls (Perls, Hefferline, and Goodman 1951). The procedure, for the most part, is to make note of all the elements in the dream in a linear fashion and then role-play each part, that is, pretend you are those elements in the dream—the water, the house, the car, the dog, the man/woman, and so on. It is not important that you believe in the theories connected to Gestalt dream work, nor is it necessary to have someone interpret your dream elements. This is your therapy; you know exactly what your dream elements mean. You put them there—just be honest with yourself. This process can lead to some interesting insights. Remember that you are the one who assigned meaning to everything in your life, and if you assigned it, then that memory can be transformed, leading to momentary and eventually long-term release (Moksha, Nirvana).

To understand some of your social conditioning, assign a gender to everything in the dream—the sky, the earth, the shoe, the closet, the car, the drug(s), the sounds, the sensations, the smells, the tampon, the blood, the hair, the bridge, and so on, when you role-play the elements. Bring it all up symbolically, role-play it, and just let it go, moving on to the next element in the dream. Symbolically purge the dream elements from your body. You do not have to have a "correct" interpretation of dream elements. Just act them out and meaning, if any, will be revealed.

Understand that any dreams connected to your tattooing experience(s), in my opinion, could be bits and pieces of that purging done under pain now manifesting. These dreams can be quite bizarre but usually not threatening. The message of a bizarre dream is not the dream elements but the "mind's" confusion, prompting it to build a context within which the information can be displayed, heard, or felt. Nothing in the dream (if the dream elements are simply random events or images accessed during tissue healing) can mean anything on its own. These bizarre dreams may come about, as mentioned, through healing of neural tissue (our bodies go through a healing phase while we sleep, and it does not seem unreasonable that healing of neural tissue triggers these internal memories). However, the bits and pieces of the dream can be approached when you put your "mind" back in and role-play and genderize the parts. (See *The Twelve Gates* for more on my personal dream work.)

After purging, move toward healthy, helpful, and non-hurtful behavior; take the middle road on your fears and desires.

Breathing

It is very important that during the pain experience and purging, you continue to breathe rhythmically and continuously. When you stop breathing (hold your breath), this causes stress and thereby accentuates the pain. Further, breathe through your nose and not your mouth, as mouth-breathing can bring on fright-flight responses and likewise accentuate the pain.

Pain and Addiction

Pain, for the most part, is something to be avoided. Our bodies are provided with sense organs that signal cuts, scrapes, bites, and more serious injuries. The chemicals generated during the pain experience have their counterpart in other chemicals designed to dampen that sensation. Some of these chemicals are endorphins or what have been termed "opiates of the mind." Self-inflected pain, as in the process of tattooing, causes endorphin dumping, which suppresses chemicals involved in our sensations, while also moderating emotions. It is common knowledge among those with several tattoos that for many hours or even days after a session there is a sense of calm and a feeling of accomplishment. In perhaps a similar way as self-mutilators (Favazza 1996:262–263), the pain, pleasure, calmness, or feeling of accomplishment go together to reinforce the event in anticipation of another session. Thus, tattooing can be addictive if all you seek is release and a mellow feeling for the moment. So as not to become addictive, the above process needs to be highly ritualized withclear goals that have a beginning, middle, and end.

Symbolism and the Tattoo

Throughout this work I have suggested general symbolic values attached to body modification, for example, rite of passage or transitions. Body modifications, then, are always symbolic. That is to say, they stand for something beyond themselves. When you watch the commercial for the new car on television, the ad is not the car. The ad is a composite of ideas about movement, from place to place, family, status, sex, and so on. A tattoo is not strictly itself, the ink under the skin. The tattoo (piercing, scar, implant, etc.) is a door that opens to a wonderland of ideas and memories, regrets and successes, and all the fear, hate, guilt, sin, love, sensitivity contained within. A tattoo is you and is more *you* than perhaps anything else. Why? Because you put it there; it never existed before and it is an expression of you. A tattoo, as a statement about one's self, is not a singular

symbol with a narrow frame of reference. For example, according to Cirlot (1962:161), a knife is:

> (a) symbol which is the inversion of sword-symbolism. It is associated with vengeance and death, but also with sacrifice. The short blade of the knife represents, by analogy, the primacy of the instinctive forces in the man wielding it, whereas the long blade of the sword illustrates the spiritual height of the swordsman.

Cirlot (1962:263) also states:

> The single rose is, in essence, a symbol of completion, of consummate achievement and perfection. Hence, accruing to it are all those ideas associated with these qualities: the mystic Centre, the heart, the garden of Eros, the paradise of Dante, the beloved, the emblem of Venus and so on. More precise symbolic meanings are derived from the colour and number of its petals.

In a popular dream analysis book (Miller 1996:264) we read:

> To dream that you wear a sword, indicates that you will fill some public position with honor. To have your sword taken from you denotes your vanquishment in rivalry. To see others bearing swords foretells dangerous altercations. A broken sword foretells despair.

For roses Miller (1996:58) states, "To dream of seeing roses, blooming and fragrant, denotes that some joyful occasion is nearing, and that you will possess the faithful love of your sweetheart." Roses, in this sense, symbolize hope.

Tresidder (2000:130) states:

> Beyond its obvious aggressive-protective function, the sword is an

important symbol of authority, justice, intellect, and light. One explanation for its unusually rich symbolism is that the arcane skills of sword-making meant that swords stronger, sharper and better balanced than others were credited with supernatural powers. Hence the frequent appearance of the sword as an emblem of magic and the many legends of magic swords, such as the Arthurian Excalibur, which can only be drawn by a man of exceptional virtue and strength—spiritual and physical.

Tresidder (2000:95) comments about the rose:

The paragon of flowers in Western tradition is the Rose—a mystical symbol of the heart, the center of the cosmic wheel, and also the sacred, romantic and sensual love. The white rose is an emblem of innocence, purity and virginity, hence the description of the Virgin Mary as the Rose of Heaven. The red rose symbolizes passion, desire and voluptuous beauty. Both are symbols of perfection. The rose's association with eternal life causes rose petals to be scattered on graves at the Roman festival of Rosaria, and Roman emperors wore rose wreaths as crowns. Mortality is symbolized by the brown rose, and the red rose can signify spilt blood, martyrdom, death and resurrection . . . In Christianity, the blood-red rose with its thorns was a poignant symbol of the love and suffering of Christ . . . The rosette (the rose seen from above) and the Gothic rose also have wheel symbolism, connoting the unfolding of generative power—making the rose a Western equivalent of the emblematic Asian lotus.

According to Green (2003:232):

The sword is a symbol of the warrior but principally a warrior of virtue, even righteousness and justice. It has long been a symbol of

power, especially in heraldry, and in some cultures skill with the sword was considered an art form. In myth, swords are oftentimes the gift of the gods to special individuals or are magical in some way, as with Excalibur, the legendary sword of King Arthur. In tattoo artwork, it is not uncommon to see swords done in fairly elaborate designs, perhaps jeweled with ornate handles, and even specific to a certain culture.

For tattooed roses, Green (2003:205) suggests the following:

Like the lotus in Asia, the rose is the preeminent floral symbol of the West. With their deep red color, they have historically been associated with blood and hence Christ in Christian iconography. Roses have been used in heraldry, freemasonry, alchemy, and in festivals of ancient Rome and Greece. In modern iconography, they are part of love symbolism and are synonymous with that which is beautiful. In tattoo art, roses are likely the most frequently appearing flower, sometimes complete with stem and thorns. As in other symbolism, their meanings in tattoo vary widely with each use, though most uses are based on the beauty and romantic symbolism for which they are so well known.

We might see tattoos and the stories that surround the symbols as mythic images no different from the stories that have come down to us in our own culture and cross-culturally. Myths share common ground with dreams and, according to Freud, there is little difference between myth and dream. Freud does have a point. Within a specific culture one would expect to find continuity among myth, dreams, and symbols important to the individual. Freud likewise stated, however, that dreams and myth are the product of the neurotic mind. Following the thread of logic further, the symbols tattooed on the body would represent workings of the neurotic mind as well. Sir James Frazer, a contemporary of Freud, made

a similar connection between dreams, myth, and neurosis. In any event, according to Frazer (1963:208), "People of the Punjab who tattoo themselves believe that at death the soul, 'the little entire man or woman' inside the mortal frame, will go to heaven blazoned with the same tattoo patterns which adorned the body in life." We can see in this example that myth and tattooing go hand in hand.

Several examples will show that tattoo symbolism is much more complicated than the above authors suggest, and that tattoo symbolism, like that of dreams, is complex and transitory.

Case Study A

Andrea, age thirty-five, mother of three children, has a rose and dagger on the back of her left shoulder (Plate 5-1). As she states, this was "a feeling thing." In other words, she did not research the symbolism of roses and daggers; these are important symbols internalized from cultural conditioning.

> The wildroses and the sword (dagger) are both me. I had the first rose and dagger done when I was nineteen, in Texas (when I was in the military); it was a feeling thing. And after the tat was done, I felt empowered.
>
> Wild roses are my favorite flower because they are the most beautiful, strongest flower (the thorns), wild, and no matter how much you cut them down, they keep coming back, like me. You have to be careful when you hold them, or you will get poked. However, the thorns are gone from my roses (like a bird with clipped wings). I feel like I was de-thorned in my earlier years ... [when I was in] ... a very vulnerable state. Very mishandled. So I had to grow a backbone and become strong ... the sword. The roses are wrapped around the sword. Now, once again, watch how you handle the roses because NOW, you will get cut if handled the wrong way.

Plate 5-1: Andrea with her rose and dagger tattoo.

The colors and sizes mean this: I wanted the roses in different stages of bloom. Just like how I've been going through life. The biggest rose, the one in full bloom and colored orange, is where I want to be and where I'm going. Orange is my favorite color. I had it redone recently and I love it! I would like to keep adding onto it as I conquer more hurdles in my life. It's like my own personal book of my life to me. Who knows, I may start looking at some different flowers to stick in there. I just gotta see where I'm at in my life. Plus, I feel soooo sexy having it!

Comparing Andrea's symbolic meanings with those quoted above, one can see a strong fit but with her own personalization. There is another factor to consider. Tattoos refer to each other. For example, I tattoo a rose on my right shoulder, as art for art's sake, and then, one year later, I have a rose tattooed on my left. With the second tattoo I might say, "I did it to symbolize balance in my life," but I would necessarily have to have the

first tattoo as a reference or starting point in order to come to that conclusion. Tattoos do not represent disconnected events or mere snapshots of a thought or emotion at that time, but large superchunks of information not always self-evident in the art itself.

Moreover, as the body is in motion, so is the art, especially when large areas of skin are involved. Alignment of tattoos as you move your body can be such that entirely different images can be seen over time. This is the well-known gestalt phenomenon. In other words, within a large tattoo, depending on the angle from which it is viewed, one can make out images or symbolic references not necessarily intended in the original tattoo.

Case Study B

Sarah, a tattoo artist, made the following statement.

> In the tattoo studio we tend to classify people; we make judgments. And oftentimes we do not understand the meaning of the symbols going under the skin. Some judgments are done for the good of the client, like when a young male wants his girlfriend's name on his shoulder, and we try and talk him out of it. Often we hear that it was the girlfriend (or boyfriend's) desire and not the one being tattooed. Sometime I take the time to listen through with clients and attempt to understand the significance of a spider, for example.
>
> I have never had someone come in and say, "I want you to tattoo a name on me because I am looking for acceptance." Or, "Will you put a rose on my hip to portray the innocence of my sexuality?" It is normally, "I saw this in a magazine and thought it was really cool." But sometimes things go much deeper. I found, however, that just talking about the tattoo was not as informative as asking about the person—where they were when they got a tattoo, and what their juvenile/adult life experiences had been like. During a recent session, for example, I bluntly asked the client: (1) what kind

of person he had been prior to a tattoo; (2) over time, how did what he was trying to express to society change, and (3) did he even know he'd changed? I had worked with this client before and because we already had a relationship, I assumed I could bring this to a more personal level.

I started by asking the man about his life as a child. He was completely thrown off and asked me what that had to do with his tattoos, but I just listened through and he started to tell me about his childhood. He grew up in the seventies and was raised in a two-parent home where he felt very accepted and admits that he was pretty spoiled. He attended a strict Catholic school in the Bay Area and was popular. The school apparently did not have a large focus on sports, but on other things like art and music. Over the years he got into music and learned how to play the guitar very well. He was almost sixteen and had started to fall in to the "rock star" category. So he grew his hair long and changed his appearance outside of school. When he was nearly eighteen he attempted to get his first tattoo without his parents' knowledge, but the studio turned him away. He didn't even know what he wanted. Then another factor played a part in his first tattoo. His parents found out that he had attempted to get one. They were furious, stated that he was immature, and demanded that he never do such a thing again. He was very insulted and felt he really needed one to prove that he could make his own decisions. He walked into the tattoo shop not knowing what he wanted and walked out with a cartoon on his shoulder that he didn't even like. But that didn't matter to him. His first tattoo on his eighteenth birthday was a Pink Panther smoking a cigarette with a bottle of Jack Daniels in his other hand! Tattooing wasn't mainstream yet, but if you were a rock star you had at least one. His parents rejected him and stated that if he was old enough to make his own decisions, he was old enough to live on his own. This was his rite of passage.

He moved out of his parents' house and in with his first girl-friend. She was ten years older than him. Now that his parents did not accept him, he was grasping for acceptance. That's where his second tattoo came into play. This one was a lot smaller—his girlfriend's initials on his right ankle. He said that there was pressure by her to get the initials, and because he was looking for her support in life, he turned into a "Mary" for her acceptance.

The third tattoo was on his other shoulder. He said that his main reason for getting his third one was because he was now in his early twenties and wanted one for himself. Not because there was pressure or because he had something to prove, but because he wanted a piece that was more personable and made a statement about himself. He chose a rose that looks as if the stem is stabbing him in the arm with just a touch of blood. He said that he still needed to have something that was masculine, but something that also appealed to him. After this piece was done he realized how addicted he really was. This happens often when people start to apply flash to their body. He felt at this point that his body had become a canvas and that it was his job to express himself on it. It was the same year that he had "found himself" and left his older girlfriend; that was followed by a cover-up session to remove her initials from his ankle. He was still going for the dark and edgy look that appealed not only to him, but also the rock and roll industry that he was trying to break into. He chose a black widow to cover his ex-girlfriend's initials. When hearing this I asked if his break-up was an easy one, almost already knowing the answer. He said no and went into detail about how much he was hurt.

I then asked if his choice of tattoos was a conscious one. He wasn't sure what I meant and so I told him about women and the symbolism of the black widow spider. He knew the story and we both thought how ironic it really was that he subconsciously picked that symbol. He also informed me how much he hated spiders. I

really felt that this tattoo was the true portrayal of how he was feeling about his past relationship.

His most visible and largest tattoo was a moon on his forearm surrounded by dark clouds with three bats over top of it. He said that he was at a point in his life predominated by sex, drugs, and rock and roll. More than ever he needed a tattoo that was visible and put an edge to his rock-star look of waist-length jet black hair and black clothes. He still wanted to express himself and felt that it really added to his dark edgy look. However, with this one he also started to feel that he was putting himself into a stereotype and said, as he reflected on his tattoos and his body, "In another life I wouldn't do it again." His tattoos revolved around proving himself and obtaining attention from others, motives that no longer existed. He no longer feels the need to rebel against society and would even consider having them lasered off.

Case Study C (Plate 5-2)

Kip, age twenty-seven, is a yoga instructor in Northern California. He relates the following about his tattoo:

I was almost killed sea kayaking in the Cook Islands in '99. This near-death experience challenged me and I was directed to a shaman on the island of Rarotonga. His name was "T," and he had me write down my beliefs so that he could match the iconography with what I wrote. The three waves that create the triangle mean *unity*. The dolphin at the bottom means *freedom*. The palm tree represents the Polynesian *tree of life*. The face at the top is the moon, and moving down is *Tonga*, the Maori *creator God*, and inside the waves at the bottom are *warriors shoulder-to-shoulder* from a bird's-eye view, and over that are *sea birds*. That means brotherly love and remembering your family away from home.

The second design is *thatch* and represents the handiwork of the

Plate 5-2: Kip (lateral portion of right thigh) and Pacific mythic themes.

people, which means *"tight community."* The third band is very intricate. At the bottom are *waves—Mother Earth;* at the top are *clouds—Father Sky.* The *circle* that creates is infinite life, and the items in the center of the circle are *stars.* Stars and the moon (from above) are how the Maori navigated, so that means *knowing your way* and not getting lost. The *gecko* is reserved for the shaman. Every seventh son was raised to be gay and shaman. "T" is very straight for the record, not that it matters, but I do not wish to misrepresent him.

At the very top is *topa,* the traditional fabric of the Maori, which is made from the palm tree. The bark of the palm tree is made up of concentric *arrowheads* and represents a positive attitude. The warriors would go into a sweat bath before battle, come out, and grab their spears. So they would be ready to go—with a positive attitude. The Maori made shelter from the *fronds* and the *coconuts* represent fertility. In 2002, I was in Maui and a *Kahuna* (elder) told me more of the story.

She told me there were layers of meaning, but that she would not tell me everything unless I was to go through a ceremony. I was of course willing, but she became sheepish about it and I was respectful and did not push her. She told me the *triangle of waves* represented The Mother Earth. The thirteen lunar months, the Polynesian calendar, were represented. She told me I was very lucky as a white person to have such a tattoo and not to take it lightly. I do not. It took four and a half hours to complete and it was painful.

Case Study D (Plate 5-3)

Katie was fifty the day she received her first tattoo. Fifty was an important transition for her, and getting this tattoo was not a spur-of-the-moment, compulsive behavior. What I understood from my research was that more and more adults are getting their first tattoo in their late thirties, forties, and even fifties, often when they are at a crossroad in life. Outside of earrings, most of this older generation are not as interested in piercing.

The first tat had to do with my rebellion. The fact that I could do something out of character, that is, at an age considered too old to start something like a tattoo, appealed to me. I decided on three flowers that represented my three kids. The tallest flower represents Erik who is quieter than the others, Jason who is big and flamboyant, and Greg, the combination of the two. The Phoenix and Dragon are my connection to my husband as our female/male energies bring balance. These symbols are also our commitment and ties to life after death, and a faith in another existence, maybe a new challenge, maybe a place to meditate between lives, maybe no place at all. It is just nice to make those symbolic connections and express a spiritual connection to those ideas and go out with hope and excitement rather than fear and despair.

Plate 5-3: Katie's tattoos. Flowers are to the left of the phoenix' wing.
Note the dragon on the left leg.

Case Study E (Plate 5-4)

Self-mutilation, as mentioned in Chapter One, is an attempt to purge
pain and suffering and is really no different in goal than group-sanctioned,
ritualized cutting, branding, or tattooing. There is a difference, however,
in the final part of the ritual process. In group-sanctioned scarification
there is a recognition that the act, the cutting away or death, was suc-
cessful and that success is embodied in the scar for all to see (thus bring-
ing group approval). In self-mutilation there is *disapproval* and so the act
is repeated over and over each time in hope that the task is accomplished.
If it is not recognized as an accomplishment by those important "others,"
then the task was not completed or successful—but there *was* a moment
of release. With self-mutilators it is important to stop that cycle by wel-
coming the behavior and redirecting it. Many self-mutilators, however, are
able to stop the cycle on their own.

Plate 5-4: "M" and her Japanese symbol for strength placed in the center of a beautiful lotus.

"M" is a very attractive twenty-year-old college student who, in her early teens, used the physical pain of self-mutilation to cancel her emotional pain. Her first attempt probably would have worked had it been ritually recognized by others, thus validating the purging and her return to and acceptance in the community—life, death, and return.

I have always looked at myself as a weak person, and since the age of thirteen or fourteen and until I was eighteen or nineteen, I was into self-mutilation. I would cut myself, using a razor blade, on my upper thighs and arms when in emotional pain, and the physical pain would take over my mind, and eventually I would forget about what was bothering me. I soon realized that this form of "release" was not healthy and it was certainly very unattractive. I then began to get tattoos.

I got my Japanese symbol from Steel Rose (Auburn, CA) on my eighteenth birthday; the symbol stands for strength. I am a very

emotional person who needed help expressing my feelings, and I needed strength to get through some problems I was experiencing at the time with my family.

I then again went through some tough times and decided to go back for another tattoo rather than cut myself. It was a lotus flower that I designed. The artist, Jackson (Fat Cat Tattoo, Carmichael, CA), and I put it all together, and had it blooming around my Japanese symbol. This was about two and a half hours' artwork. Instead of cutting and making myself ugly, I decided to add some artwork and color.

Tattooing was a very emotional and spiritual thing for me. It was a release of all stress in my life at that time. After every tattoo I feel better, almost as if a thousand-pound weight has been lifted off my shoulders. Through tattooing I have learned to control my anger and my feelings prompting self-mutilation. Tattooing is a very effective way for me to experience a true release, emotionally and spiritually; I can't speak for others. Although I can't directly see my tattoos, because they are on my back, I know they are there, and the thought of them helps me remember what I went through, why and how I should never cut myself again. Self-mutilation and tattooing are very similar . . . they both help me deal with my feelings of depression and anger, but tattoos are more socially accepted than cutting.

What I have discussed in this chapter is neither aberrant nor pathological, and it is certainly not new. All cultures at all times have used pain, sex, and drugs, singularly or in combination, to visit the spiritual world. The major reason for this is that all three can almost instantly provide access to primal fears and desires, and you can quantify reactions and qualify results. The goal in the spiritual sense is *not* the pain, the sex, or the drug—these are only methods for transcending the physical and entering into the spiritual. For many, however, plant gods and ritual sex are

not available, which leaves meditation, prayer, and submission to a deity, or body modifications and pain.

Plant Gods

Certain plants and mushrooms produce chemicals that alter awareness far beyond that of simple meditation (see Merkur 2001), and through them anyone can commune with god. This is the old-time religion. This is the offering under the Christmas tree (*Amanita muscaria,* a mushroom that grows parasitically on its roots); this is the flying carpet in the Persian myths (the purple, hallucinogenic harmaline dye used is from Syrian Rue—*Peganum harmala*); this is the *ankh* (which is symbolic of life, the phallus, the vagina, bootstrap, and the mushroom—see *The Twelve Gates*) in Egyptian tradition. In the Vedas of the early Aryan civilization (1500–1200 BCE) we encounter Soma, a plant god, who offers documentation of that spiritual connection. In Zoroastrianism, a few hundred years later, we encounter Haoma, the same plant god. Moses encounters the plant god on the mountain.

Early scriptures were not written for the masses, as few could read, and many of the references, if taken literally, miss a potential deeper meaning. For example, Christ has been referred to as the sacrificial lamb, symbolized as a lamb or the blood on the lamb's wool (Plate 5-5b). John 1:28–30: "This all happened at Bethany on the other side of the Jordan. The next day John saw Jesus coming toward him and said, 'Look, the lamb of God, who takes away the sin of the world! This is the one I meant when I said, "A man who comes after me has surpassed me because he was before me." In Peter 1:19 we read, ". . . but with the precious blood of Christ, a lamb, without blemish or defect." In Revelation 5:12 is "worthy is the Lamb, who was slain, to receive power and wealth and wisdom and strength and honor and glory and praise." Revelation 14:4 has "These are those who did not defile themselves with women, for they kept themselves pure. They follow the Lamb wherever he goes." And in Revelation

17:14 we read, "They will make war against the Lamb, but the Lamb will overcome them because he is Lord of lords and King of kings—and with him will be his called, chosen and faithful followers."

When looked at from another angle (Plate 5-5a), we see something different. "Now Moses was tending the flock of Jethro his father-in-law, the priest of Midian, and he led the flock to the far side of the desert and came to Horeb, the mountain of God. There the angel of the Lord appeared to him in flames of fire from within a bush. Moses saw that though the bush was on fire it did not burn up" (Exodus 3:1–2)

In ancient Egypt we encounter three general types of temple pillar caps (called capitals). They are the lotus, papyrus, and less frequently mushroom pillars. Plate 5-6a clearly shows a composite capital that includes mushrooms and the lotus, with the uppermost cap displaying gills.

In St. Mark's Basilica in Venice, Italy, we notice a curious feature among the mosaics in the furthest dome to the right when you enter the basilica. Plate 5-6b is the mosaic of the "tree" of good and evil (representing all

a b

Plate 5-5: (a) The God-plant encountered by Moses *(Amanita muscaria)*. (b) Blood on lamb's wool (the sacrificial Lamb, Christ's blood), also resembling *Amanita muscaria*. By coincidence the first four letters are the name of the Egyptian god, Amen or Amun.

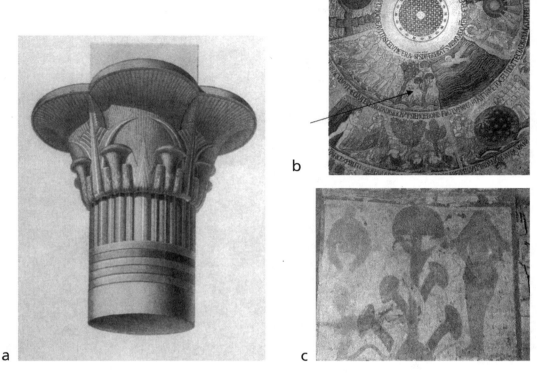

Plate 5-6: (a) Most of the temple columns in ancient Egypt depicted either a lotus or a papyrus opened or closed. In the Roman period the caps or capitals were often composite. The drawing below is composite but includes mushrooms, with the upper caps displaying gills (from Raven 2000:58). Also see Arthur 2000:55. (b) The "tree" of good and evil in the Garden of Eden, St. Mark's Basilica, Venice, Italy. (c) The "tree" of good and evil, thirteenth-century Christian fresco, France (Allegro 1970:74).

the paired opposites) in the Garden of Eden. This does not look much like a tree to me. Compare this to Plate 5-6c, a thirteenth-century Christian fresco from France.

Again from ancient Egypt, we see a strange tree (Plate 5-7a), with interesting "fruit," from a scene in the tomb of the priest Panehsy (Nineteenth Dynasty), Thebes. Here we see the tree goddess (Hathor, Nut, or Isis) offering food and drink to Panehsy's *ba*.

The mushroom *Amanita muscaria* (as well as many other mushrooms and plants) has been part of human culture for thousands of years, and it is more than likely that these plants were considered sacred. Not until well into modern times (Plates 5-7b–d), did people understand the chemistry of these plants and their interaction with neural chemicals. This is a sacrament. By consuming the plant you are consuming the body of the deity within, and through its body you reach into that other realm, the spirit world, with things to see and people, gods, demons, and animals to talk with. The human body morphs out of the flesh, through a mushroom (the body of the god), and to the spiritual realm (mental or spiritual modification).

Plate 5-7: (a) Tree goddess offering food and drink to the priest Panehsy, Nineteenth Dynasty (1307–1196 BCE). Note the "fruit" on the tree. (b) Christmas candies and *Amanita muscaria*. (c) Cool jacket patch *(Amanita muscaria)*. (d) Christmas ornaments from Russia—note the Mushroom Gatherer (again, *Amanita muscaria*).

Dancing with plant chemicals might even be considered a more refined or civilized method of spiritual communion than tattooing or scarification, and could actually undercut a basic idea in Judaism, Christianity, and Islam—that is, the idea that suffering is part of the path, and the individual cannot redeem himself nor is he or she allowed, at least in Islam, to be a prophet. Being a prophet is simply freedom of speech, but it is dangerous. Under the influence of powerful plant chemicals, experiences, sounds, and so on seem very real, and someone led through an experience with an expectation of seeing god and "actually" having the conversation would be a convincing apostle.

These types of plant chemical experiences were slowly withdrawn from the general public. Now access to the spiritual world is through a select group of intermediaries (Brahmins, priests, religious clerics) who transcend to this "other" world or level, while the average person, at least in the monotheistic traditions, is restricted to this world and subservience to, rather than communion with, the spiritual realm. Yes, the average person has access to a wide range of drugs, but in most instances the drugs are used recreationally, or out of dependence, rather than for spiritual reasons. The same case can be made for sex.

Sex and Spirituality

Sex magic for entering the spiritual world extends far back into our prehistoric past. It has been documented in ancient India, Egypt, Persia, Greece, and China and is still with us today.

> Sacred sexuality has been particularly repressed in Western society
> ... Placing the words "sacred" and "sexuality" together creates an
> uncomfortable paradox for many people. How can sexuality, with
> its host of negative connotations, be part of the spiritual realm? In
> our modern world sexuality is largely condemned by major religions. We are taught that it is dark, degenerative, a primary sin of

humanity, to be countered only by suppression and redeemed by celibacy. Moralists and religious fundamentalists of all persuasions consider it an evil influence, capable of destroying faith, and tempting good souls to sin, hell and torment. (Mann and Lyle 1995:6)

Sacred sexuality, like plant substances, was gradually withdrawn. No more copulating in the fields in May *(Beltane),* as did the ancient Celts, and no more altars of initiation—except for the deserving and righteous few. The Arthurian Legends, however, brought spiritual sex back to the individual, where it becomes the sacred sacrament to a love for no other reason than love. In other words, there is this overwhelming joy when together and sorrow when apart; you love to be in love and all the torment that goes with it, and it does not have to be sexual—it just is. Sex can then be seen as the sacrament, the giving of joy through participation in it, and because almost anyone can have an orgasm, anyone could be a god or a goddess, or demon.

In the Hindu tradition it is believed that energies arising from the orgasm(s) could be used to move up the Chakras and eventually illuminate (see Chapter Three). That energy could be experienced and in a sense made tangible through the body, that is, through the sexual act. Sex in this tradition is a normal thing, and because you are god anyway what difference does it make if you commune with yourself? Recall in more recent times, however, the psychoanalyst Wilhelm Reich (1897–1957), who is best remembered for his "orgone box," a perpetual-motion and healing device that concentrated and/or amplified the female orgasm. He was arrested, jailed, and died in jail awaiting trial for fraud.

Once again, if anyone can have an orgasm, what is the point of the middle-man/woman or priest? Sacred sex had to go.

Pain and Spirituality

Not everyone has access to the plant substances, nor the experience to use them. Not everyone has a partner for spiritual sex or is willing to masturbate him or herself to the spirit world, but we all have experience with pain, distress, and discomfort. These are the most common mechanisms for entering the spiritual realm. Near-death experiences and out-of-body travel are reported for those who have come to the boundary of the other side through pain or shock—from, for example, an automobile accident, a fall, and other injuries. Fevers often accompany injuries and are associated with very vivid images and dreams. The spiritual realm, whatever that energy is that informs all, is approachable before we die. The vehicle of that approach is your body, through your senses and emotions, and ultimately manipulated by your mind, or that which has one foot in you and the other stretches to that energy—Atman, Aten, God, Allah, Jesus, Astarte, Mary, Buddha—this energy goes by many names. But when you still the small part of the mind that is "consciously processing stuff" (that part of you that chatters all the time), you are with the other mind: "I and the Father are one." Again, sex, drugs, and pain used in a *ritual, communal capacity,* contrary to Freud, are the royal road to the subconscious and all the spiritual experiences one could ever desire.

The Individual and Society

Conclusions

My journey has led me over well-trodden ground and my conclusions are not new. First, body modifications of the nature outlined in this work are a symbolic gesture for claiming and exhibiting information about the self and others, that is, one's group, tribe, or nation. These are visual displays and are part of our Old World Monkey heritage, where we opted for visual and auditory displays, while the New World Monkeys chose auditory and olfactory displays (sent markings with urine). Maybe that is why New World Monkeys never got out of the trees; they could never develop stealth and information distortion as to their location and location of game animals, the enemy, and so on. If you don't show your face, keep your mouth shut, cover your tracks, then the game or the enemy cannot detect you. On the other hand, I have to urinate and I urinate around my nest, I cannot willingly change the scent to that of another animal, and I cannot bury it or cover it up with another scent. I would not make a very good predator and we had to become top predator or go extinct. Visual and auditory signals rapidly fade; olfactory signals do not.

Second, there are numerous forms of body modification including scarring, tattooing, mutilation (male and female circumcision, removal of hand, foot, nose, tongue, lips, etc.), dieting, cosmetic surgical procedures including breast and lip augmentation and liposuction, cosmetic dental procedures, body building, yoga, face and body painting, hair removal and replacement, not to mention the unintentional alterations brought about by repetitive work habits, clothing and shoes, and accidents of one type or another.

Third, all these methods surround a central figure, the individual. In societies that tend not to accentuate individualism, one encounters (a) the prohibition of body modification; (b) unless governmentally/religiously imposed as a form of punishment; (c) or engaged to anchor the

Plate 6-1: Yubitsume, or a sacrificial offering made to an oyabun (a godfather-like figure in the Japanese Yakusa or crime underworld) for some infraction of the rules that did not warrant death.

individual to a group. In Japan, for example, tattooing is associated with gangsters and the criminal underworld or the Yakuza (Kaplan and Dubro 1986). The Yakuza, who practice extensive body tattooing, do so as a sign of courage and strength. But within the Yakuza they practice a ritual form of body mutilation called *yubitsume* (Plate 6-1). Outside of murder or banishment for a violation of gang rules, the top joint of the little finger is ritually removed, wrapped in silk, and given to the counterpart of the Italian godfather, the *oyabun*. This type of tattooing is about belonging and willing subservience to a group. The spiritual aspect comes through in the tattooing itself and the mythical significance of the images.

The human body is an instrument of the State, and one may think that the variety of modification a culture permits equates with individual freedom. But, you are only free to choose from that which your tribe

or culture deems important or proper. Scarification is very important in Africa and Asia because it tells others who you are by the group's standards, but the scarification is not usually a voluntary act if you want to be a full-fledged member; it is demanded by the group and the ancestors and in this way the ancestors become immortal and so do you.

In industrialized Western countries, Japan being a noticeable exception, what you do to your physical body (outside of killing yourself and pathological self-mutilation—see Favazza 1996) is of little concern as long as you show up for work. Marking your body is no longer a necessary requirement with social security numbers, fingerprints, and DNA testing. With DNA testing, in a symbolic way, we have gone back inside, into the "cave," those mysterious encryptions on the walls of the double helix.

From another direction, more people are purposely opting for body modification with a multitude of motives and methods, but one of the functions of these alterations is that they are a signal of individuality and at the same time a signal of membership and acceptance, if only in the general membership of those who have gone before. This is a move toward belonging and life, and away from loneliness and death.

Another conclusion is that most body modifications current in North America are done during periods of stress, crisis, and points of transition, and thus are very symbolic—inkblots. Body modifications, then, offer methods of personal therapy, enacted millions and millions of times over the course of humanity, but methods that should not be entered into lightly (see

Plate 6-2: Pain and suffering are cornerstones of the Judaic, Christian, and Islamic traditions. Here Christ stands at the center as an image of salvation and spirituality. (Drawing inspired by John A. Rush; art by Juliana Correa.)

Plate 6-2). If fact, as you search your soul through the symbols that are important to you, and then pull up some of your "traumas," you might slowly realize that all is illusion, all is impermanent, you need some of your demons, and that everything is just fine the way it is.

Bibliography

Aldred, C. 1996. *Egyptian Art.* London: Thames & Hudson.

Allegro, J. 1970. *The Sacred Mushroom and the Cross.* London: Hodder and Stoughton.

Alper, J. 2003. "Rethinking Neanderthals." *Smithsonian,* Vol. 34, No. 3 (June), 82–87.

Antelme, R., and Rossini, S. 2001. *Sacred Sexuality in Ancient Egypt: The Erotic Secrets of the Forbidden Papyrus.* Rochester, VT: Inner Traditions.

Arthur, J. 2000. *Mushrooms and Mankind: The Impact of Mushrooms on Human Consciousness and Religion.* Escondido, CA: The Book Tree.

Arriaza, B. 1995. *Beyond Death: The Chinchorro Mummies of Ancient Chile.* Washington, DC: Smithsonian Institution Press.

Avalon, A. 1974 (orig. 1919). *The Serpent Power: The Secrets of Tantric and Shaktic Yoga.* New York: Dover Publications.

Bahn, P., and Vertut, J. 1988. *Images of the Ice Age.* London: Windward.

Barker, K. 1985. *The NIV Study Bible.* Grand Rapids, MI: Zondervan Bible Publishers.

Baumler, W., Eibler, E., Hohenieutner, U., Sens, B., Sauer, J., and Landthaler, R. 2000. "Q-switch Laser and Tattoo Pigments: First Results of the Chemical and Photophysical Analysis of 41 Compounds." *Lasers in Surgery and Medicine,* Vol. 26, Issue 1: 13–21.

Berdan, F., and Anawalt, P. 1997. *The Essential Codex Mendoza.* Berkeley: University of California Press.

Berns, Marla. 1988. "Ga'anda Scarification: A Model of Art and Identity." In, *Marks of Civilization,* ed. A. Rubin, Los Angeles: University of California, pp. 57–76.

Bernstein, J. 1987. "The Decline of Masculine Rites of Passage in our Culture: The Impact on Masculine Individuation." In, *Betwixt & Between: Patterns of Masculine and Feminine Initiation,* eds. L Mahadi, S. Foster, and M. Little, La Salle, IL: Open Court, pp. 135–158.

Bettelheim, B. 1962. *Symbolic Wounds: Puberty Rites and the Envious Male.* New York: Collier Books.

Birket-Smith, K. 1959. *The Eskimos.* London: Thames & Hudson.

Bradley, J. 2000. "Body Commodification? Class and Tattoos in Victorian Britain." In, *Written on the Body: The Tattoo in European and American History,* ed. J. Caplan, Princeton, NJ: Princeton University Press, pp. 136–155.

Budavari, S. 1996. *The Merck Index, 12th Edition.* Whitehouse Station, NJ: Merck & Co.

Campbell, J. 1990. *Transformation of Myth through Time.* New York: Harper & Row.

Campbell, S. 2001. *Getting Real: Ten Truth Skills You Need to Live an Authentic Life.* Novato, CA: HJ Kramer.

Camphausen, R. 1997. *Return of the Tribal: A Celebration of Body Adornment.* Rochester, VT: Park Street Press.

Capel, A., and Markoe, G. (eds.) 1996. *Mistress of the House, Mistress of Heaven: Women in Ancient Egypt.* New York: Hudson Hills Press.

Caplan, J. (ed.) 2000. *Written on the Body: The Tattoo in European and American History.* Princeton, NJ: Princeton University Press.

Caplan, J. 2000. "Introduction." In, *Written on the Body: The Tattoo in European and American History,* ed. J. Caplan, Princeton, NJ: Princeton University Press, pp. xi–xxiii.

Chauvet, J., Deschamps. E., and Hillaire, C. 1996. *Dawn of Art: The Chauvet Cave, The Oldest Known Paintings in the World.* New York: Harry N. Abrams.

Chinchilla, M. 2002. *Stewed, Screwed & Tattooed.* Fort Bragg, CA: Isadore Press.

Cirlot, J. 1962. *A Dictionary of Symbols.* New York: Philosophical Library.

Clark, R. 1978. *Myth and Symbol in Ancient Egypt.* London: Thames and Hudson.

Clendinnen, I. 1991. *Aztecs.* New York: Cambridge University Press.

Clottes, J., and Lewis-Williams, D. 1998. *The Shamans of Prehistory: Trance and Magic in the Painted Caves.* New York: Harry N. Abrams.

Coe, M. 1967. *The Maya.* New York: Frederick A. Praeger.

De Landa, F.D. 2000 (orig. cir. 1581). *An Account of the Things of Yucatan.* Mexico: Monclem Ediciones.

Diaz, B. 1967. *The Conquest of New Spain.* New York: Penguin Books.

Diaz, G., and Rodgers, A. 1993. *The Codex Borgia.* New York: Dover Publications.

Dibble, C., and Anderson, A. 1974. *Florentine Codex: General History of the Things of New Spain.* Sante Fe, NM: The School of American Research and Museum of New Mexico.

Driver, H. 1961. *Indians of North America.* Chicago: University of Chicago Press.

DuBois, C. 1961. *The People of Alor: A Social Psychological Study of an East Indian Island.* New York: Harper & Row.

Devereux, P. 1997. *The Long Trip: A Prehistory of Psychedelia.* New York: Penguin/Arkana.

Drewal, H. 1988. "Beauty and Being: Aesthetics and Ontology in Yoruba Body Art." In, *Marks of Civilization,* ed. A. Rubin, Los Angeles: University of California, pp. 57–76.

Engler, A. 2000. *Body Sculpture: Plastic Surgery of the Body for Men and Women.* New York: Hudson Publishing.

Ernst, C. 1997. *The Shambhala Guide to Sufism: An Essential Introduction to the Philosophy and Practice of the Mystical Tradition of Islam.* Boston: Shambhala.

Favazza, A. 1996. *Bodies Under Siege: Self-mutilation and Body Modification in Culture and Psychiatry.* Baltimore, MD: The Johns Hopkins University Press.

Frazer, J. 1963 (orig. 1922). *The Golden Bough.* New York: Macmillan.

Furst, P. 1990. *Flesh of the Gods: The Ritual Use of Hallucinogens.* Prospect Heights, IL: Waveland Press.

Gadalla, M. 1999. *Historical Deception: The Untold Story of Ancient Egypt.* Greensboro, NC: Tehuti Research Foundation.

Gardner, H. 1983. *Frames of Mind: The Theory of Multiple Intelligences.* New York: Basic Books.

Gardner, R., and Heider, C. 1968. *Gardens of War: Life and Death in the New Guinea Stone Age.* New York: Random House.

Gell, A. 1993. *Wrapping of Images: Tattooing in Polynesia.* New York: Oxford University Press.

Gilbert, S. 2000. *The Tattoo History Source Book.* New York: Juno Books.

Giovannoli, J. 2002. *The Biology of Belief: How Our Biology Biases Our Beliefs and Perceptions.* Rosettapress.com.

Goffman, E. 1963. *Stigma: Notes on the Management of Spoiled Identity.* Englewood Cliffs, NJ: Prentice-Hall.

Goodison, L., and Morris, C. (eds.) 1998. *Ancient Goddesses.* Madison, WI: The University of Wisconsin Press.

Goodison, L., and Morris, C. 1998. "Introduction." In, *Ancient Goddesses,* eds. L. Goodison and C. Morris, Madison, WI: The University of Wisconsin Press, pp. 6–21.

Gottlieb. 2003. *In the Paint: Tattoos of the NBA and the Stories Behind Them.* New York: Hyperion.

Grabmeier, J. 2001. "Among the Maya, Writers for Defeated Kings met a Cruel Fate." http://researchnews.osu.edu/archive/mayans.htm.

Graves, K. 1971. *The World's Sixteen Crucified Saviors, or Christianity before Christ.* New York: University Books.

Green, T. 2003. *The Tattoo Encyclopedia: A Guide to Choosing Your Tattoo.* New York: Simon & Schuster.

Grieve, M. 1992 (orig. 1931). *A Modern Herbal.* New York: Dorset Press.

Grimes, G. 2000. *Deeply into the Bone: Re-Inventing Rites of Passage.* Berkeley: University of California Press.

Gritton, J. 1988. "Labrets and Tattooing in Native Alaska." In, *Marks of Civilization,* ed. A. Rubin. Los Angeles: University of California, pp. 181–190.

Groning, K. 1997. *Decorated Skin: A World Survey of Body Art.* London: Thames & Hudson.

Gustafson, M. 2000. "The Tattoo in the Later Roman Empire and Beyond." In, *Written on the Body: The Tattoo in European and American History,* ed. J. Caplan, Princeton, NJ: Princeton University Press, pp. 17–31.

Hall, D. *Prison Tattoos.* New York: St. Martin's Griffin.

Hansen, H. 1998. "Bodies from Cold Regions." In, *Mummies, Disease & Ancient Cultures,* eds. A. Cockburn, E. Cockburn, and T. Reyman. New York: Cambridge University Press, pp. 138–153.

Herdt, G. (ed.) 1982. *Rituals of Manhood: Male Initiation in Papua New Guinea.* Berkeley: University of California Press.

Herdt, G. 1981. *Guardian of the Flutes: Idioms of Masculinity.* New York: McGraw-Hill.

Hirschfelder, A., and Molin, P. 1992. *The Encyclopedia of Native American Religions.* New York: Facts on File.

Holyland, R. 2001. *Arabia and the Arabs from the Bronze Age to the Coming of Islam.* New York: Routledge.

Hornung, E. 1999. *The Ancient Egyptian Books of the Afterlife.* Ithaca, NY: Cornell University Press.

Hornung, E. 2001. *Akhenaten and the Religion of Light.* Ithaca, NY: Cornell University Press.

Hsu, H. 1986. *Oriental Materia Medica.* New Canaan, CT: Keats Publishing.

Iamblichus. 1991. *Egyptian Mysteries: An Account of an Initiation.* York Beach, ME: Samuel Weiser.

Jaynes, J. 1990. *The Origin of Consciousness in the Breakdown of the Bicameral Mind.* Boston, MA: Houghton Mifflin.

Jenkins, J. 1998. *Maya Cosmogenesis 2012.* Santa Fe, NM: Bear & Company.

Jones, C. 2000. "Stigma and Tattoo." In, *Written on the Body: The Tattoo in European and American History,* ed. J. Caplan, Princeton, NJ: Princeton University Press, pp. 1–16.

Juergensmeyer, M. *Terror in the Mind of God: The Global Rise of Religious Violence.* Los Angeles: University of California Press.
Klein, R., and Edger, B. 2002. *The Dawn of Human Culture.* New York: John Wiley & Sons.

Krutak, L. 1998. "St. Lawrence Island Yupik Tattoo: Body Modification and the Symbolic Articulation of Society." *Chicago Anthropology Exchange* 27:54–82.

Krutak, L. 1999. "St. Lawrence Island Joint-Tattooing: Spiritual/Medicinal Functions and Intercontinental Possibilities." *Etudes des Inuit Studies* 23(1–2):2229–252.

Levi-Strauss, C. 1969. *The Raw and the Cooked: Introduction to a Science of Mythology.* New York: Harper & Row.

Lewis-Williams, D. 2002. *The Mind in the Cave.* London: Thames & Hudson.

Lock, A., and Colombo, M. 1999. "Cognitive Abilities in a Comparative Perspective." In,
Handbook of Human Symbolic Evolution, eds. A. Lock and C. Peters. London: Blackwell, pp. 596–643.

Lock, A., and Peters, C. (eds.) 1999. *Handbook of Human Symbolic Evolution.* London: Blackwell.

Longhena, M. 2000. *Maya Script: A Civilization and Its Writing.* New York: Abbeville Press.

Loxley, I. (ed.) 1998. *The Eternal Cycle: Indian Myth.* Amsterdam: Time-Life Books.

Mahadi, L., Foster, S., and Little, M. (eds.) 1987. *Betwixt & Between: Patterns of Masculine and Feminine Initiation.* La Salle, IL: Open Court.

Mallory, J. 1989. *In Search of the Indo-Europeans: Language, Archaeology and Myth.* London: Thames and Hudson.

Mann, A., and Lyle, J. 1995. *Sacred Sexuality.* Rockport, MA: Element Books.

Maxwell-Stewart, H., and Duffield, I. 2000. "Skin Deep Devotions: Religious Tattoos and Convict Transportation to Australia." In, *Written on the Body: The Tattoo in European and American History,* ed. J. Caplan, Princeton, NJ: Princeton University Press, pp. 118–135.

McCabe, M. 2002. *Tattoos of Indochina: Magic, Devotion, & Protection.* Atglen, PA: Schiffer Publishing.

Mercury, M. 2000. *Pagan Fleshworks: The Alchemy of Body Modification.* Rochester, VT: Park Street Press.

Merkur, D. 2000. *The Mystery of Manna: The Psychedelic Sacrament of the Bible.* Rochester, VT: Park Street Press.

Merkur, D. 2001. *The Psychedelic Sacrament: Manna, Meditation, and Mystical Experience.* Rochester, VT: Park Street Press.

Meskell, L. 2002. *Private Life in New Kingdom Egypt.* Princeton, NJ: Princeton University Press.

Milia, D. 2000. *Self-Mutilation and Art Therapy: Violent Creation.* New York: Jessica Kingsley.

Miller, G. 1996. *10,000 Dreams Interpreted: An Illustrated Guide to Unlocking the Secrets of Your Dreamlife.* New York: Barnes & Noble.

Mithen, S. 1994. "From Domain Specific to Generalized Intelligence: A Cognitive Interpretation of the Middle/Upper Palaeolithic Transition." In, *The Ancient Mind: Elements of Cognitive Archaeology,* eds. C. Renfrew and E. Zubrow, New York: Cambridge University Press, pp. 29–39.

Morgan, E. 1990. *The Scars of Evolution: What Our Bodies Tell Us About Our Human Origins.* New York: Oxford University Press.

Neumann, E. 1972. *The Great Mother: An Analysis of the Archetype.* Princeton, NJ: Princeton University Press.

Olivares, N. 1997. "Cultural Odontology: Dental Alterations from Peten, Guatemala." In, *Bones of the Maya: Studies of Ancient Skeletons,* eds. S. Whittington and D. Reed, Washington, DC: Smithsonian Institution Press, pp. 105–115.

Pearlmutter, D. 2004. *Investigating Religious Terrorism and Ritualistic Crimes.* Boca Raton, FL: CRC Press.

Pearson, M. 2002. *The Archaeology of Death and Burial.* College Station, TX: Texas A&M University Press.

Perls, F., Hefferline, R., and Goodman, P. 1951. *Gestalt Therapy: Excitement and Growth in the Human Personality.* New York: Delta Books.

Pfeiffer, J. 1982. *The Creative Explosion: An Inquiry into the Origins of Art and Religion.* New York: Harper & Row.

Preston, M. 1998. *Hypnosis: Medicine of the Mind.* Mesa, AZ: Blue Bird Publishing.

Propp, V. 2001. *Morphology of the Folktale.* Austin, TX: University of Texas Press.

Raven, M. 2000. *Atlas of Egyptian Art.* Cairo, Egypt: The American University in Cairo Press.

Reed, B. (ed.) 2002. *Nothing Sacred: Women Respond to Religious Fundamentalism and Terror.* New York: Thunder's Mouth Press.

Renfrew, C., and Zubrow, E. (eds.) 1994. *The Ancient Mind: Elements of Cognitive Archaeology.* New York: Cambridge University Press.

Robinson, J. 1998. *The Quest for Human Beauty: An Illustrated History.* New York: W. W. Norton and Company.

Roberts, A. 1988. "Tabwa Tegumentary Inscription." In, *Marks of Civilization,* ed. A. Rubin, Los Angeles: University of California, pp. 41–56.

Roome, L. 1998. *Mehndi: The Timeless Art of Henna Painting.* New York: St. Martin's Press.

Rosecrans, J. 2000. "Wearing the Universe: Symbolic Markings in Early Modern England." In, *Written on the Body: The Tattoo in European and American History,* ed. J. Caplan, Princeton, NJ: Princeton University Press, pp. 46–60.

Ross, C., and Jones, K. 1999. "Socioecology and the Evolution of Primate Reproductive Rates." In, *Comparative Primate Socioecology,* ed. P. Lee, New York: Cambridge University Press, pp. 73–110.

Rossi, E. 1993. *The Psychobiology of Mind-Body Healing: New Concepts of Therapeutic Hypnosis.* New York: W.W. Norton.

Rossi, E., and Cheek, D. 1988. *Mind-Body Therapy: Methods of Ideodynamic Healing in Hypnosis.* New York: W.W. Norton.

Rubin, A. (ed.) 1988. *Marks of Civilization.* Los Angeles: University of California Press.

Ruck, C., Staples, B., and Heinrich, C. 2001. *The Apples of Apollo: Pagan and Christian Mysteries of the Eucharist.* Durham, NC: Carolina Academic Press.

Rush, J. 1996. *Clinical Anthropology: An Application of Anthropological Concepts within Clinical Settings.* Westport, CT: Praeger.

Rush, J. 1999. *Stress and Emotional Health.* Westport, CT: Auburn House.

Rush, J. 2002. "Rites, Ritual and Responsibility: Dilemma in American Culture." In, *Rites of Passage: A Thematic Reader,* eds. Judie Rae and Catherine Fraga. Toronto, Canada: Thomson Learning.

Rush, J. (forthcoming). *The Twelve Gates: The Midnight Journey.*

Ruspoli, M. 1986. *The Cave of Lascaux: The Final Photographs.* New York: Harry N. Abrams.

Sadakata, A. 1997. *Buddhist Cosmology: Philosophy and Origins.* Tokyo: Kosei.

Sanders, C. 1989. *Customizing the Body: The Art and Culture of Tattooing.* Philadelphia: Temple University Press.

Saraswati, S., and Avinasha, B. 1996. *Jewel in the Lotus: The Tantric Path to Higher Consciousness.* Valley Village, CA: Tantrika International.

Saul, J., and Saul, F. 1997. "The Preclassic Skeletons from Cuello." In, *Bones of the Maya: Studies of Ancient Skeletons,* eds. S. Whittington and D. Reed. Washington, DC: Smithsonian Institution Press, pp. 28–50.

Schwartz, R. *The Curse of Cain: The Violent Legacy of Monotheism.* Chicago: University of Chicago Press.

Senzaki, N. 2000. *The Iron Flute: 100 Zen Koans.* Boston, MA: Tuttle Publishing.

Sheehy, G. 1984. *Passages: Predictable Crises of Adult Life.* New York: Bantam Books.

Spencer, B., and Gillen, F. 1968 (orig. 1899). *The Native Tribes of Central Australia.* New York: Dover Publications.

Spess, D. 2000. *Soma: The Divine Hallucinogen.* Rochester, VT: Park Street Press.

Spindler. K. 1994. *The Man in the Ice: The Preserved Body of a Neolithic Man Reveals the Secrets of the Stone Age.* London: Weidenfeld and Nicolson.

Steinsaltz, A. 1980. *The Thirteen Petalled Rose: A Discourse on the Essence of Jewish Existence and Belief.* New York: Basic Books.

Task Force on DSM-IV. 1994. *Diagnostic and Statistical Manual of Mental Disorders, 4th Edition.* Washington, DC: American Psychiatric Association.

Taylor, E. 1999. *Shadow Culture: Psychology and Spirituality in America.* Washington, DC: Counterpoint.

Thorwald, J. 1963. *Science and Secrets of Early Medicine.* New York: Harcourt, Brace & World.

Tierney, P. 1989. *The Highest Altar: The Story of Human Sacrifice.* New York: Viking Penguin. Tresidder, J. 2000. *Symbols and Their Meanings.* London: Duncan Baird.

Vale, V., and Juno, A. 1989. *Modern Primitives: An Investigation of Contemporary Adornment & Ritual.* San Francisco: RE/Search Publications.

Valentine, B. 2000. *Gangs and Their Tattoos: Identity, Gangbangers on the Street and in Prison.* Boulder, CO: Paladin Press. van Dinter, M. 2000. *Tribal Tattoo Designs.* Boston: Shambhala.

Vingerhoets, A., and Cornelius, R. (eds.) 2001. *Adult Crying: A Biopsychological Approach.* New York: Brunner-Rutledge.

Warner, M. 1998. *No Go the Bogeyman.* New York: Farrar, Straus and Giroux.

Weiser, S. 1991. "Forward." In, *Egyptian Mysteries: An Account of an Initiation.* York Beach, ME: Samuel Weiser.

Wells, S. 2002. *The Journey of Man: A Genetic Odyssey.* Princeton, NJ: Princeton University Press.

Whittington, S., and Reed, D. (eds.) 1997. *Bones of the Maya: Studies of Ancient Skeletons.* Washington, DC: Smithsonian Institution Press.

Wilkinson, T. 2003. *Genesis of the Pharaohs: Dramatic New Discoveries Rewrite the Origins of Ancient Egypt.* London: Thames & Hudson.

Zimmerman, M. 1998. "Alaskan and Aleutian Mummies." In, *Mummies, Disease & Ancient Cultures,* eds. A. Cockburn, E. Cockburn, and T. Reyman. New York: Cambridge University Press, pp. 138–153.

Zur Needen, D., and Wicke, K. 1992. "5200-Year-Old Acupuncture in Central Europe?" *Science* 282:242–243.

Index

About the Author

John A. Rush, Ph.D., N.D., is a Professor of Anthropology at Sierra College, Rocklin, California, teaching Physical Anthropology and Magic, Witchcraft, and Religion. Dr. Rush's publications include *Witchcraft and Sorcery: An Anthropological Perspective of the Occult* (1976), *The Way We Communicate* (1976), *Clinical Anthropology: An Application of Anthropological Concepts within Clinical Settings* (1996), and *Stress and Emotional Health: Applications of Clinical Anthropology* (1999). He is also a Naturopathic Doctor in private practice.